MAY 2015

Fondation *Cartier*
pour l'art contemporain

30 ANS

Fondation *Cartier* pour l'art contemporain

30 ANS

VOLUME 1
FROM JOUY-EN-JOSAS TO PARIS
1984–2014

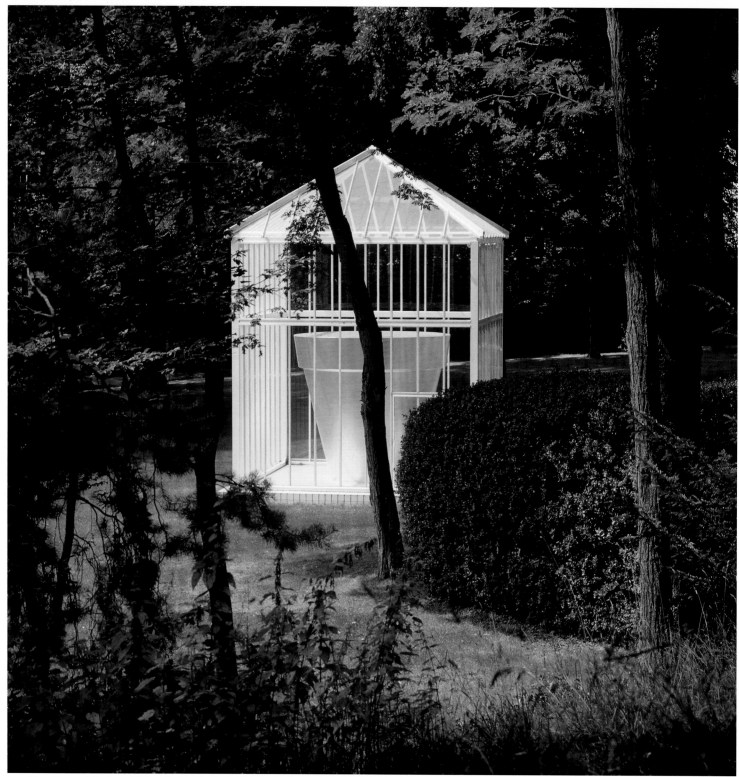

Jean-Pierre Raynaud, *La Serre*, 1985, park of the Fondation Cartier pour l'art contemporain, Jouy-en-Josas. Photograph by Daniel Boudinet

In 1984, Cartier launched the Fondation Cartier pour l'art contemporain to stand as a beacon of innovation and artistic freedom. A space for contemporary artists and creators at the avant-garde of their practice. Its cutting-edge exhibitions highlight artists from around the world, from famous names to young and emerging talents. This mix is an integral part of our founding vision: to give a wide palette of artists *carte blanche* to create.

The Cartier brothers set great store by the power and beauty of the arts. They brought Art Deco designs to jewelry before the term was even coined, and drew inspiration from the modern Cubist and Fauvist movements that revolutionized the art world in their day. For the past three decades, the Fondation Cartier has actively supported artistic creativity through direct commissions, free of constraints. Art needs freedom to break new ground and Cartier could not imagine its involvement any other way.

Contemporary art is forever on the move, carving new avenues ahead of the zeitgeist. It cannot and should not be tied down. In the spirit of bold creation that forged Cartier itself, the Fondation Cartier imposes no codes or commercial agenda on the artists it supports, giving them simply the means they need to create. The Fondation bears the Cartier name and conveys the Cartier spirit but enjoys its own identity, dedicated to the arts and to vanguard ideas. In 30 years of existence, it has commissioned over 1,000 works and fostered privileged relationships with artists, perpetuating the keen and trusted patronage that has proved so vital throughout the history of art.

Time is the finest spokesperson for our ideal of patronage. It confirms the Fondation Cartier's legitimacy and proves its commitment to upholding eclectic, open and visible action, a momentum driven by the pleasure of sharing.

A vibrant expression of the modernity of the Maison Cartier, the Fondation Cartier is testament to the generosity of a patron passionate about the artists it exhibits, for they are devoted to broadening our vision of the world. As André Malraux famously put it: "Art is the shortest path from man to man."

Stanislas de Quercize
President & CEO Cartier International

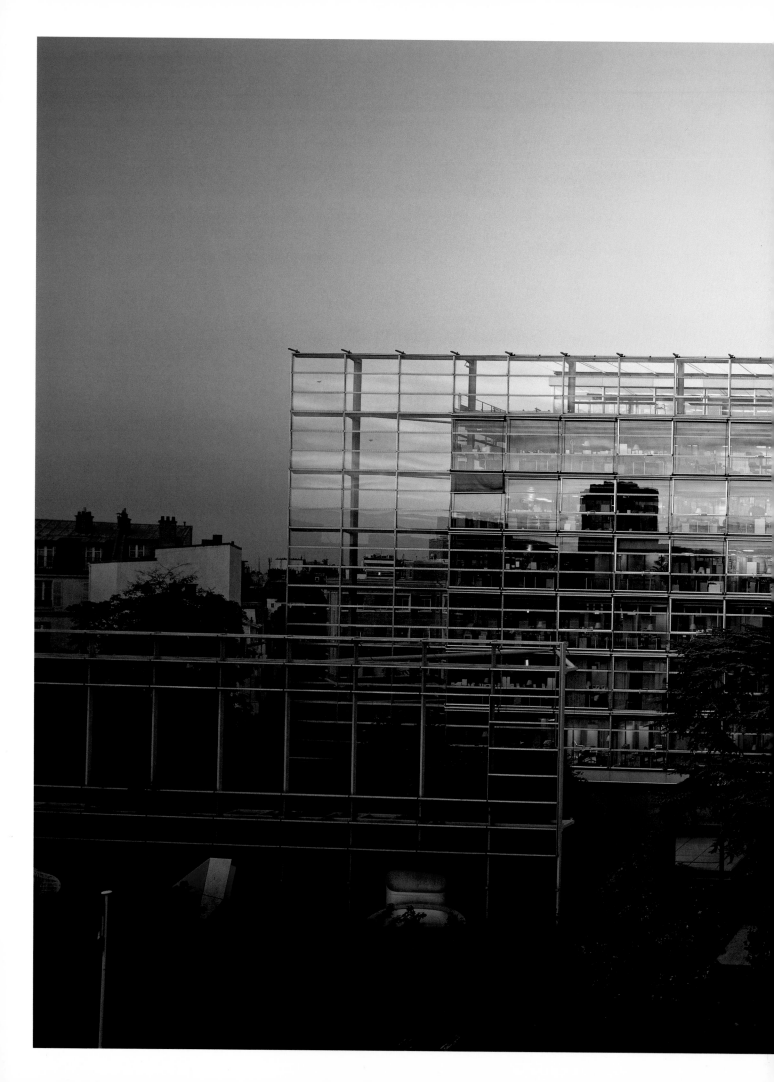

THE FONDATION CARTIER POUR L'ART CONTEMPORAIN

THE FONDATION CARTIER POUR L'ART CONTEMPORAIN

INTERVIEW WITH ALAIN DOMINIQUE PERRIN PRESIDENT OF THE FONDATION CARTIER POUR L'ART CONTEMPORAIN

Herb Ritts, *César, Cahors*, 1993

STÉPHANE PAOLI: A little over thirty years ago, you created a happening by crushing watches.

ALAIN DOMINIQUE PERRIN: It was sensational. It took place in San Diego, California, in September 1981. The idea for this happening wasn't mine. It came from Jim Bykoff, a very good American lawyer who specialized in intellectual property issues. At the time, Cartier, like other luxury brands, was being hit full on by counterfeiting operations in Mexico. Four thousand counterfeit Cartier watches had been seized in Tijuana by U.S. Customs and brought into the United States. So the idea—which was crazy, but extremely amusing—was to crush those watches in a parking lot using a steamroller. I agreed to it, on the condition that Cartier New York's public relations department get involved and that the event receive a lot of publicity.

S. P.: You immediately saw the potential for a big communications operation?

A. D. P.: At Cartier, we were among the first to create events way back in the 1970s. But admittedly this was an extraordinary coup. I was in the steamroller, sitting next to the driver, and when we got to the parking lot, all I could see was a sea of cameras: 240 American, Japanese and European television stations. When we began crushing the watches, they flew out everywhere and exploded all over the place. Those images were shown on the news and broadcast by all of the media. It created the biggest "buzz" of my life!

S. P.: And that was when the idea of a foundation was born?

A. D. P.: In a way, yes. In fact, I was already thinking of creating a Fondation Cartier based on the same theme, but with a completely different purpose: defending the rights of artists.

S. P.: Since, of course, counterfeiting affected all of the arts.

A.D.P.: Yes, and in particular artists like César, Arman and Klein. Dada and the readymade movement launched by Duchamp had paved the way for imitation. Artists tend to be poorly protected, and my idea was to set up a foundation whose aim would be to help them defend themselves—entirely at our expense and using our own lawyers. But it would have been a complete flop because artists couldn't care less. It's not something that interests them. Finally, one day, César said to me: "Look, it's very nice of you, but honestly, I'd rather you create something that would enable us to exhibit." So that's how the idea was born.

The story of the steamroller was in fact one of the founding events that led to César's involvement in the creation of the Fondation Cartier. He was the one who took me to the Domaine du Montcel in Jouy-en-Josas—for the destruction of yet another load of counterfeit watches, which he then made into his *Compressions*. It was a magical place and he showed me around, saying, "This is where you should do something. The estate is for rent and I know the owner very well. You

could turn it into a marvelous exhibition space: the grounds could accommodate monumental sculptures and the rooms could be converted." I told him I would consider the idea.

s. p.: You had a feeling that people, at that time, would be interested in a place like that?

a. d. p.: At my request, a survey was conducted to find out what young people in five European countries—France, Germany, Italy, Spain, the UK—did in their leisure time. The study showed us that, while young adults between the ages of 25 to 35 years old did all kinds of activities, there was a strong interest in art, and especially in contemporary art. Young people were going back to museums. That was in 1983. Jack Lang was the head of an exemplary Ministry of Culture and, riding a wave that came from the United States, was throwing open the doors of museums and putting the emphasis on contemporary art.

And so I decided to start a contemporary art foundation. I developed a business plan and presented the project to the president of the Cartier group, Joseph Kanoui, and the young CFO, Richard Lepeu. They believed in it and supported me. I remember our major shareholder, Dr. Anton Rupert, whom I was very close to, telling me to be careful. "It might become a bottomless pit," he wrote to me. I took that into consideration, but I went ahead and created the Fondation Cartier anyway.

I inaugurated it on October 20, 1984, together with Monique and Jack Lang, Claude Mollard (his visual arts advisor, a remarkable man who was in fact the driving force behind the promotion of contemporary art in France back in the early 1980s), Marie-Claude Beaud and a whole slew of artists. César was in the process of making his *Hommage à Eiffel* (fig. 1 to 3) on the grounds of the Fondation, a colossal sculpture made entirely from scraps of the Eiffel Tower that would take him seven years to complete. Unfortunately, even though it is one of his major works, it has since been forgotten because it remained behind in Jouy-en-Josas.

So that's how it all happened. The idea for setting up the Fondation Cartier originally came from César.

s. p.: I would like to talk about the context, and in particular about the issues of "breaking away" and cooperation. Back in 1981, you had François Mitterrand, Jack Lang and Jacques Attali,[1] who even suggested nationalizing Cartier. It was a rather curious situation…

a. d. p.: It was in 1978, during the legislative elections, that Jacques Attali suggested nationalizing Cartier as a sort of preparation for François Mitterrand's winning the presidency. We knew perfectly well that nationalizing Cartier was impossible because we knew the company's tax structures: Cartier hadn't been French for a long time, since 1934. At the most, they might have been able to nationalize the boutique on Rue de la Paix…

[1] French economist and writer who was Special Advisor to President Mitterrand from 1981 to 1991.

I'm a man of freedom. I respect other people's freedom and I expect to be treated in the same way. I'm all for free enterprise. When César gave me the idea for this foundation and I began to take a serious interest in the situation of artists in our society, I realized that they were often used for manipulation or propaganda purposes by a political establishment that was, on the whole, rather shady, shall we say. Jack Lang and Francois Mitterrand had just taken office at the time, and they also took advantage of artists. That was the theme of my speech at the inauguration. I wanted to provide artists with a space of freedom. With the government and the Ministry of Culture they had no freedom. They were forced to enter into the system. Where the government would take a year to make a decision, I would take a week. When I sat back down, Monique Lang said: "Well! That's not very socialist!" But I held out.

 s. p.: Is it true that the activities of the Fondation have always, from the very beginning, been completely separate from the commercial side of Cartier?

A. D. P.: After I had the idea for the Fondation in 1981, I had lunch with Jacques Toubon—that was before he became Minister of Culture—and I said to him, "I'm going to create the Fondation Cartier and I'll deduct the cost from Cartier's public relations budget, just like Leclerc does when he sponsors this or that soccer team. It's the same thing." He advised me against it. He warned me that, fiscally, I would be taking a huge risk because sports sponsorship was covered by legislation, but that wasn't the case for art. "I'm sorry, but this is a business choice I should be free to make. Instead of putting my name on a soccer shirt, I want to put it on artistic activities, on exhibitions. I want to help promote art in France by making a private space available to it. Is Mr. Leclerc right and I'm wrong? I don't see how it would be possible to tax me." I was ready to fight, to go to court, to appeal to the European Union. Jacques Toubon told me that I would lose. I persisted.

 s. p.: So a big risk was involved. Were the shareholders aware of this?

A. D. P.: Yes. And they let me do it. The relationship with the shareholders is very important because even though I'm the boss, I need their support. But I take responsibility for what I do and I moderate the risks I take.

 I launched the Fondation Cartier in 1984 on that basis and, although I didn't know it at the time, François Léotard would come to my rescue two years later. In the meantime, I never did have a tax audit. We were very lucky!

 s. p.: In 1986, François Léotard asked you to put together a report on corporate sponsorship.

A. D. P.: He was appointed Minister of Culture in May 1986, and I asked him to inaugurate the exhibition *Les Années 60* in the same year. I had

invited Ringo Starr, Françoise Hardy, Hugues Aufray, all the big names of the time (fig. 4 and 5). François went up to the podium and began his speech. Then, right in the middle of it, he turned to me and said: "In fact, I've made a decision. Corporate sponsorship does not exist in France, but it exists in many other countries. I'm asking Alain Dominique Perrin to kindly accept a mission on this subject." I hadn't been informed at all. I mumbled that I didn't have time, but he didn't budge. I didn't really have the choice. After the inauguration, I told him that Cartier would not only fund the mission, it would be the very first sponsor.

[2] Elite institutions of higher education that graduate many of France's politicians, CEOs and senior officials.

[3] HEC (Hautes Études Commerciales) is a prestigious French business school.

Then I went around to the *Grandes Écoles*,[2] HEC,[3] to the universities, and hired no less than forty-four professionals in the field. I explained the project to them: "This is what the Minister wants, and I want to do a good job. We're going to write up a report on corporate patronage that will be entitled *French Patronage* and will contain proposals for a French-style patronage plan." The report described how sponsorship worked in Brazil, Germany, Italy, Japan, Spain, the UK and of course the United States. I found a very short memo written by Pierre Bérégovoy in 1985, when he was Minister of Economy, Finance and Industry, stating that it was acceptable for companies to contribute to cultural events as long as the money was spent in their own interest and in the interest of their business activities, and they could prove it through articles or documents. I used that as my basis.
In September I submitted a sizeable report to François Léotard on how patronage could be developed in France. It was an important subject for him and he wanted his term as Minister of Culture to be marked by a sponsorship law. At his request, I traveled all over France, from October 1986 to February 1987, to present the project to chambers of commerce and regional authorities everywhere. It required a lot of organization! As it was widely reported in the press, Édouard Balladur, who was then Minister of Economy, Finance and Privatization, took it seriously. He put Georges Pébereau in charge of setting my proposals to fiscal music. We worked together to create the final sponsorship bill and in July 1987 the "Léotard Law" on corporate sponsorship was voted in Parliament by an overwhelming majority.

s. p.: From the very outset, the Fondation's perspective has been to explore as far and wide as possible, while also serving as a beacon. The steamroller event, for example, was a sort of planet-wide beacon that made an impact not only in the United States, but in Europe and Asia as well.

a. d. p.: I did exactly the same thing when I was at the head of Cartier. If there was ever a time in my life when I was a visionary, it was when I sensed that luxury could become a real business, on one condition, however: by working on distribution. The secret of market penetration is distribution, having a network. Unfortunately, you can't reach

consumers through quality and beauty alone. On the other hand, when you're proposing luxury products and they become accessible, not so much in terms of price, but in terms of distribution, then you have a veritable war machine in your hands. Just look at the success of Apple. I was born into a family of collectors and I was an antiquary for a long time. I loved the work. Antique hunting was something I did for many years and I acquired an eye for it. At a flea market you have to act quickly, just like at an auction. You have to appraise a piece of furniture in thirty seconds, identify its defects, its irregularities… And when you find something fabulous, you have to go for it. It's a gift. And I have that gift; I got it from my grandfather. When I started off in the luxury business, I was able to recognize, right away, the value of the products I was shown. In fact, that's still my role today for all of the Richemont brands. Since I'm the President of the Strategic Committee, people come to me with their drawings and prototypes. Sometimes I tell them to start all over again, and once in a while I spot a project that I think is interesting. In that kind of situation, I'm in my element.

s. p.: At the same time, you are very respectful of the choices made by the Fondation's directors: Marie-Claude Beaud from 1984 to 1994, and Hervé Chandès today. You leave the door wide open.

a. d. p.: Completely. That's the contract I have with them. It's part of the founding charter, which I established and drew up with Marie-Claude Beaud, and Hervé Chandès has succeeded her with great intelligence. When I hired Marie-Claude, I told her: "What I want to offer art is a place of freedom. It's not about doing the same thing, only cheaper, like the Centre Pompidou or the Musée d'Art Moderne de la Ville de Paris or the Musée d'Art in Toulon. I want it to be different. You will of course choose the artists you want to exhibit, I won't interfere with that. But I do want to have a veto because I want to be able to oppose exhibits that I find objectionable. I promise I won't abuse it: you won't see me often. But you'll have to submit the programming to me. I need to talk to my shareholders and validate each project myself." She agreed.

She also had to respect a founding principle of our project, which was to regularly exhibit unknown artists with a prominent artist. "The superstar and the American stars" was the expression I used—like at the Olympia, before Sylvie Vartan's time,[4] when two or three small, unknown groups would get up and sing (which, by the way, is how I got to know the Beatles). I wanted the "superstar" to attract the crowd, which would then discover "the American stars," the young aspiring artists. "Your art, Marie-Claude, is to unearth young, unknown artists who have a chance of becoming great artists. It's up to you to discover them and up to us to help others discover them." It wasn't easy to impose on César, for example, an English artist whom he couldn't care less about, but we managed it.

[4] The Olympia is a legendary concert hall in Paris. Singer and music hall impressario Sylvie Vartan performed there in the 1960s and 1970s.

5 *A Tribute to Ferrari*, Jouy-en-Josas, 1987. See pp. 70–71 and 201.

6 *Design automobile. Les Maîtres de la carrosserie italienne*, Paris, Centre Pompidou, 1990.

7 *Vraiment faux*, Jouy-en-Josas, 1988. See pp. 72–73.

S. P.: One very interesting point, which has distinguished the Fondation Cartier from the very beginning, is its multidisciplinary approach.

A. D. P.: Yes, the other founding principle that was dear to me had to do with holding an annual thematic exhibition. I said to Marie-Claude Beaud, "You'll be able to get off the beaten path precisely because you come from that world." I wanted to introduce the public once a year—during the period when we have the highest number of visitors, in other words, in summer—to a theme related to contemporary art or contemporary thought which had never been done by a museum before. That was how we got the idea for Ferrari (fig. 6 to 8).[5] Marie-Claude's first reaction was, "What? Ferrari?" I replied, "Do you know who Ferrari is? He's the greatest artist of the 20th century!"
I've always wanted to break away, to show things that people wouldn't find anywhere else. François Léotard coined a marvelous expression, "the cultural clergy," and he warned me to watch out for them. When I announced in 1987 that I was honoring Ferrari as if he were Picasso (and for me, he is, on an everyday level), the cultural clergy screamed, saying I was crazy, that it was ridiculous, that cars had nothing to do with contemporary art. And the result? It was an international success! It was hailed by the press worldwide. And three years later, the Centre Pompidou hosted an exhibition on Italian car design.[6]

We have never stopped opening our doors to themes that are absent from museums. Twenty years later, when the Fondation Cartier decided to exhibit David Lynch, we came up against the clergy once again: "Whatever will they think of next?" the people at the Centre Pompidou, the Ministry of Culture and City Hall exclaimed in chorus.

S. P.: It was Andrée Putman who created the scenography for *A Tribute to Ferrari*. Once again, the approach was very all-inclusive, or even systemic, if you like.

A. D. P.: Absolutely. In 1988, for the exhibition *Vraiment faux* on counterfeit art, we exhibited an absolutely incredible collection of eighty fake Mona Lisas that Marie-Claude Beaud had dug up from museums around the world.[7] But we also displayed a lot of fakes that were outside the realm of art: fake Cartiers, fake Vuittons, fake Guccis. The catalog cover was made of fake grass. That exhibition was a huge success.

Every year there was a different theme: the 1960s, the 1980s, birds, etc.

S. P.: Or design, as far back as 1985, with *Vivre en couleur*.

A. D. P.: For the inauguration of the Fondation in the fall of 1984, we decided to honor César since we felt it was really thanks to him that the Fondation Cartier had come into being. The exhibition was devoted to his ironworks because although his *Compressions* and *Expansions* were well known, people had pretty much forgotten that he had started off working with scrap iron. But what next?

Marie-Claude Beaud wanted to tackle a sphere that had never been featured before: design, with Philippe Starck—who was unknown at the time—, Pascal Mourgue and that whole gang. For the title, *Vivre en couleur*, I was inspired by a slogan that was being used by RFM![8] It also became the name of the circle of friends of the Fondation Cartier, an association that is totally free and works by cooptation.

[8] A French radio station.

s. p.: In short, you've never stopped taking risks. Is that still the case today in 2014?

A. D. P.: From the outset, I defined the Fondation Cartier as a private venue and a place of freedom where decisions are made quickly and artists can exhibit freely. The founding charter that Marie-Claude Beaud and I drew up contains a principle that makes this possible: for each exhibition, we commission works from artists. We buy works created for an event, not for a collection. In addition, I made sure that the statutes, when they were drafted, included the option of selling the works in our possession. The alienable status of our collection is specific to the Fondation Cartier. As you know, no French museum has the right to sell its works. As a result, their basements are full of uninteresting things that are falling apart. The Fondation Cartier is the only institution in France whose collection consists mainly of commissioned works that it is free to sell.

The Fondation de France, which is our umbrella organization, did not immediately agree to this. We finally convinced them by guaranteeing that all the proceeds from the sales of works would be put back into the pot in order to buy new works of art. So the works we keep represent our history, but we aren't collectors.

s. p.: Will we be able to see these works—all of them—this year, for the thirtieth anniversary of the Fondation?

A. D. P.: Since there are 1,300 pieces in all, it would be impossible to show all of them. The most important ones will of course be exhibited. Hervé Chandès is working very hard on that. And this year we're selling two works—both of which are major works, but have nothing to do with our history—because we need the funds to buy another work, a sculpture by Ron Mueck. That's an example of what I was saying. What other museum or private foundation has that freedom?

s. p.: There was another "breaking away" in the early 1990s: you left Jouy-en-Josas and asked Jean Nouvel to design a building whose purpose would be to exhibit contemporary art.

A. D. P.: In Jouy-en-Josas, we were renting the Domaine du Montcel. When the landlord first saw me coming to rent the property where he and his friends played *pétanque*, and which was costing him a fortune, he must have thought, "Good riddance!" A few years later, and after quite a lot of work fixing it up, I had brought the place to life and made it famous. When the time came to renew the lease, the owner told me

9 Groupe des assurances
nationales, a French
insurance company.

he was going to double the rent. He probably thought he could do it because it was Cartier. Well, he was badly mistaken!

Then one night, by chance, I met a man who worked with Gan,[9] who had just purchased the American Center on Boulevard Raspail. We chatted and he told me about the real estate transaction they were planning. They weren't allowed to turn it into an office building, so he was looking for some other kind of activity. "Maybe a sports center…" And then he added, "The Fondation Cartier would be great." I suggested we discuss the matter again and, some time later, he came to see me in my office (which was also decorated by Jean Nouvel!) with three or four executives from Gan. He explained the project to me. It was in quite an advanced stage, and there was already an architect involved. I looked it over and told him, "I think we can come to an agreement, but on one condition: I choose the architect." He called me back three weeks later: "I've studied the problem. It will delay things and cost us the termination fee, but we can change the architect. We're willing to do that, but whom do you have in mind?" Jean Nouvel.

s. p.: Why Jean Nouvel?

a. d. p.: He was a friend, I knew his work and I loved his architecture. Jean Nouvel had already made a fabulous warehouse for Cartier in Switzerland, in the Fribourg region, and we were negotiating a project for a factory. Jean came to see me and he asked me what I wanted. "A space to display our works." "Okay, but what else?" I told him, "The Fondation Cartier must endure. What I want, Jean, is a monument for Paris. For you, it will be a terrific rite of passage, and for us it's vital." Certain phrases always stick in your mind, and even today, when he talks about it, Jean says, "Perrin wanted a monument for Paris, so I made him a monument for Paris."

s. p.: And he had the nerve to design a building without walls!

a. d. p.: He showed me his project: it was nothing but glass. "But where do we hang the works? You're crazy!" Marie-Claude Beaud had the same reaction. But, very serenely, Jean replied: "Not at all. Why is this design interesting? Because it allows you to build whenever you want. What I'm offering you is a beautifully transparent showcase. With reflections as far as the eye can see. Inside, you can do what you want. You build up, you take down. You create your own walls, and each time they're different. It gives you the advantage of enormous spaces." Jean didn't back down and he was right—because the building is magnificent. It's true that mounting an exhibition in this space is expensive because you have to construct it each time, but the visual results are so spectacular! Jean built this building with love. It's a real accomplishment, and he considers it one of his best creations. To him, it represents absolute purity. And it's a huge success (fig. 9 and 10).

s. p.: And are you thinking of another place now?

A. D. P.: Of course.

S. P.: In order to have more room for the collection?

A. D. P.: We could never show the entire permanent collection. Not only is it too big, but it's not, in my opinion, something that's desirable. I want it to remain a little mysterious. We regularly lend works to other institutions around the world, to Japan, to the United States, to Brazil, for example. But as I said, the purpose of our collection is to represent the history of the Fondation Cartier. I don't want it to become a museum. A permanent collection then becomes a petrified collection. However, in the past two years we've been thinking of possible solutions for expanding. The most logical would be to take over the land adjoining the Fondation. But they're not making it easy for me. Jean Nouvel has drawn up a wonderful project and it's on the table.

S. P.: That's how François Pinault[10] ended up in Venice.

A. D. P.: It's exactly the same story. And that's how I myself might end up in Venice or somewhere else one day. A while back, I had a great project, a very interesting project, once again with Jean Nouvel, on Île Seguin.[11] And I have to say that Nicolas Sarkozy, who was President at the time, was pushing it, he wanted it to happen. I naturally asked for certain commitments, particularly from the city of Boulogne-Billancourt, in terms of access to the island by train, subway, boat, etc. I wanted written guarantees, with specific dates and penalties for delays. They said they couldn't work like that. I warned them that I wouldn't budge until I was sure there would be transportation for my visitors, and that I wasn't willing to wait four years for them to get the funds. They never committed and so I had to give it up. I had a great project for that islet, I had really tested the waters out there, but it's not going to happen. One day maybe, but not right now.

S. P.: Meanwhile, things are developing in London, in China, in Germany.

A. D. P.: And that makes me very happy! I like being a pioneer. With Cartier, I was a forerunner in the area of luxury goods distribution. I created a new business model that everyone adopted after me: Hermès, Chanel, etc. Then, with the Fondation, I invented another kind of model: the private art exhibition space. Previously, in France, art had never come under the private sector; it had always been official.

I'd like to mention that it's strictly forbidden for the artists who exhibit at the Fondation Cartier to be used by the Maison Cartier. I'm adamant about that. If you want to help artists, you love them and respect them. The only resources we offer them are those of the Fondation. Their artwork is unique. It is not repetitive.

When new foundations are established—Pinault, Vuitton, Prada—I'm delighted. It's very good news, I welcome them. Artists need to have outlets that enable them to exhibit and express themselves

[10] French business magnate and art collector.

[11] Islet on the Seine River, west of Paris near the city of Boulogne-Billancourt.

freely without having to fear the infamous clergy. For such a long time, they weren't free. Now they know they can breathe more easily thanks to people like us. When Matthew Barney—whose name we didn't even know how to spell—came to France to exhibit, he didn't think twice, he came straight to us. Ron Mueck doesn't want to go anywhere else either. They're artists who didn't want to get caught up in the politico-administrative system and we offered them a space of freedom worthy of its name. When Hervé Chandès and I make a decision, the funds are available immediately and the process is set in motion with unbelievable fluidity and responsiveness. Hervé Chandès is very good at that. That freedom is what I'm most proud of.

Of course, the formulas I mentioned are always applied: the "American star" with the celebrity, the thematic concepts. Every day I say to Hervé Chandès, to everyone: "Don't be afraid. Go for it with all your might. Be wild and crazy, do what's never been done before, as long as it's innovative and in good taste."

s. p.: Basically, you have always been a trailblazer.

a. d. p.: David Lynch, Patti Smith or even Raymond Depardon, not to mention *Mathematics* and the Yanomami… Whatever we do is unexpected, out of the ordinary! That's really what has made our fame and why the whole world now comes to the Fondation—even though it's a little out of the way. Because of our location, our numbers remain limited. The most we've ever had are the 310,000 visitors for Ron Mueck's exhibition in 2013. And in fact, I can't really explain that figure: with nine sculptures, he smashed our attendance record! I must admit that I don't have the answer to attracting such crowds for every exhibition.

In the past thirty years, we've had fabulous exhibitions and innovated in many ways. Once we began exhibiting anything and everything, whatever is atypical in the world of art, everyone else started doing the same thing.

s. p.: The Fondation has become a one-of-a-kind laboratory of ideas. When you put Misha Gromov together with David Lynch, Takeshi Kitano and Raymond Depardon, well, something's bound to happen!

a. d. p.: That's how we operate and will continue to operate. You're talking about *Mathematics* in 2011,[12] but there have been other combinations: Patti Smith and David Lynch, Cédric Villani and Jean-Michel Alberola, or Raymond Depardon and Paul Virilio in 2008 for the exhibition *Native Land*,[13] and Paul Virilio and Mœbius in 1999 for *Un monde réel*.[14] Hervé Chandès is very good at coming up with the most extraordinary mixtures and interesting interconnections.

s. p.: From the outset, your point of view has always been to turn art into something popular.

a. d. p.: Of course art is for everyone. And it should remain that way.

[12] *Mathematics, A Beautiful Elsewhere*, Paris, 2011–12. See pp. 180–83 and 249.

[13] Raymond Depardon and Paul Virilio, *Native Land, Stop Eject*, Paris, 2008–09. See pp. 166–69 and 243.

[14] *Un monde réel*, Paris, 1999. See pp. 162–65.

When I hired Marie-Claude Beaud, for example, I told her: "Rock 'n' roll is a brilliant theme. Don't let it get away. Don't let someone else take it. The history of rock 'n' roll is a real social issue." When European journalists heard that we were preparing the *Rock 'n' roll 39-59* exhibition in 2007 (fig. 11 and 12), they were waiting to pounce on us, ready to call us jokers, impure. I hired the producer and collector, Gilles Pétard, who said to me: "We'll go and get the best, the Americans. The greatest writers, journalists, producers of rock 'n' roll from the 1950s. They're still alive. And I promise you, no one will be protesting." He was right.

And to my great satisfaction, Eddy Mitchell and Johnny Hallyday, our two national rockers, came and spent two and a half hours visiting the exhibition together. It was Eddy, the absolute purist, guiding Johnny, who couldn't believe his eyes.

 s. p.: There's one thing that strikes me about you, and that's your sense of loyalty: an ongoing commitment through the exhibition programs and lasting ties forged with everyone who accompanies you along the way.

a. d. p.: That's my nature, my upbringing, my culture. One important thing that has guided me throughout my life is rugby. I played rugby for a very long time. Rugby is an extraordinary school of friendship, loyalty and courage. Unfortunately, it's gone professional, but it's still the only sport in which, after thrashing each other for years and years, sworn enemies get together at dinners or reunions to show their love and respect for each other. You won't find that in any other sport. Rugby is a fantastic love story.

I'm insanely loyal as a friend. My buddies, my gang, are everything to me. In my career I've surrounded myself with people who are still there. Bernard Fornas, who took over from me at Cartier and in part at Richemont: I was the one who hired him a long time ago. Stanislas de Quercize, the new head of Cartier, is also one of my "children." It's true that I'm loyal and I've surrounded myself with loyal people. I don't think you can build much of anything without loyalty.

Interview by Stéphane Paoli, journalist and host of the Nights of Uncertainty at the Fondation Cartier pour l'art contemporain, Paris, January 2014.

A PIONNEERING SPIRIT

FRANCO COLOGNI

BERNARD FORNAS
CO—CEO OF RICHEMONT GROUP

RICHARD LEPEU
CO—CEO OF RICHEMONT GROUP

I am not a contemporary art expert, nor even a collector. I simply have faith in my style and taste. I enjoy culture, and the arts—and most of all, beauty. Rather than a connoisseur, I'd say I am a keen and inquisitive amateur.

I was present at the birth of the Fondation Cartier. As someone close to Alain Dominique Perrin and who has worked with him for 40 years, I was curious to witness his first steps in the contemporary art world.[1] As my friend Alain laid the groundwork for his foundation project, he pronounced two words that have remained a leitmotif to this day, and which I hold dear: "responsibility" and "inclusiveness." The word "responsibility" is very important; it means being conscious of what we do, and of our duty, which is to do it to the best of your ability. The Fondation members must make this their prime concern, so that visitors may appreciate it to the fullest. As for the notion of "inclusiveness," it is a reminder that the Fondation Cartier must be part of the contemporary world: an inclusive foundation is not an elite circle, but rather a democratic space open to one and all.

A golden rule of the Fondation Cartier stipulates that its founder— the Maison Cartier—is *a patron of the arts*. That means making donations to bring about projects, all corporate interests aside. In a world that is increasingly prone to exploiting art and culture—and where sponsorship is most often the guarantee of "positive brand image" in return— I believe it is fundamental to see the Maison Cartier as a patron.

In my opinion, it is the multicultural and multiethnic outlook of the Fondation Cartier that differentiates it from other foundations. It has demonstrated the courage not only to take the avant-garde route, but also to break new ground and fully explore the world in which we live. This approach has made the Fondation Cartier a mirror of its time—to which it also brings the value of beauty.

The Fondation's other unique feature is its transdisciplinary and multidisciplinary approach. The former means it focuses not only on painting and the conceptual arts, but also on photography (the Fondation Cartier supported the Printemps de Cahors), cinema, design, fashion, science, nature, video, the performing arts, music and graphics. The multidisciplinary nature of the Fondation Cartier's programming is reflected in different approaches to displaying work, from regular exhibitions to publications, the Nomadic Nights and performing arts— while never forgetting the primary mission of patronage: artist commissions. This is how its collection came into being—a collection that will no doubt be the subject of a future exhibition, or even give rise to the creation of its own Fondation Cartier Collection museum.

[1] Franco Cologni (1934) joined Cartier in 1969 with the "Cartier lighter." He created the first foreign subsidiary of the Maison Cartier, in Milan. He was then appointed CEO of Cartier International in 1980, Vice-President in 1986, and finally President. From 2002 to 2007 he held the post of Senior Executive Director of Richemont Group. Since then he has been Non-Executive Director of the Board of Directors.

The Fondation Cartier's spaces—both interior and exterior, at Jouy-en-Josas and its current incarnation, the extraordinary Boulevard Raspail building—have always been conducive to these transdisciplinary and multidisciplinary approaches. They are areas of freedom for every citizen.

What has interested me most at the Fondation Cartier is not so much the personal exhibitions of today's known and up-and-coming artists—which one can find elsewhere—but the way it has set off to explore new horizons alongside the visual arts. For example, one of the shows with which the Fondation Cartier ostensibly struck out into this art of polarity, defending the notion of inclusiveness while entering a world that was not exactly considered contemporary art at the time (though it is today), was *Vivre en couleur*, devoted to design.[2] In the same manner, Formula 1 champion Enzo Ferrari, who had been known exclusively for cars and motors, became a recognized designer thanks to the Fondation. With *A Tribute to Ferrari*[3] and then with the *La Vitesse*[4] exhibitions the Fondation proved that beauty could lie within any technology.

I was also struck by *Jean-Paul Gaultier* exhibition, another example of the Fondation Cartier's approach: in this case turning an everyday job and substance into a work of art.[5] It involved twinning the world of fashion and a common consumer item: bread. I remember that this show not only featured Jean Paul Gaultier's bread-based creations, but also those of the men and women who make and sell bread for a living.

Another exhibition I found truly interesting, and which is another example of the Fondation Cartier's commissioning policy, is *Native Land*,[6] featuring the work *Exit*, by Elizabeth Diller and Ricardo Scofidio and inspired by Paul Virilio, which showed the flux of populations around the world. Much has been said, written and published about this subject, but only the Fondation Cartier has actually shown all the visual beauty of migrations. The exhibition illustrated the world's roundness, that it revolves around these migrations and is not linked to one single country. By tackling these kinds of major economic and social questions, the Fondation Cartier demonstrates that far from being beholden to the "empire of the muse," it operates in the real world, a world influenced by these very topics.

Something that I find profoundly interesting at the Fondation Cartier, each time my cultural curiosity leads me there, is its ability to bring together different worlds. Contemporary art is often segmented into territories or cultures; yet, by setting out on different paths, the Fondation Cartier has had the audacity—or one might say the courage—to show that the world moves in all kinds of different directions, without ever forgetting to reveal the beauty hidden in each object.

[2] *Vivre en couleur,* Jouy-en Josas, 1985.

[3] *A Tribute to Ferrari,* Jouy-en Josas, 1987. See pp. 70–71 and 201.

[4] *La Vitesse,* Jouy-en-Josas, 1991. See pp. 78–79.

[5] *Pain Couture by Jean Paul Gaultier*, Paris, 2004. See pp. 147–49.

[6] Raymond Depardon and Paul Virilio, *Native Land, Stop Eject*, Paris, 2008–09. See p. 166–69 and 243.

I would also like to mention an aspect that no one, especially in the press, ever brings up: backstage at the Fondation Cartier—all the people working in the shadows in order to prepare these exhibitions for the public. Everybody knows the artist and the curator. But on a day-to-day basis, the forklift driver transporting the work of art, the maintenance man hammering nails in the wall or the press secretary are all of utmost importance. For, unlike other companies, the Fondation Cartier is driven by a community of people with major qualities that go beyond their professionalism: they are passionate about their work and they take great pleasure in doing it. I regret that more is not said about them, for in the world we live in, these qualities are essential to success.

To conclude, on each of my visits to the Fondation Cartier, I am always struck by the way it has been able to reach young people. Without necessarily attempting to "educate" them—what a disagreeable word—it has managed to encourage them, most notably through its guided tours, to not make do with simply *seeing*, but rather to focus on *looking*. This gives them access to a vast world while allowing them to enjoy its essential elements: originality and beauty.

Interview by Grazia Quaroni, curator of the Fondation Cartier pour l'art contemporain, Paris, February 2014.

A PIONEERING SPIRIT
BERNARD FORNAS
CO-CEO OF RICHEMONT GROUP

I discovered the Fondation Cartier long before joining the Maison Cartier, when I was working in other places. The first time I visited the site at Jouy-en-Josas, for the exhibition *Les Fers de César*, I was just a Parisian art-lover.[1] I was struck by the site itself and the way that art was being democratized there. To put this back in context, in 1984 contemporary art did not enjoy the same kind of exposure it gets today, nor inspire as much enthusiasm from investors. By creating an art space of this nature, the Maison Cartier and the directors of the Fondation Cartier proved to be real pioneers in the contemporary art world.

When I joined Cartier in 1994, I kept close to the Fondation Cartier and have been drawn to the diversity of its programs and the multifarious themes explored ever since. The exhibition devoted to math and mathematicians, for example: it's a subject so specific it could be reserved for specialists, but the exhibition showed just how many people are interested in this topic.[2] For my part, it introduced me to a realm I knew little about: I studied math like everyone else, of course, but the exhibition went far beyond the things I was ever taught. It provided a chance to meet some amazing people, like Cédric Villani, a mathematician so driven by his passion that he seems to live in another world! This fantastic experience was all down to the Fondation Cartier.

I also remember the exhibition *Jean Paul Gaultier*,[3] which featured a real bakery, and the exhibition devoted to Ron Mueck: I had seen a few photographs of his work but did not know it very well. When I stopped before the giant woman in her bed, I was mesmerized.[4] In a different field, the exhibition *Native Land* with Raymond Depardon and Paul Virilio was also extraordinary.[5] The same goes for the exhibition devoted to Takeshi Kitano: originally more of a television or cinema figure, this Japanese artist showed some incredible works at the Fondation Cartier, which Parisian children had great fun discovering during workshops conceived specially for them.[6] It is this diversity in the choice of artists and the themes presented that makes the Fondation Cartier so very relevant.

I would also like to highlight an aspect that strikes me as fundamental: the distinction between the Fondation Cartier, its artists and its programming on the one hand, and the corporate activity of the Maison Cartier on the other. This golden rule established in 1984 was the best decision possible. There is an ethic of not using the artists shown at the Fondation Cartier for commercial purposes, unlike some other institutions. It does Cartier great credit to have kept its artistic activity separate from its corporate business; from the start it was a

[1] *Les Fers de César*, Jouy-en-Josas, 1984. See p. 195.

[2] *Mathematics, A Beautiful Elsewhere*, Paris, 2011–12. See pp. 180–83 and 249.

[3] *Pain Couture by Jean Paul Gaultier*, Paris, 2004. See pp. 147–49.

[4] Ron Mueck, *In Bed*, 2005, collection of the Fondation Cartier pour l'art contemporain, Paris, exhibition *Ron Mueck*, Paris, 2005.

[5] Raymond Depardon and Paul Virilio, *Native Land, Stop Eject*, Paris, 2008–09. See pp. 166–69 and 243.

[6] Beat Takeshi Kitano, *Gosse de peintre*, Paris, 2010. See pp. 154–55 and 247.

7 Bernard Fornas
served as President
& CEO of Cartier
from 2002 to 2013.

very strong stand—a brave one, even, because it kept the Fondation apart from the Maison Cartier's success. It was a move that shows the spirit of innovation that drives the Maison Cartier. It has asserted a genuine ethical attitude toward art that never ceases to delight me. Throughout the time that I was running the Maison Cartier, never once did it cross my mind to take an element of an artist's creation and print it on a Cartier product.[7] It would have struck me as thoroughly misplaced, or even dishonest. Each stays in their own domain: the Maison Cartier in jewelry and the Fondation Cartier in contemporary art. This approach has prevailed for 30 years.

Today the Fondation Cartier has experienced major successes, thanks to its programming, but also to Jean Nouvel's building, which truly adds to its aura. Between the Fondation's outside appearance and the exhibitions within, there is a visual synergy that perfectly echoes the concept of contemporary art. It is a symbolic building that stands out from the architecture of the 14th arrondissement around it. Time has given it an authority that has allowed it to achieve the recognition it now enjoys. At the moment, the Fondation Cartier is somewhat disadvantaged by its surface area and its rather outlying location. Some projects have been limited by the building's size, and the number of visitors allowed in the exhibition spaces is restricted by security regulations: people sometimes have to wait for hours outside before entering. Despite these practical hitches, it has managed to build itself an impressive place in the art world—not just in France, of course, but abroad as well. It deserves a larger space. In my view, its future is closely connected to the prospect of a location in which even more imposing exhibitions can be held, drawing even more people. When it moved to the Boulevard Raspail from the site in Jouy-en-Josas—which proved a success despite its distance from Paris—the Fondation Cartier started a second phase of its history. I think that one day it will have to inaugurate a third: the phase of maturity, with a site that will allow it to fill its rightful place in the world.

If I were to sum it up, I would say that the Fondation Cartier pour l'art contemporain is defined by its pioneering spirit, its values, its ethics, its relevant programming and the fact that it has developed over several phases: the next one is essential, for it will be a phase of fulfillment for the Fondation Cartier's international dimension.

Interview by Hervé Chandès, General Director of the Fondation Cartier pour l'art contemporain, Paris, March 2014.

A TRUE INSTITUTION
RICHARD LEPEU
CO-CEO OF RICHEMONT GROUP

Originally I was not particularly familiar with contemporary art. I was initiated into modern art when I married; my father-in-law was a doctor and Picasso, Braque and Villon were patients of his. He was a patron of the arts who lived surrounded by artists. To me, that was what patronage meant: being close to artists, acquiring or commissioning their works. When Robert Hocq first brought up the idea of a foundation, I didn't fully understand what he meant: the art world was still quite unknown to me.[1] There was an artist who paved the way for us: César. He told us about the Domaine du Montcel in Jouy-en-Josas, a fabulous place that its owner, Jean Hamon, was looking to turn into a site for contemporary art. He had already welcomed artists such as César and Arman there; Arman had created *Long Term Parking* in the grounds. We used to go there at weekends to play *boules* and enjoy the swimming pool. It was like a country house. This is how the Fondation Cartier came into existence. Jean Hamon was instrumental in triggering its creation; Alain Dominique Perrin's intuition, charisma and passion did the rest.

When the idea of opening an exhibition space became clearer, we looked for a top-level art professional and Marie-Claude Beaud joined the team. She immediately launched projects, opened doors and commissioned works, setting very high standards. Both she and Alain Dominique Perrin made a decisive mark on the Fondation's identity. It was like a meeting between fire and water! I have extraordinary memories of this era; I always believed in the project, both strategically and as a channel for patronage. And because it was simply a fascinating adventure!

The political dimension came some time later, when Cartier started to spend significant amounts on producing exhibitions or commissioning works. At that point we lobbied the authorities, which led to a report on patronage and then to the first tax laws in favor of patronage. In the early 1980s in France, we sensed that a foundation would need a framework in order to assure society of its legitimacy. Artistic values are part of the Maison Cartier's DNA, which made its decision to commit contemporary creation quite natural. The Fondation Cartier was originally seen as a communications tool for the house—with paltry returns and results compared with the quality of the projects— but this was certainly not how we experienced it from the inside. One of the things I particularly appreciated—and which has undoubtedly helped to define the Fondation Cartier's specificity and authenticity— is its proximity to artists. We were constantly in touch with them, we

[1] Robert Hocq was President of Cartier Paris from 1973 to 1979.

were producing their works. In this sense, we had returned to the origins of patronage, in historical terms. When the Fondation Cartier opened in 1984, we conducted an extraordinary communications campaign. But it is the body of projects that have been produced over the past 30 years that matter most, the works wich we have initiated and acquired for the collection, year after year. The Fondation Cartier is often viewed as entirely independent from Cartier: the public does not necessarily make the connection between Cartier and the Fondation, and that's excellent. The Fondation Cartier has now entered the realm of a true institution. We are proud of this achievement. One of the other key points is the total lack of ambiguity between Cartier's corporate affairs and the Fondation's programming. This is its strength. It has impeccable, established governance that has never failed in all these years. This endurance is also what gives the Fondation Cartier its scope and legitimacy.

After twenty years spent in the building designed by Jean Nouvel on Boulevard Raspail—a beautiful place with a strong identity—the time has now come to write the third page in the history of the Fondation Cartier. To assert its dimension as a museum institution, to show its collection and tell its story, spun by a wealth of relationships forged over time. Cartier's strength lies in the continuity of the people who have made it what it is. This is also the strength of the Fondation Cartier, whose programming has been orchestrated by just two directors: Marie-Claude Beaud for the first decade and Hervé Chandès for the past two. There is a filiation and a loyalty to artists. The Fondation Cartier still exists by virtue of its well-organized beginnings. It is now ready to go even further. And I wager that it will. It must continue to uphold its pioneering spirit, to initiate the creation of artworks, and to take an interest in young artists. But it must also continue to respond to the ways in which the public's relationship to art is evolving, and to become even more international while preserving its authenticity and experimental nature. The Fondation Cartier is one of the only institutions that conceive such specific, large-scale projects: we are the "haute couture" of contemporary art, not the "prêt-à-porter". And the artists know this.

Interview by Hélène Kelmachter, curator of the Fondation Cartier pour l'art contemporain, and by Hervé Chandès, General Director of the Fondation Cartier pour l'art contemporain, Geneva, February 2014.

JOUY-EN-JOSAS
1984-1993

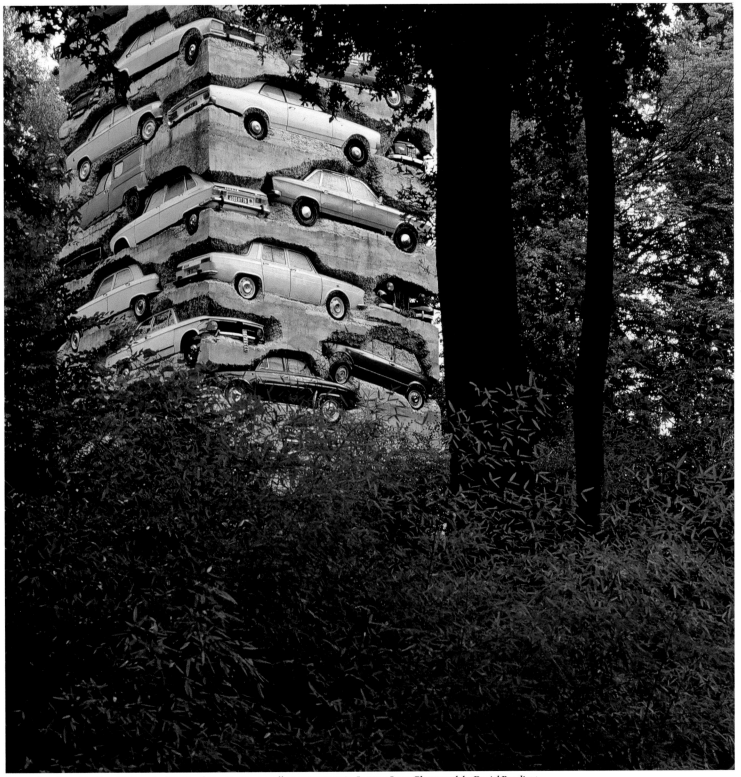

Arman, *Long Term Parking*, 1982, park of the Fondation Cartier pour l'art contemporain, Jouy-en-Josas. Photograph by Daniel Boudinet

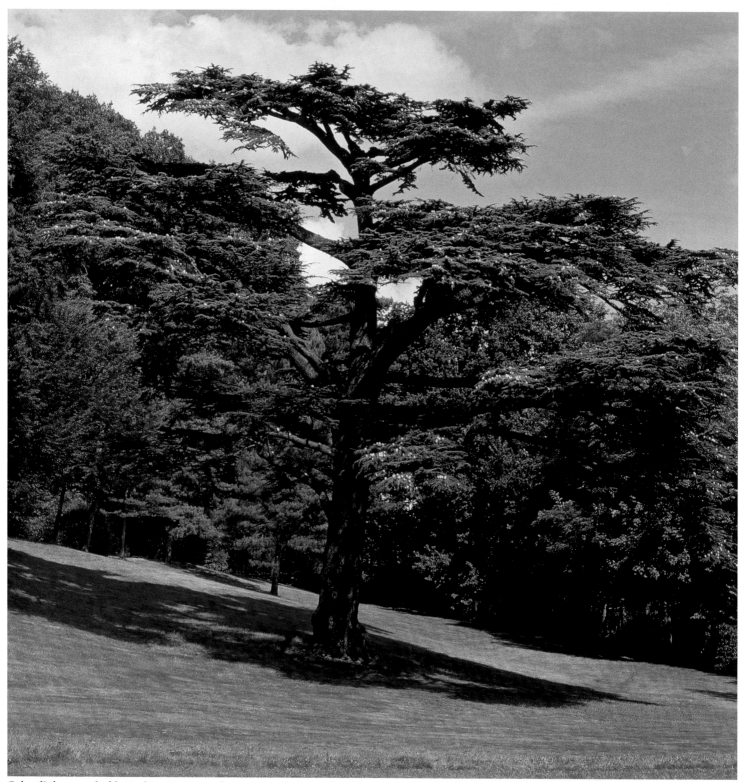
Cedar of Lebanon, park of the Fondation Cartier pour l'art contemporain, Jouy-en-Josas. Photograph by Daniel Boudinet

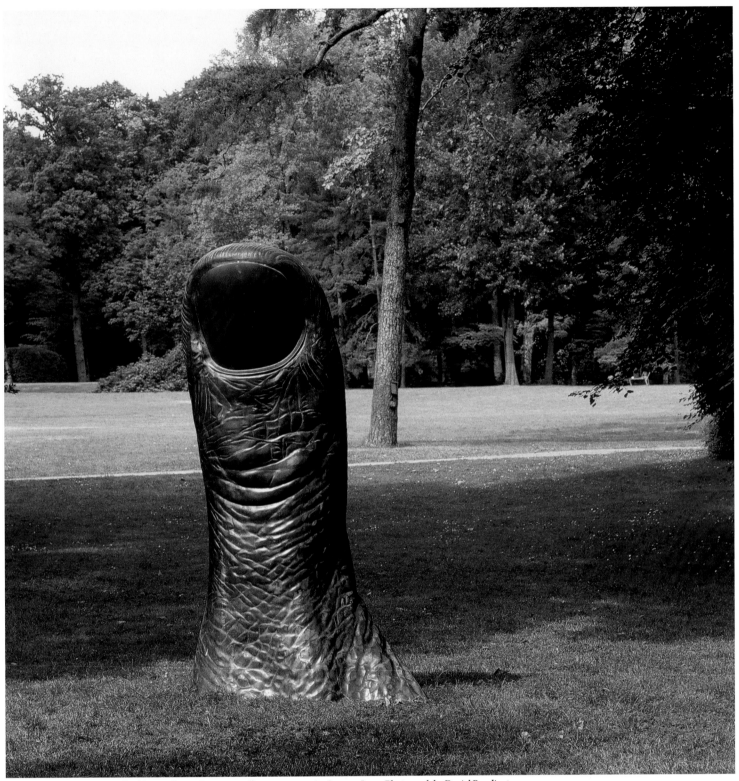

César, *Le Pouce*, 1964–66, park of the Fondation Cartier pour l'art contemporain, Jouy-en-Josas. Photograph by Daniel Boudinet

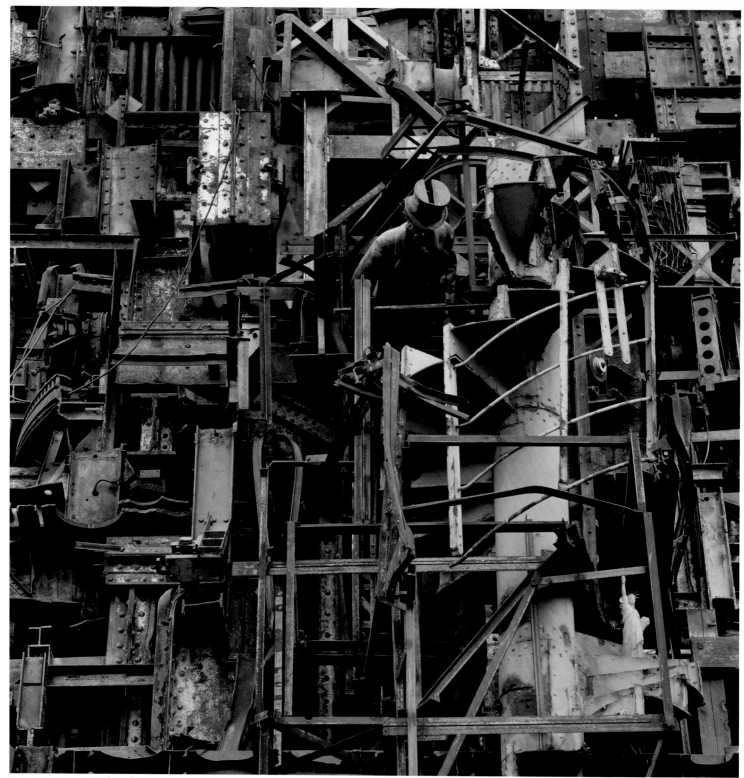

César, *Hommage à Eiffel* (detail), 1983–89, park of the Fondation Cartier pour l'art contemporain, Jouy-en-Josas. Photograph by Daniel Boudinet

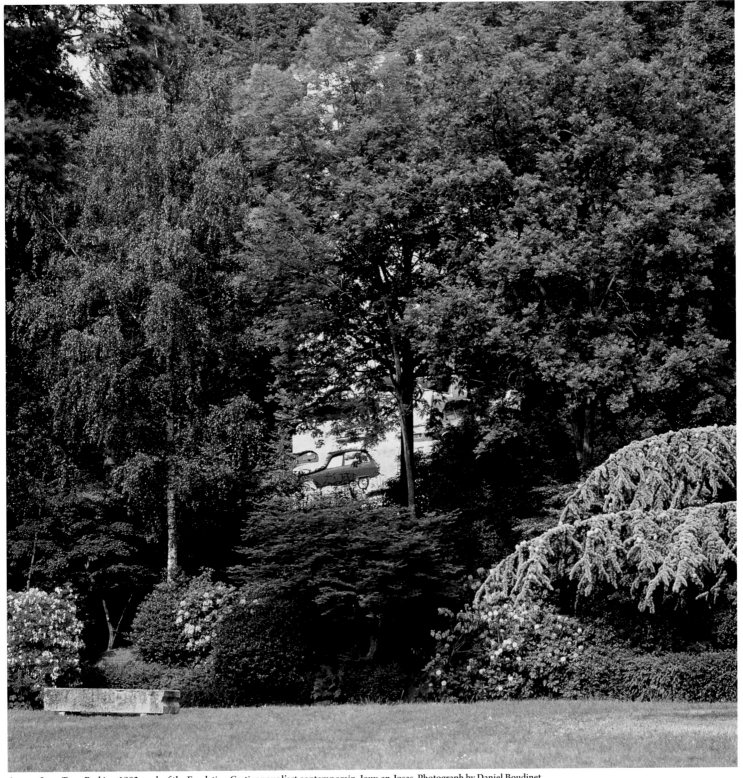

Arman, *Long Term Parking*, 1982, park of the Fondation Cartier pour l'art contemporain, Jouy-en-Josas. Photograph by Daniel Boudinet

Jean-Pierre Raynaud, *La Serre*, 1985, park of the Fondation Cartier pour l'art contemporain, Jouy-en-Josas. Photograph by Daniel Boudinet

Barry Flanagan, *The Boxing Ones*, 1985, park of the Fondation Cartier pour l'art contemporain, Jouy-en-Josas. Photograph by Daniel Boudinet

Giuseppe Penone, *Biforcazione*, 1987–92, park of the Fondation Cartier pour l'art contemporain, Jouy-en-Josas

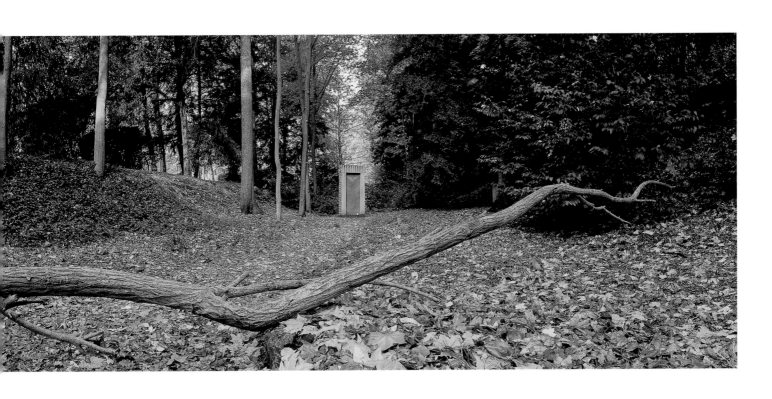

THE JOUY-EN-JOSAS YEARS

INTERVIEW WITH
MARIE-CLAUDE BEAUD
DIRECTOR OF THE FONDATION
CARTIER POUR L'ART CONTEMPORAIN
FROM 1984 TO 1994

Alain Dominique Perrin and Marie-Claude Beaud, park of the Fondation Cartier pour l'art contemporain, Jouy-en-Josas, 1984

HELENE KELMACHTER: The Fondation Cartier pour l'art contemporain was inaugurated in October 1984. What was the French contemporary art scene like at the time?

MARIE-CLAUDE BEAUD: The early 1980s were a real turning point for contemporary art in France. When Jack Lang became Minister of Culture in 1981, art began to see some real respect: contemporary art in particular. Museums in Les Sables-d'Olonne, Marseille, Saint-Étienne, Grenoble, Nantes, and Bordeaux had already been doing remarkable work in favor of contemporary artists; and their efforts were bolstered by the establishment of the FRAC (Fonds régionaux d'art contemporain). I had been the curator of the Musée d'Art in Toulon since 1978. It was so exciting to take part in the changes that were taking place on the artistic scene, and to witness the emergence of a new generation of artists and galleries. Another aspect of that period was the internationalization of the art scene. When Cartier launched its Fondation in 1984, the world of museums and contemporary art spaces had begun to change. As far as foundations went, however, the sole reference in France was the Fondation Maeght, which celebrates its 50th anniversary this year—a happy coincidence for the Fondation Cartier. Nowadays, everything has totally changed—the art world, the art market, even artistic training. I'd say that there has been a complete boost for art, contemporary art in particular. But it is true to say that we were a relatively lone player in the early days.

H.K.: You were the Fondation Cartier's first director. Was your move from public museum to private foundation a natural fit?

M.-C. B.: At the Fondation's inception, Cartier's name was associated with creation and its image was one of tradition, fine workmanship and luxury goods, but it had no presence in the contemporary art world. These were two very different territories. Which was precisely what interested me. I was also very taken with the speed and responsiveness that are the hallmarks of the business world. Alain Dominique Perrin's desire to make the Fondation Cartier into a place that would be open to all forms of contemporary art was in keeping with my vision of art as a crossroads of different disciplines, from painting and graphic design to fashion and even music. Furthermore, Cartier's position as a luxury brand gave me access to things I would not normally have been able to have. There was a desire to make everything exceptional, with a high level of attention to detail. We had everything designed from scratch: furnishings, coffee cups and plates for the Petit Café… I was able to work with designers such as Agnès Comar, Élisabeth Garouste, François Bauchet, Mattia Bonetti, Éric Jourdan, Pascal Mourgue, and Martin Szekely. Few organizations can take on such commissions. On the other hand, the Fondation Cartier's first steps were not devoid of controversy. We were entering an exclusive

preserve: up until then, culture had belonged mainly to the public sphere. I had to fight hard for five years to overcome this. I was seen as a traitor to the world of museums. The specialized press wouldn't cover us for the longest time, and showered suspicion on us, at least in France; Americans on the other hand were more used to this approach. Cartier was willing to take that risk. To create a foundation in its image was a bold move.

H.K.: From 1984 to 1993, the Fondation Cartier was connected to one place: the Domaine du Montcel, at Jouy-en-Josas, and its sculpture park…

M.-C. B.: I found the place fascinating from the start (fig. 1 to 6). It had a history as the Collège du Montcel, the school where Gérard Garouste, Patrick Modiano and Jean-Michel Ribes had studied. It also had a strong link to César—whose work I had exhibited early on in his career at the Grenoble Museum. César knew its owner, Jean Hamon, and, naturally, Alain Dominique Perrin. Then there was the park, with Arman's 1982 sculpture, *Long Term Parking*, and Daniel Spoerri's *Déjeuner sous l'herbe* from the following year. We continued to commission works of art. But it wasn't so much the monumental aspect of these works that interested me; it was the interaction between art and nature.

I lived on site and I think that was a determining factor. I wanted to invite artists, set up workshops, and turn the Fondation Cartier into a living, creative space (fig. 7 to 14). With its artists in residence, the Fondation Cartier was never empty. I remember Cai Guo-Qiang setting off explosives to put an end to noisy parties; Huang Yong Ping taking it upon himself to "heal" with paper paste "transfusions" a tree in the park that had been uprooted by the storm in 1990; and also Chéri Samba—we had to slip a message under his door in order to request an "audience" and be admitted to his studio for a visit. We also invited French artists such as Judith Bartolani, Marc Couturier, Fabrice Hyber, and Jean-Michel Othoniel, as well as artists from the world over, who we met during trips abroad in preparation for these shows. Some of these artists were present due to political-artistic events, such as the Chinese artists we welcomed after the Tiananmen Square massacre, and whom we helped with their residence permits. These artists were entirely free to create without the slightest constraint: there were no set themes and they were under no obligation to exhibit their work. Jean de Loisy, who was curator at the Fondation Cartier at the time, initiated our collaboration with young art critics such as Hans Ulrich Obrist, whom we got to know thanks to Christian Boltanksi. Hans was in his twenties and had just set up his first exhibit in his Saint-Gall kitchen. After that we took him along with us to Japan. This experience turned out to be very influential in his career. The human dimension has always been very important to the Fondation

Cartier. The relationship we have with artists is essential, but our connection to the art scene and to collectors is also of utmost importance. I must say that the Fondation Cartier's board of directors was quite a surprise and very international: it included Cartier representatives, collectors, and museum directors, and struck a perfect balance between art and finance.

H. K.: The idea of sharing this passion for art could also be sensed in the Fondation's approach to welcoming visitors, and offering them a contemporary art experience.

M.-C. D.: From the outset we chose docents over guards. This was a totally new concept in France. I borrowed this approach from Marcia Tucker, founder of the New Museum in New York. Museums should be life-affirming spaces. In fact, things have moved in that direction everywhere in the world, thanks mostly to the work of architects. There has definitely been what I call a "Bilbao effect" in the evolution of museums.

H. K.: Another pioneering initiative associated with the Fondation Cartier was using designers for the scenography of the exhibits.

M.-C. D.: We did not want to use museographers in the strictest sense of the term. We have always been driven by the desire to encounter creators of all kinds, have them work together, and question them in order to learn from their answers. I have always been interested in design and in the thought process that goes into the presentation of art works. I was also close to people in theater and the dance world, and found that there were similarities between them and the contemporary art field. One of my fondest memories of an exhibition design is from the *A Tribute to Ferrari* exhibit.[1] I chose Andrée Putman. She was the high priestess of black and white, and she said to me, "But really Marie-Claude, you cannot be serious, red is so vulgar!" To which I answered, "I know, but you're the only person I can imagine doing this." Then she was hooked. That exhibition was an astonishing experience; a team of mechanics was on hand each day to keep the engines running.

For me, graphics are an essential part of exhibition design. I think that is one of the things that I brought to the Fondation Cartier. At the beginning of my career I met Frutiger, and then the entire Swiss school, including Bruno Pfaeffli and Gérard Ifert, and then later Ruedi Baur.

The same goes for our work with landscapers. I was absolutely fascinated by gardens. First of all I invited Tobie Loup de Viane, and then after he died I worked with Pascal Cribier, François Roubaud, and finally Louis Benech—all of whom came up with remarkable projects.

H. K.: Very early on, there were design and architecture exhibits…

M.-C. D.: As well as fashion, and automobile shows. Nothing was off-limits. That's another thing that Cartier allowed: to always get the best people, in all fields. And that was what personally interested me the most. It was a way of looking at the world without hierarchy getting in

[1] *A Tribute to Ferrari,* Jouy-en-Josas, 1987. See pp. 70–71 and 201.

2 *Machines d'architecture*,
Jouy-en-Josas, 1992.
See p. 211.

the way. Many museums still believe in a hierarchy of genres, which is a legacy of the 17th century, when painting was the dominant discipline.

To show the work of architects such as Elizabeth Diller and Ricardo Scofidio, John Hejduk and Daniel Libeskind in 1992 was rather trailblazing.[2] I studied in college with Maurice Besset, who was Le Corbusier's spiritual heir. He made me aware of architecture, as well as design, graphic design, and fashion. That openness to mixing and matching different genres was also expressed through the themed exhibitions that were developed by Jean de Loisy.

H. K.: Alongside this openness to all fields of creation, painting has also played an important role in the Fondation Cartier's programming.

M.-C. B.: In the 1980s, there was a new school of painting that was linked to street and pop culture, well before street art: Free Figuration. The Fondation Cartier was launched at the time and naturally became interested in that whole scene, most notably when it commissioned François Boisrond to design the park, among other things. In 1987, we brought Rémi Blanchard, François Boisrond, Robert Combas, and Hervé Di Rosa together at Parnac to make a huge mural painting (fig. 15). But mostly, our interest in painting in general was also part of the same spirit of openness I mentioned earlier. We didn't consider anything to be off-limits, be it in genre-mixing, or more traditional means of expression. We were able to explore our passion for painting with exceptional artists such as Shirley Jaffe (fig. 16), Joan Mitchell, and Gérard Garouste. The fact that Hervé Chandès had worked with gallery owner Jean Fournier, and that he knew all these painters, was a decisive factor. It enabled us to bring together American and European artists.

I never questioned whether painting would disappear. When you exhibit art you have to be attentive and receptive, but you also have to innovate: set trends rather than follow them. The Fondation Cartier was always open to discovery, to artists who had been rejected, who were unpopular or whose work was rarely shown. This could also be seen in the acquisitions made for the collection. We would buy the works of artists with whom we had worked, and with whom we had developed a relationship. We would go to look at their work in their studios, but we never purchased their work without going through their gallery. That was a principle I imposed. These acquisitions were a way of encouraging the artists, but also the galleries, a network without which it would be impossible to proceed differently to museums.

H. K.: These acquisitions have been exhibited regularly all over the world. That international dimension is an essential part of your contribution to the Fondation Cartier.

M.-C. B.: The fact that early on in my career I was posted in cities that almost always bordered other countries (Switzerland in the case of

Grenoble; Italy in that of Toulon) taught me to look abroad. By the late 1980s I began developing international programming at the Fondation Cartier. It was in that spirit that we organized the Gérard Garouste exhibit in Tokyo and in Santa Monica for example.[3] Things were easier in Japan, since Garouste's work was perhaps closer to the Japanese sensibility. In the United States, we were aided by the fact that Leo Castelli had already presented that artist's work. Alain Dominique Perrin wanted the Fondation Cartier to promote French artists abroad, notably by circulating works from the collection. This led us to presenting the *Too French* exhibition in Hong Kong in 1991, and then in Tokyo in 1992.[4] The original title was *Too French, So French, But French*—an expression I kept hearing in the United States in the 1970s. Our international program was promoted by Cartier's subsidiaries around the world. Thanks to each of them we were able to kindle relationships with the great international museums, as well as local artistic scenes and the specialized press. It was both a wonderful opportunity and a demanding one.

We also initiated a scheme that was not reiterated in the end: giving a major work by a French artist to a significant contemporary art museum abroad. We did this for example in 1993 with the donation of Christian Boltanski's *The Reserve of Dead Swiss* to the Tate Modern in London. I wanted to do this in all the countries our projects led us to.

H. K.: What personal memory best expresses the Fondation Cartier and the work you did there?

M.-C. B.: Every moment was magical at the Fondation Cartier. Because of the presence of the artists, but also because of the art scene, the collectors… It was really very special.

If I had to take one memory in particular, it would be The Velvet Underground concert in 1990.[5] The event occurred during the Andy Warhol exhibit, held after I met Warhol in New York through the director of the Cartier subsidiary in the US.[6] Then Jules Frutos introduced me to Lou Reed and his wife Sylvia, and I invited them to come to Jouy-en-Josas, which they did (fig. 19 and 20). Lou had told me that he wouldn't perform, so I didn't insist. And yet, four days before the opening he had someone call to say that he would perform pieces from the album *Songs for Drella*, with John Cale. We had invited the *Exploding Plastic Inevitable*. At the end of the concert, Lou Reed came on stage and called out to Sterling Morrison, who was wandering around in the park and couldn't be found. Maureen Tucker was there too. It was an unforgettable moment!

I am happy that performing arts, music, dance and poetry have been developed as part of the Fondation Cartier's Paris programming, through the Nomadic Nights. "Nomadic" is an apt word to define our work.

[3] Gérard Garouste, *Les Indiennes*, Santa Monica Museum for Contemporary Art, Santa Monica, and Touko Museum of Contemporary Art, Tokyo, 1990.

[4] *Too French*, Hong Kong Museum of Art, Hong Kong, 1991–92, and Hara Contemporary Art Museum, Tokyo, 1992.

[5] The Velvet Underground on stage, Jouy-en-Josas, June 15, 1990. See p. 82–83.

[6] *Andy Warhol System: Pub-Pop-Rock*, Jouy-en-Josas, 1990.

H. K.: Let's talk about the Fondation Cartier's move to Paris. You didn't have an easy time adapting to Jean Nouvel's building, did you?

M.-C. B.: The idea of commissioning a well-known architect was essential for Alain Dominique Perrin from the start. We had already contacted Jean Nouvel for a project at Jouy-en-Josas that never came to fruition. He also built a factory for Cartier in Freiburg in 1990. The most brilliant features of the original idea for the building on Boulevard Raspail are the layers that together make up the double façade. They are extraordinary, elegant, perfectly thought out. We asked Jean Nouvel to design the furnishings, the lamps: the project as a whole. I always got along well with him. However, we did not see eye to eye over his museographic approach. I understood Jean's concept, but the building's constraint is patent, in that you have to build to get away from the glass. From time to time certain artists like to play on this. But not everybody can. The artworks themselves sometimes have to struggle with nature outside, whose presence cannot be ignored. When construction was over, I called upon American architect Frederick Fisher to work on the interior. He came up with what I thought was a very interesting idea: to dig under the garden in order to open up the basement and extend it. This did not take place in the end. Another bone of contention with Jean Nouvel concerned the garden. I wanted to commission a real garden, whereas Jean's idea was more of a construction—a kind of continuation of his building. He wanted to cover the ground with ivy, tear down the surrounding walls and replace them with glass panels. He might have been right, but it wasn't what I wanted. So instead of a landscaper, I decided to work with an artist, Lothar Baumgarten, who created a very interesting and beautiful project.[7]

[7] Lothar Baumgarten, *Theatrum Botanicum*, commission for the garden of the Fondation Cartier, Paris, 1994.

H. K.: Now that you no longer work for the Fondation Cartier, what is your outside take on its relationship to the contemporary art scene, and its specificity?

M.-C. B.: In addition to the quality of the projects shown at the Fondation Cartier, one of the first things to highlight and commend is its longevity. In its approach to programming the Fondation Cartier has always avoided the lure of blockbuster art; on the contrary, many of the works shown there have gone on to achieve that status later. The best example of this is probably Takashi Murakami. We were also the first to show Ian Hamilton Finlay (fig. 17 and 18). This happened with overlooked artists as well, such as Thierry Kuntzel, and elusive ones like James Lee Byars.

I believe the Fondation Cartier has always inspired great respect internationally. Both through the projects it has spearheaded world-wide, and for its openness to other cultures and the space it provides for them in its programming. The Fondation Cartier does not seek out countries that are "fashionable"; it shines a light on them before they're

in vogue. This was the case with Chinese artists such as Cai Guo-Qiang and Huang Yong Ping, or critic Fei Dawei. These individuals have all remained genuinely faithful to the Fondation Cartier. This loyalty, and the friendship that the artists share with Hervé Chandès, like Patti Smith and David Lynch for example, make the Fondation Cartier unique. They are part and parcel of its history. Hervé Chandès' strength lies in the relationships he has fostered with artists and with other personalities whose roles have been essential to the Fondation: people such as Gilberto Chateaubriand and Paul Virilio. This ability to keep close relationships with artists, the loyalty toward figures like Raymond Hains or Raymond Depardon—these are the Fondation Cartier's hallmarks. It gives people a voice. That is the Fondation Cartier: in the case of Murakami, showing an artist's work before he becomes fashionable; in that of Virilio, taking a sociological stand;[8] with the Yanomami, showing concern for nature and its preservation;[9] and through Jean Paul Gaultier revealing a different side of fashion…[10] In a word, the Fondation Cartier trusts in artists.

H. K.: Are there any exhibitions you worked on that didn't see the light of day?

M.-C.B.: We prepared an exhibition on the theme of luxury. The idea was to choose a utopian keyword for artists, architects, and designers. The Bunker concept was to have been given to Shiro Kuramata. Hiroshi Teshigahara had come up with a bamboo path in the park… But the outbreak of the first Gulf War put an end to all that.

Another show that didn't happen was *Look de l'Est*. The idea came from Lou Reed, who was interested in the Czech Republic. He often went to Prague, and even got to meet its first democratically elected president, Václav Havel. We were preparing this exhibition in 1989 when the Berlin Wall came down. This event touched me personally. I was in Berlin in 1961 when the Wall was built. I was 14 years old. I would see the Wall in the morning on my way to school, and couldn't understand this separation. When I was a little girl, near Belfort, my great grandfather had me stand one day on the Swiss border, and asked me, "Do you see a difference?" I said I didn't. He added, "You see those cows over there? Do you think they taste a difference in the grass they are eating?" I thought they didn't, and that there was no difference on one or other side of the border. It turns out that geography is more generous than history!

Interview by Hélène Kelmachter, curator of the Fondation Cartier pour l'art contemporain, Paris, January 2014.

[8] *La Vitesse*, Jouy-en-Josas, 1991, see pp. 78–79; Paul Virilio, *Unknown Quantity*, Paris, 2002–03, see p. 231; Raymond Depardon and Paul Virilio, *Native Land, Stop Eject*, Paris, 2008–09, see pp. 166–69 and 243.

[9] *Yanomami, Spirit of the Forest*, Paris, 2003.

[10] *Pain Couture by Jean Paul Gaultier*, Paris, 2004. See pp. 147–49.

HOW TO TURN
EACH RELATIONSHIP
WITH AN ARTIST
INTO A TREASURE

INTERVIEW WITH
JEAN DE LOISY
CURATOR OF THE FONDATION
CARTIER POUR L'ART CONTEMPORAIN
FROM 1990 TO 1993

JEAN DE LOISY: I still try to maintain the same kind of energy I had when I was at the Fondation Cartier—that is to say that I always strive to develop strong relationships with artists, and to innovate. I believe that is one of the Fondation Cartier's strongest suits. From the outset, Marie-Claude Beaud ensured that it was open to all fields of creation; she created connections between branches, and set up exhibitions that were different from whatever the public was used to. When she put on *A Tribute to Ferrari* in 1987,[1] it was a totally new concept both for a contemporary art space to display automobiles, and for Andrée Putman to do the exhibition design. That show brought about a new approach to viewing, and even a new conception of beauty. Today it is quite common for exhibitions to break down the barriers between art, craftsmanship, perfection, and design. Marie-Claude Beaud had already done so intuitively.

GRAZIA QUARONI: Where did you work before joining the Fondation Cartier in 1990?

J. DE L.: At the Musée d'Art Contemporain in Nîmes. Though in 1987 I was guest curator of the Fondation Cartier's Ian Hamilton Finlay exhibit.[2] At the time I was working for the Ministry of Culture, in charge of public commissions for historical monuments. The exhibit was fairly controversial, with Finlay becoming the subject of quite a battle in the art world. At the same time, the Fondation Cartier launched an initiative with Suzanne Pagé, director of the ARC,[3] commissioning Finlay to create a monument for the Jardin des Menus Plaisirs in Versailles in commemoration of the bicentennial of the Declaration of Human Rights.

Alain Dominique Perrin then entrusted me with programming while Marie-Claude Beaud developed the international activities of the Fondation Cartier. My role was basically to strengthen ties to the art world in general, and to artists in particular, in order for the relevance of the Fondation Cartier's position to be more readily grasped, and to dispel the suspicions that were rife in regard to corporate initiatives. The Fondation Cartier was a pioneer at the time. I set about inviting well-known artists whose work had rarely been shown in France, such as James Coleman, James Turrell, and Bill Viola. Thus the international dimension of the Fondation Cartier, which had already established strong ties to outstanding artists such as Joan Mitchell, was further strengthened.

G.Q.: You were very involved with setting up the residencies that have since become synonymous with the Fondation Cartier's success.

J. DE L.: The Fondation Cartier has welcomed artists since its inception; this is part of its very fabric. When I joined in, Christian Caujolle alerted me to the plight of certain Chinese artists. Thanks to him, Marie-Claude Beaud and I were able to give residencies to Ling Fei, Huang Yong Ping, and art critic Fei Dawei. Their residencies coincided with

[1] *A Tribute to Ferrari*, Jouy-en-Josas, 1987. See pp. 70–71 and 201.

[2] Ian Hamilton Finlay, *Poursuites révolutionnaires*, Jouy-en-Josas, 1987.

[3] Set up in 1966 by the Musée d'Art Moderne de la Ville de Paris, the ARC—Animation / Recherche / Confrontation—is a research and exhibition space devoted to contemporary art.

those of Absalon and Jean-Michel Othoniel. We also invited international critics in order to introduce them to the Parisian scene and allow them, once they returned home, to talk about French creation. I found Hans Ulrich Obrist in Saint-Gall. He was 21 years old at the time, and holding exhibitions in the kitchen of his small apartment. Christian Boltanski had told me about him. During his residency at the Fondation Cartier, Hans Ulrich went to visit many studios. He went everywhere, to see the greats as well as up-and-coming artists. Most notably, he became close to Absalon and Fabrice Hyber.

H. K.: You also developed large-scale themed exhibitions, the first of which, *La Vitesse*,[4] marked the beginning of a long collaboration between the Fondation Cartier and Paul Virilio.

J. DE L.: Speed is a fascinating theme. I see this project as a kind of initiation that allowed me to explore the relationship between contemporary art and other fields, such as science and the social sciences. It was a prescient exhibition, as Paul Virilio pointed out, for it was the last time speed was queried in relation to the world and the spread of information before the advent of Internet. The exhibition explored the notion of modernization since the late 19th century: the way it relates to the different branches of science, aeronautics and engineering research—and its influence on artists. We also put forward experiments of all kinds—artistic (Robert Smithson, Bernard Bazile), biological, and astrophysical.

H. K.: Then, the following year, 1992, you organized *À visage découvert*.[5] The blend of contemporary and primitive art was very innovative.

J. DE L.: One of the principles of the Fondation Cartier was that its summer shows be about society. And this was certainly the case in *A Tribute to Ferrari*, and *La Vitesse*. I remember Alain Dominique Perrin asking me if an art show could be a popular show. In a certain sense, *À visage découvert* was an answer to this question. I believe it was also a turning point for the Fondation Cartier's concept. It was a totally new experience for me, and one that gave me the opportunity to work with remarkable people, such as the philosopher and art historian Georges Didi-Huberman. Though he was not directly involved in choosing the objects for the show, he did contribute to its thematic organization. Through the guiding principles that he laid out, I was able to draw on my visual memory to come up with surprising objects that would mesh with anthropological research. The most important questions were: what is mankind and what does he have to say about form? How does form reveal something that structures the thought process, the being or the spirit of the person one meets, and how does the face convey this interior construction? The face as an interior construct was a philosophical hypothesis, in the manner of Levinas and Deleuze. And obviously it was an opportunity to show that the questions facing an

[4] *La Vitesse,* Jouy-en-Josas, 1991. See pp. 78–79.

[5] *À visage découvert,* Jouy-en-Josas, 1992. See pp. 65–67.

artist in the 20th century were the same as those posed by a 5th-century artist or an African artist. The idea was about how to convey. I have always believed that the best way to bring contemporary art to those who are wary of it is to show them that the question was just as loaded and difficult to resolve five thousand years ago.

The most striking event for me, however, was meeting Jacques Kerchache. After *À visage découvert*, we carried on seeing each other every week until he died. I would go to his place and we would engage in what I called "looking exercises." We would look at objects from his collection and ask ourselves: which is the best of the lot? Why is this one more beautiful than that one? He taught me to be exigent in a way that I never would have learned otherwise. He taught me to look at works that I would never have been able to see as accurately and as freely. It was around this time that he mentioned his voodoo project and showed us the 113 objects in his collection. The Fondation Cartier brought his project to life in 2011, highlighting its ability to maintain and consolidate links with others over time.[6]

G. Q.: You have always been committed to alternating between projects mixing different time periods and civilizations, and exhibitions by French artists.

J. DE. L.: Initially I developed a passion for medieval art, then for contemporary art. At the Fondation Cartier I began to associate objects from different civilizations and to understand that this enriched the visual experience, that the works shed light on each other, not through formal connections but through conceptual ones. That is to say, I began to treat works from the past as conceptual objects and not as simple formal ones. In general, for example, the associations that were made between a modern artist and a Japanese rock landscape were always formal. However, for me the question is more about underscoring the mental aspect of these connections.

The Fondation Cartier offered me this kind of visual freedom. A liberty inextricably linked to the people running the Fondation, but also to the means granted to artists for their work and research. We were able to travel, discover, meet people, and learn. And as always, the human dimension was front and center. Thanks to the residencies and exhibitions we developed strong relationships with artists such as Absalon, Jean-Michel Alberola, Richard Baquié, and Marc Couturier. The Fondation Cartier has always remained faithful to the artists with whom it collaborates. I am convinced that this is absolutely exceptional in our field. The idea was never to go for media stunts. The Fondation Cartier has always presented artists who did not necessarily have much public exposure. That is one of its great virtues.

H. K.: The Fondation Cartier collection is a reflection of these strong ties and this faithfulness to artists you mentioned. Each

[6] *Vodun: African Voodoo*, collection of Anne and Jacques Kerchache, Paris, 2011. See pp. 142–43.

acquisition adds to this history in the making, and contributes to building the idea of a veritable community.

J. DE L.: Here again I would like to come back to the notions of visual freedom, openness and curiosity that the Fondation Cartier has always embodied. This is also true of its acquisitions committee. I remember when we bought *Box*, by James Coleman. Pierre Messmer immediately said, "Wow! That's remarkable!" I was very touched by the fact that a man of his age, with supposedly conventional tastes, could be enthused by such a work.

Thanks to the Fondation Cartier, I was also able to see the Carnegie Prize exhibition in Pittsburgh in 1991; there I discovered the photographs of Japanese artist Hiroshi Sugimoto. As soon as I returned to France, I suggested that we buy them for the collection, which we did.

Today, thanks to Hervé Chandès' programming, which embraces vastly different styles—from Matthew Barney to Brazilian pop art—the Fondation Cartier displays an openness that I find truly commendable and unique in France. As for its collection, it features artists who have worked with the Fondation. It is not a collection beholden to the market. It is a collection of projects. It is because the Fondation Cartier has appreciated and worked with an artist that this collection has been built. Each work is a personal adventure, a meeting between the Fondation Cartier and the artist. And each time, these encounters yield absolute treasures.

Interview by Hélène Kelmachter and Grazia Quaroni,
curators of the Fondation Cartier pour l'art contemporain, Paris, February 2014.

EXHIBITION À VISAGE DÉCOUVERT, 1992
Pablo Picasso, *Tête de femme*, 1931

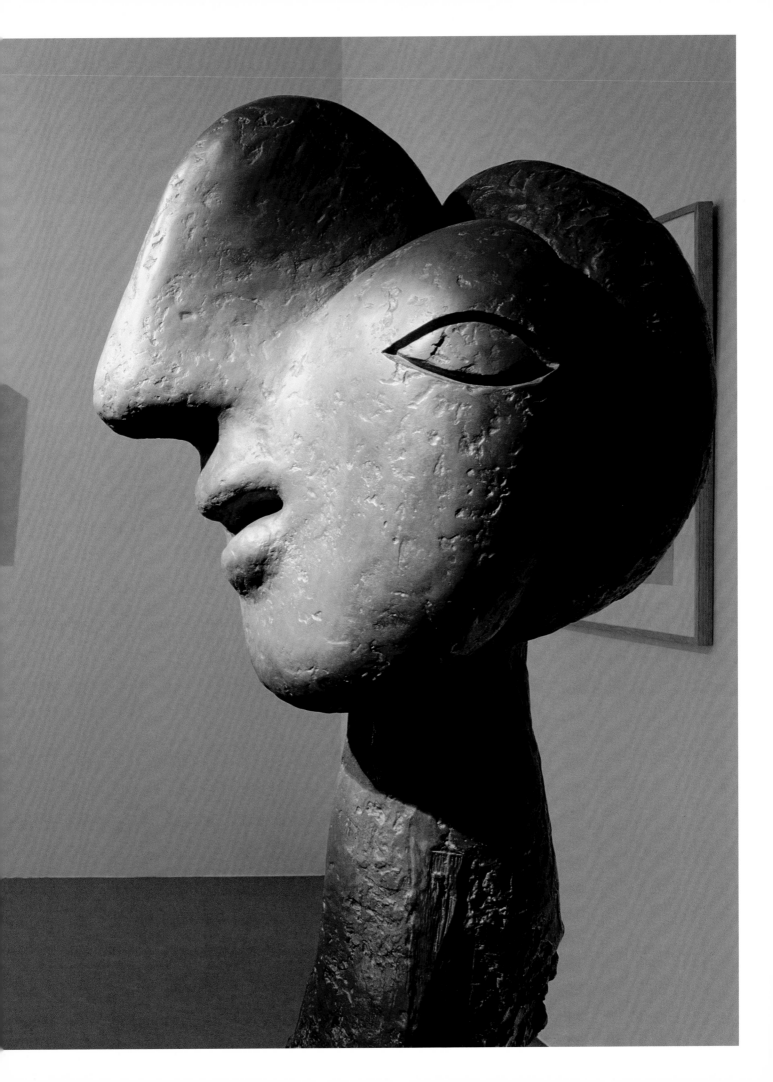

EXHIBITION *LES ANNÉES 60 : 1960–1969,
LA DÉCADE TRIOMPHANTE*, 1986
Exhibition design by André Courrèges

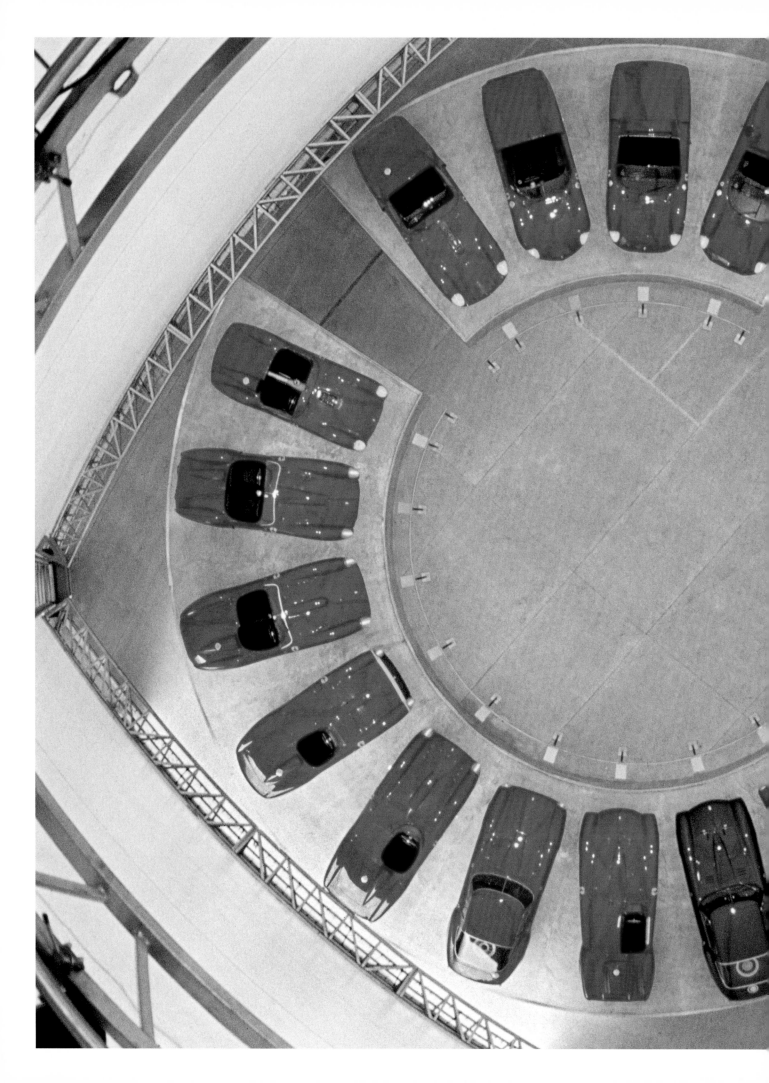

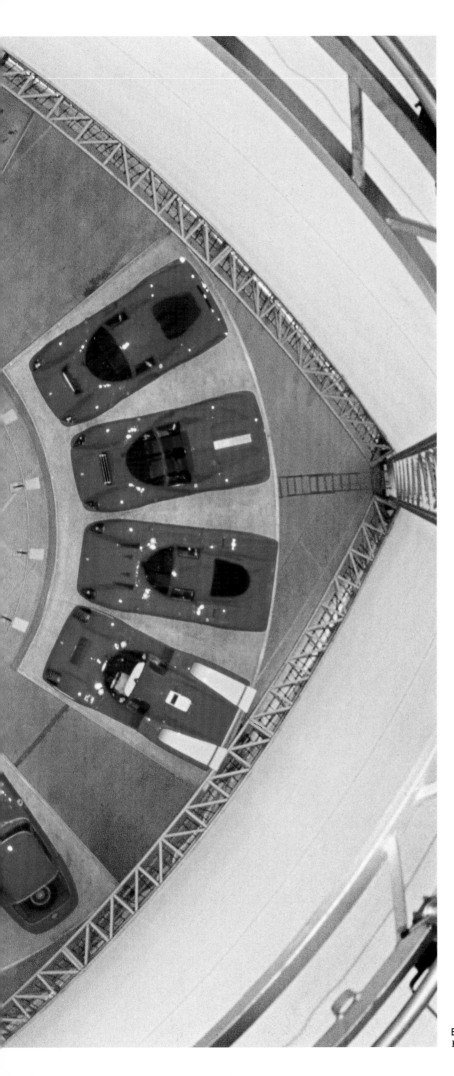

EXHIDITION *A TRIBUTE TO FERRARI*, 1987
Exhibition design by Andrée Putman

EXHIBITION *VRAIMENT FAUX*, 1988
Exhibition design by Élisabeth Garouste and Mattia Bonetti

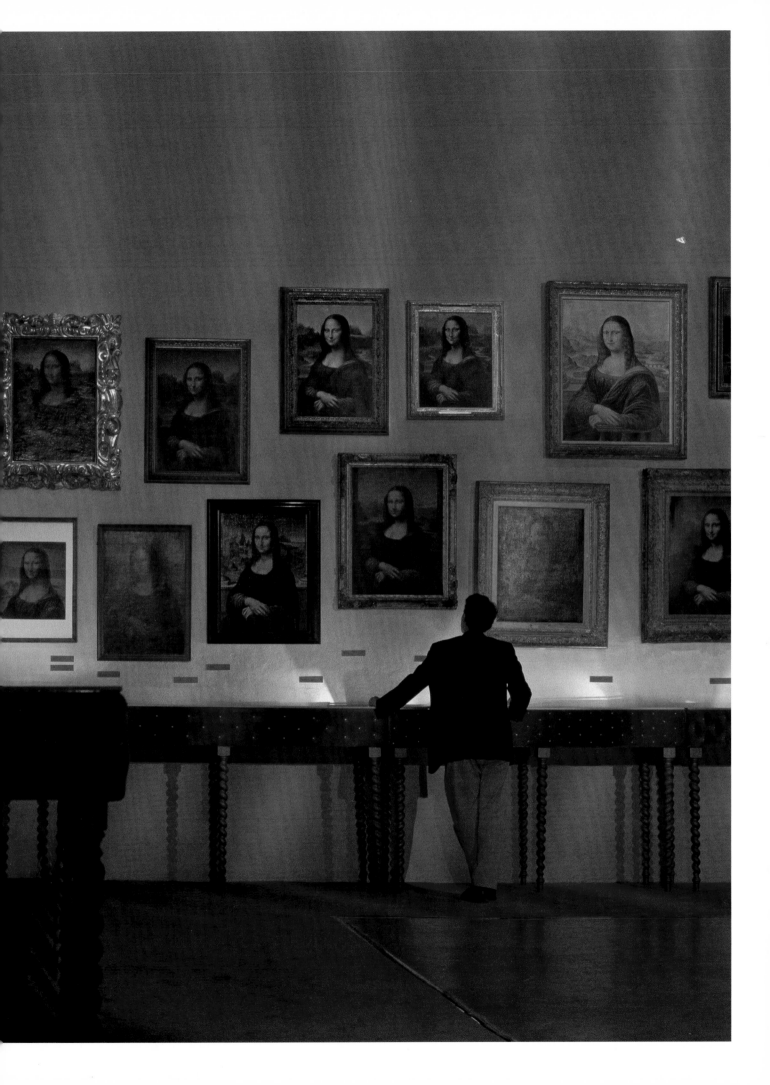

EXHIBITION GERARD GAROUSTE, *LES INDIENNES*, 1988

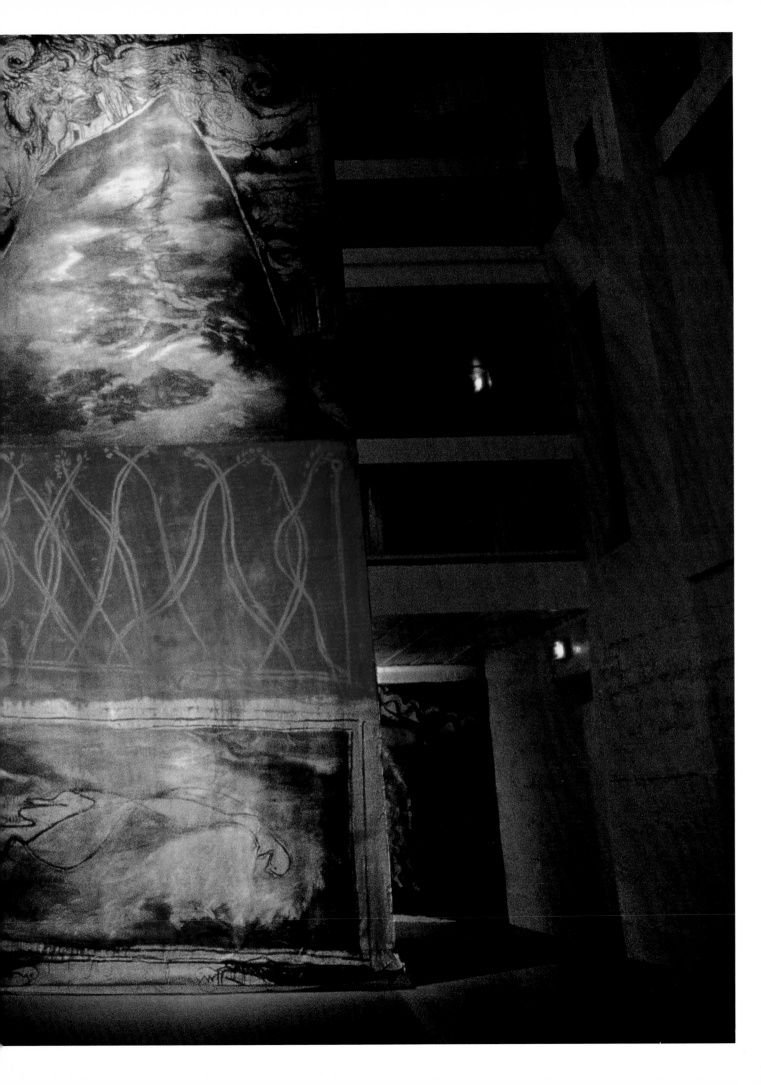

EXHIBITION BILL VIOLA, *THE SLEEP OF REASON*, 1990

EXHIBITION *LA VITESSE*, 1991

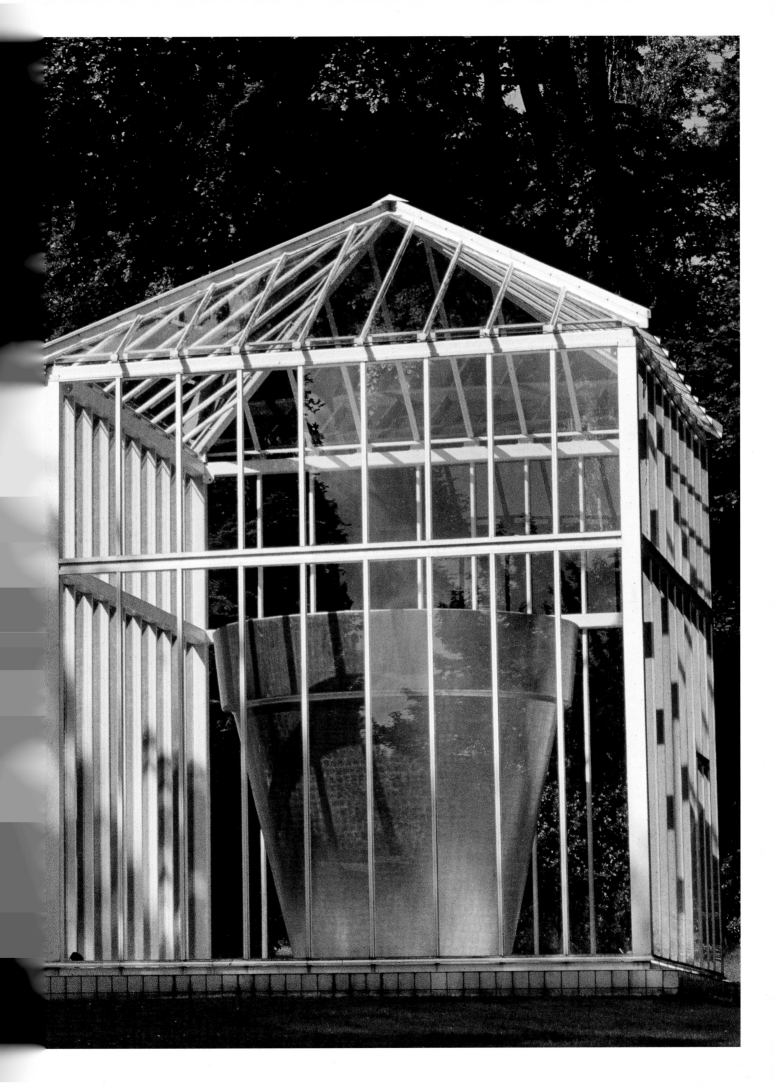

EXHIDITION AZUR, 1993
James Lee Byars, *The Path of Luck* series, 1989

THE VELVET UNDERGROUND, JUNE 15, 1990
Sterling Morrison, Maureen Tucker, Lou Reed and John Cale
photographed in the park of the Fondation Cartier
pour l'art contemporain, Jouy-en-Josas

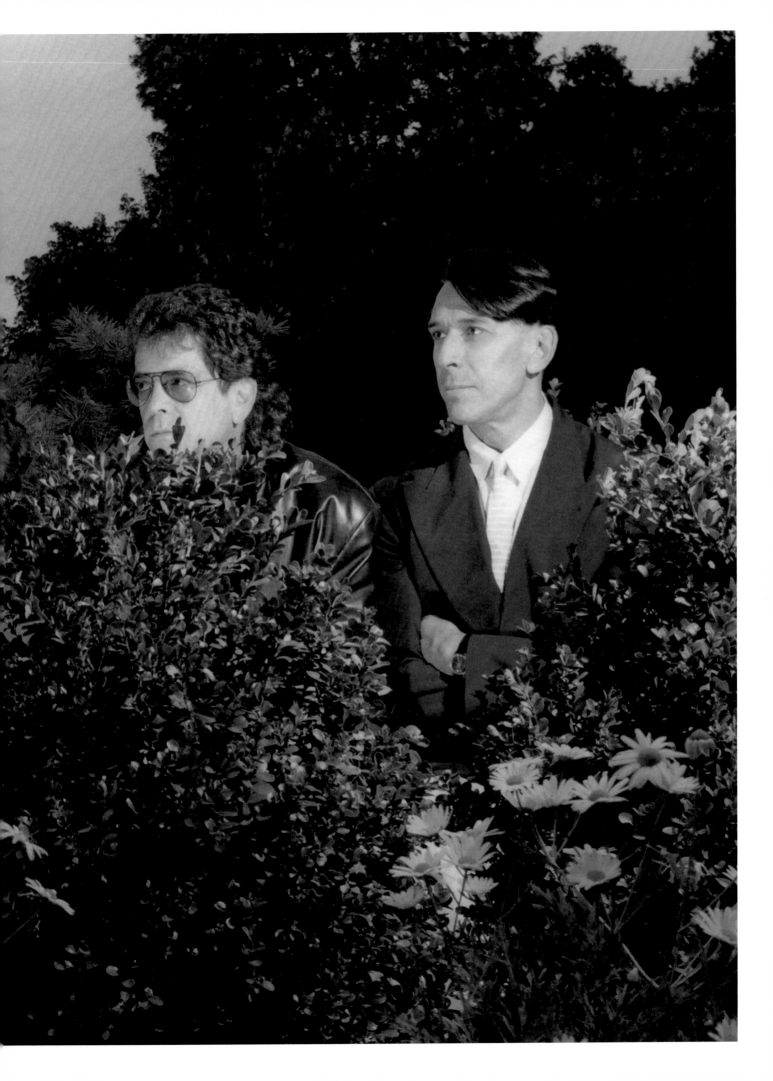

PARIS
1994–2014

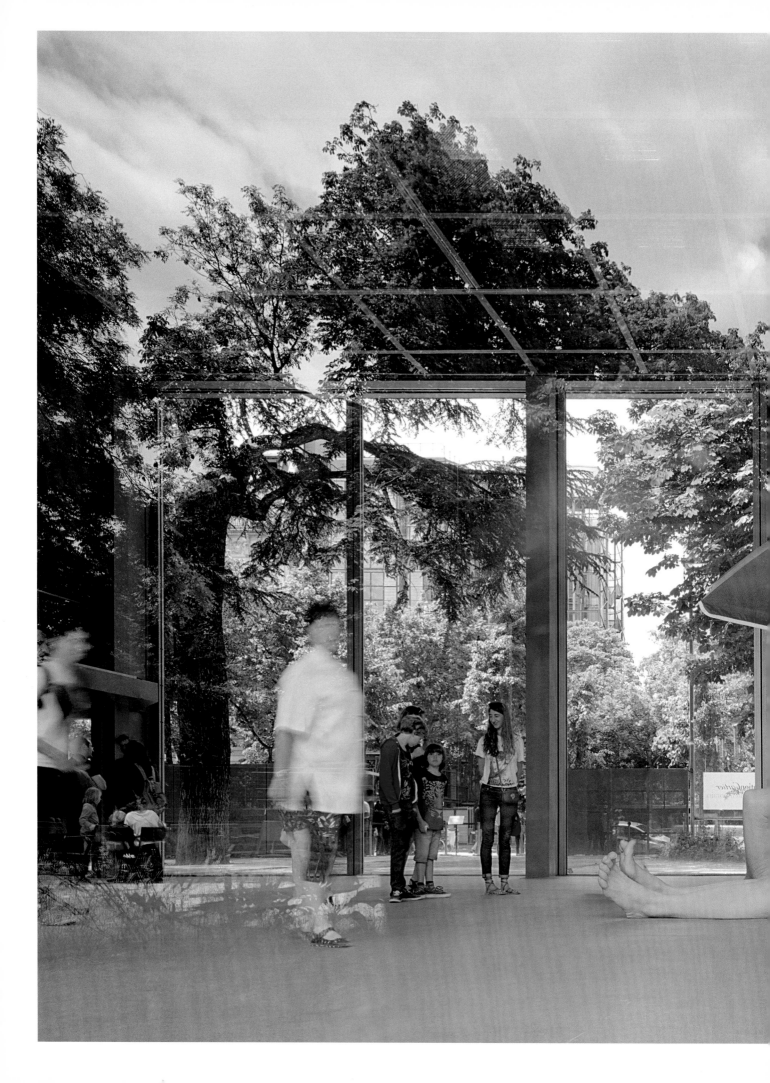

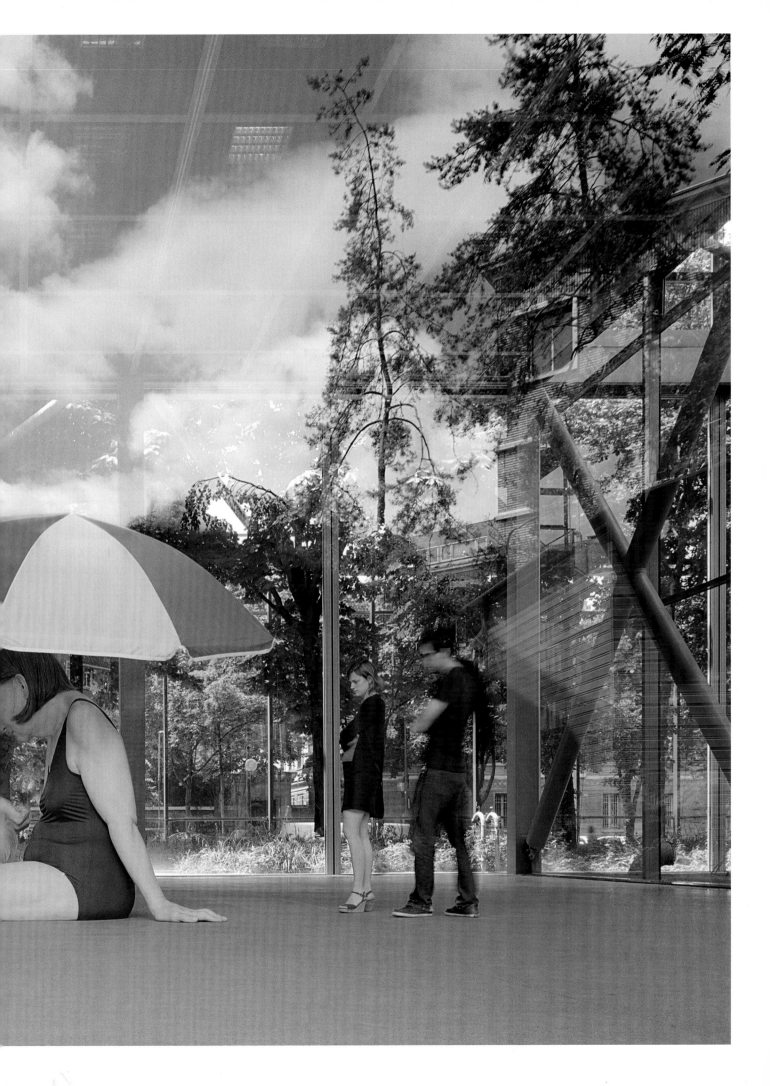

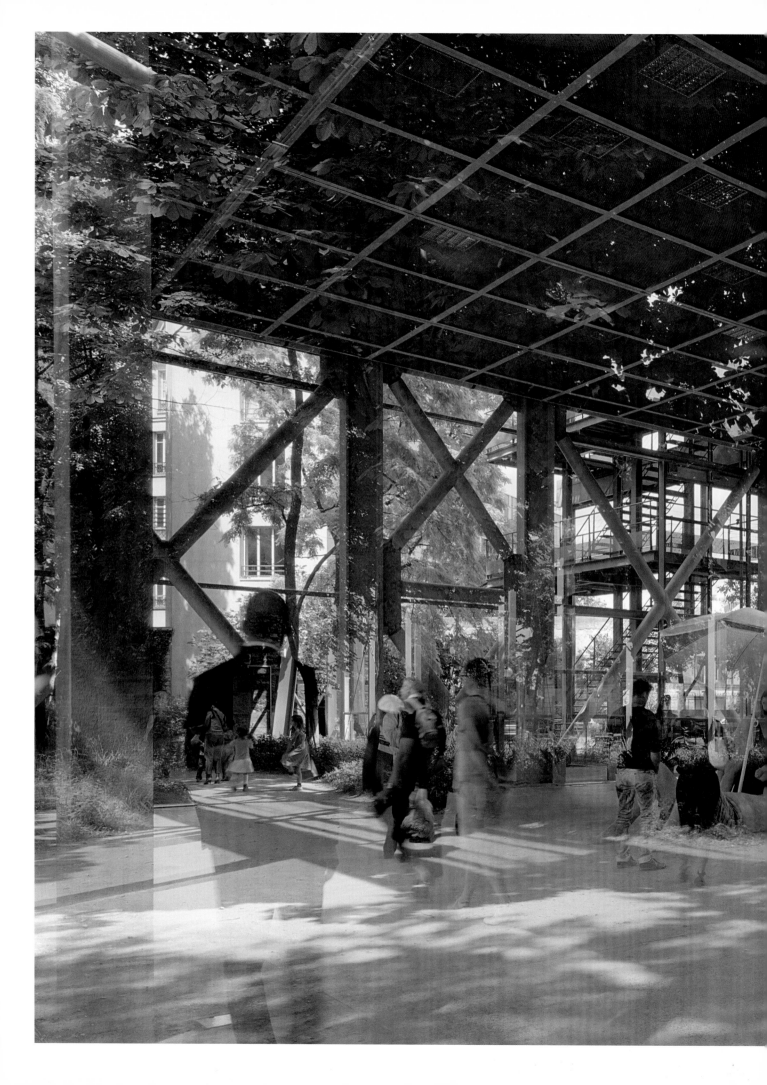

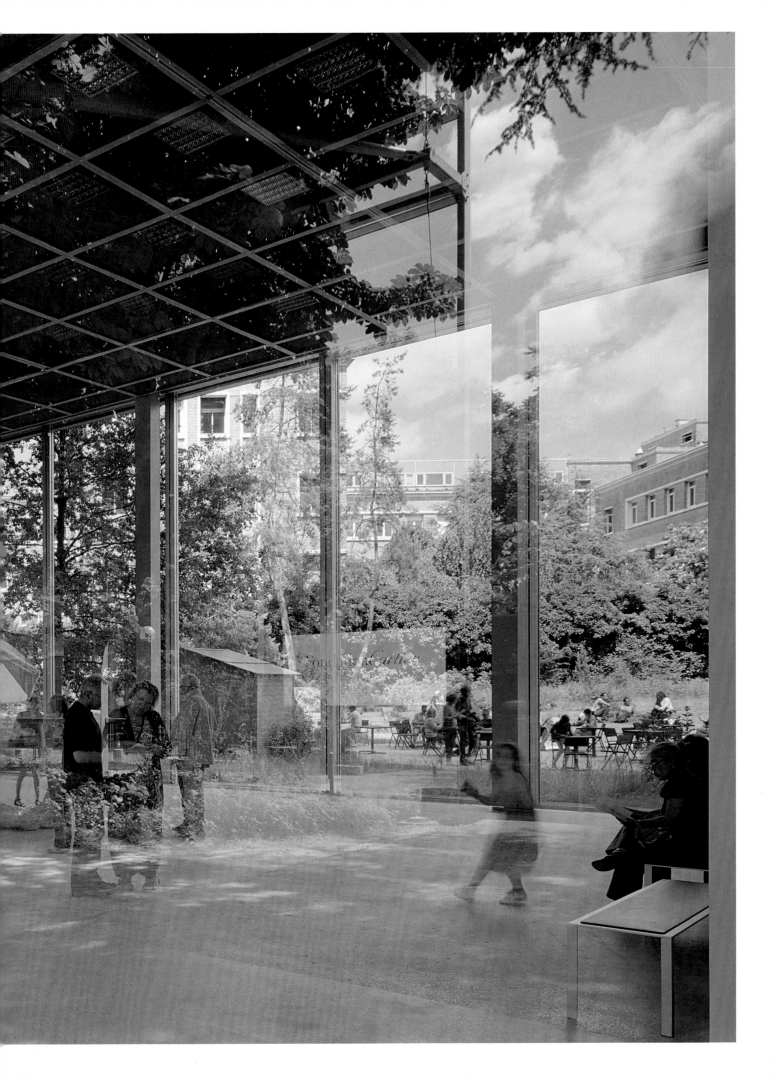

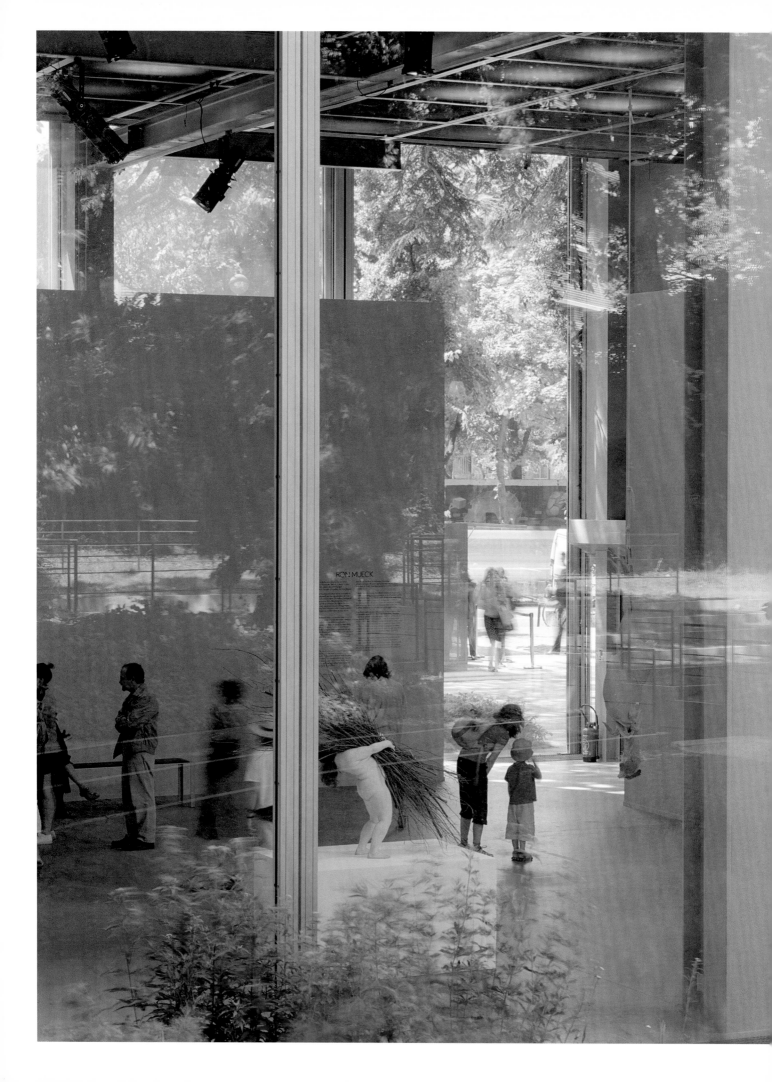

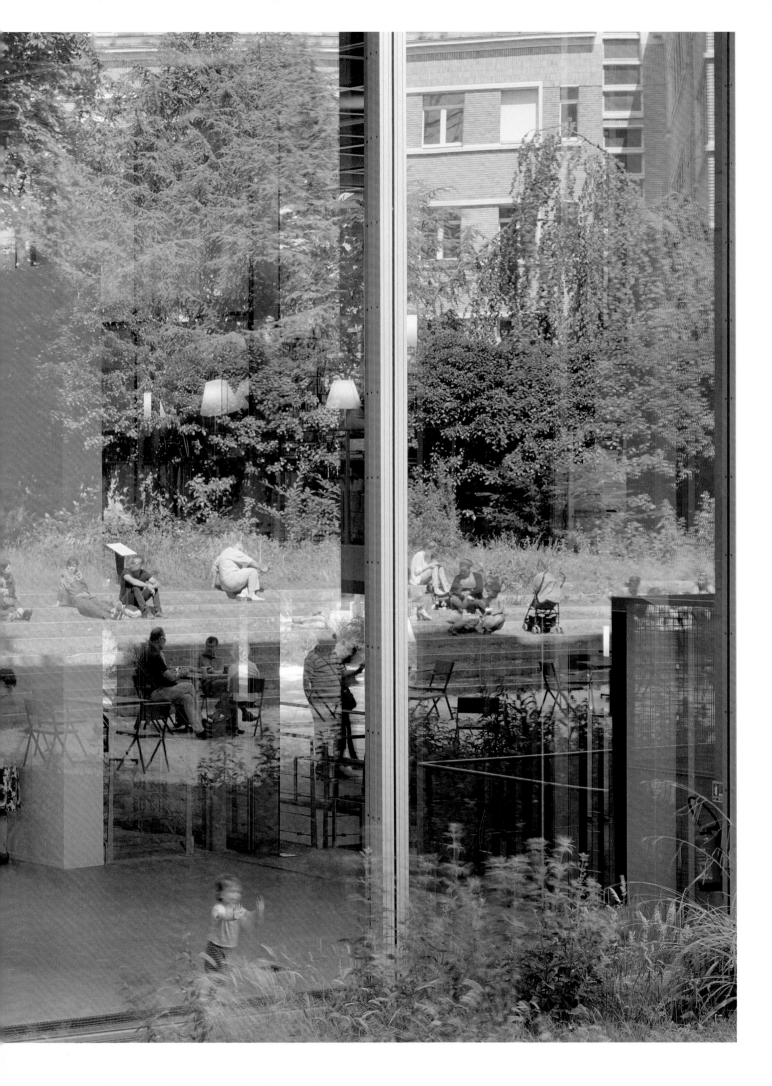

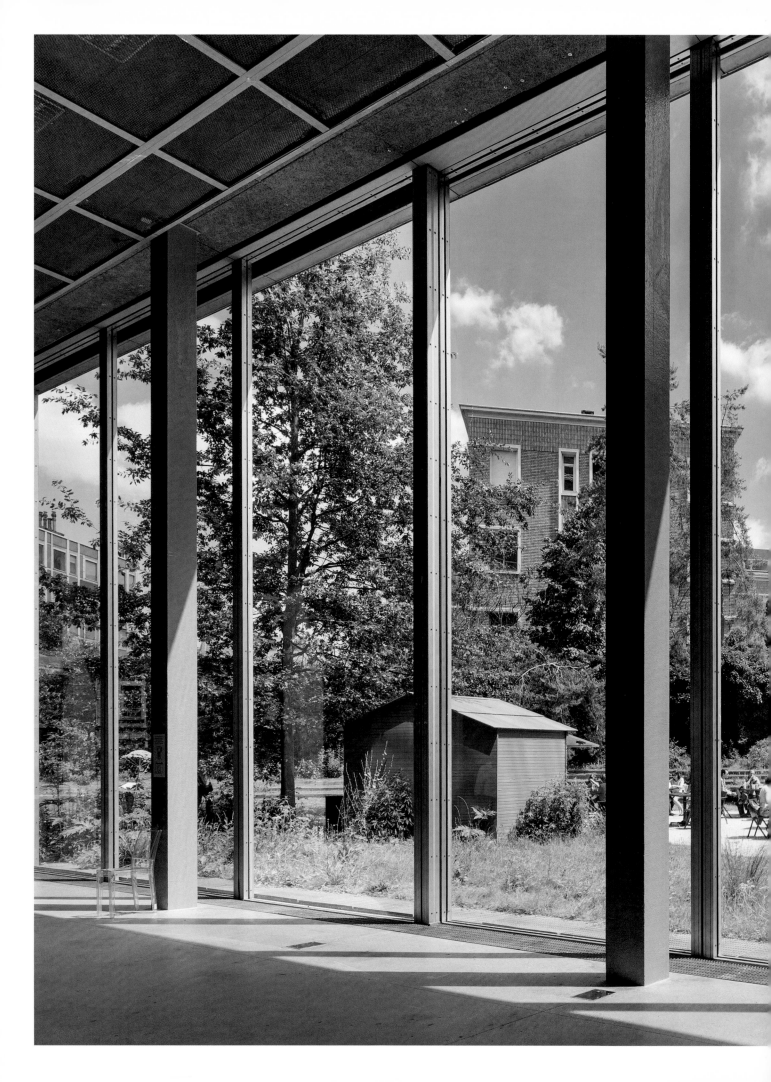

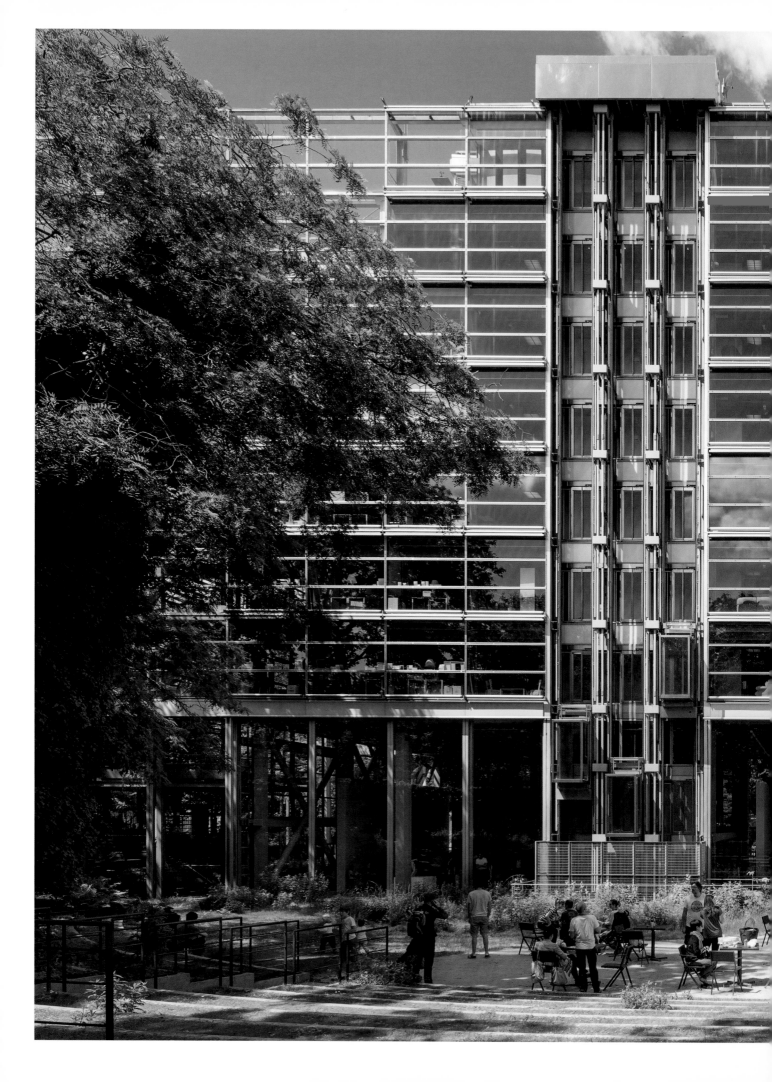

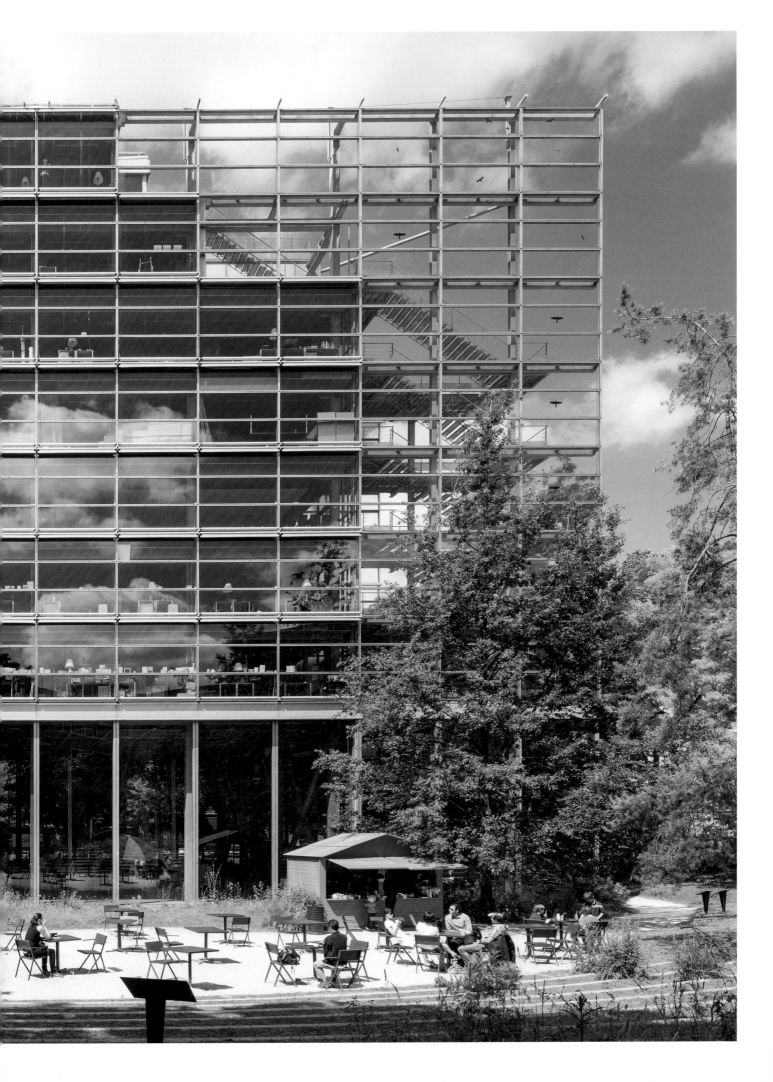

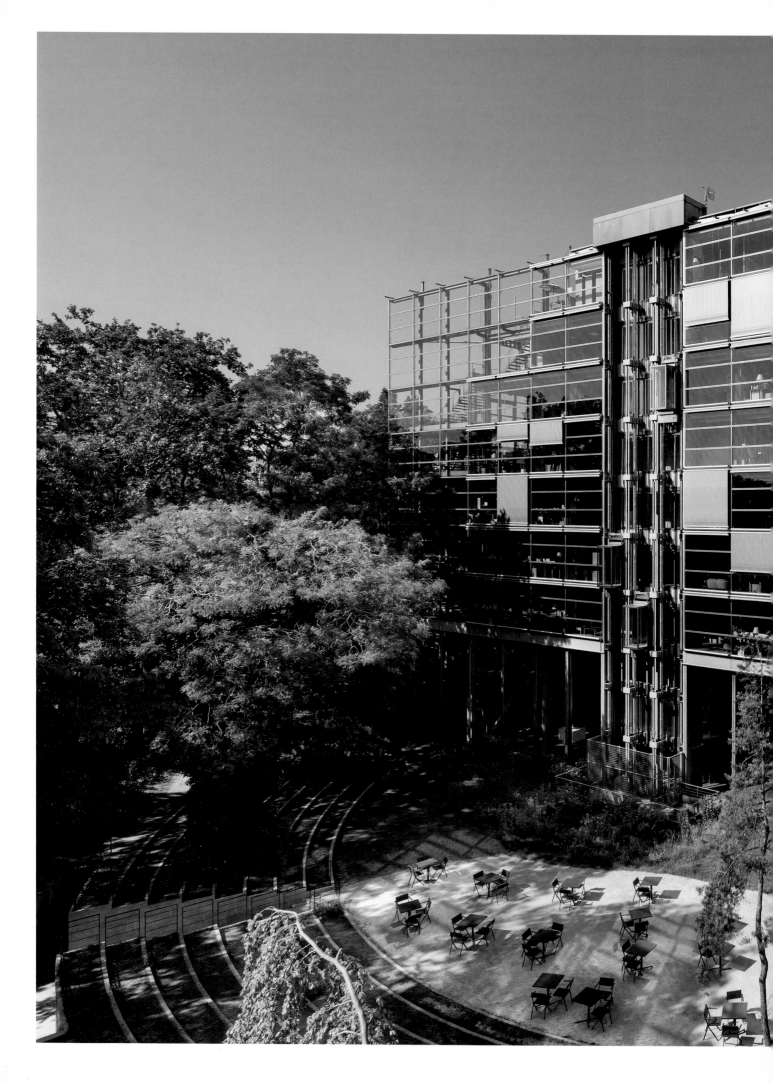

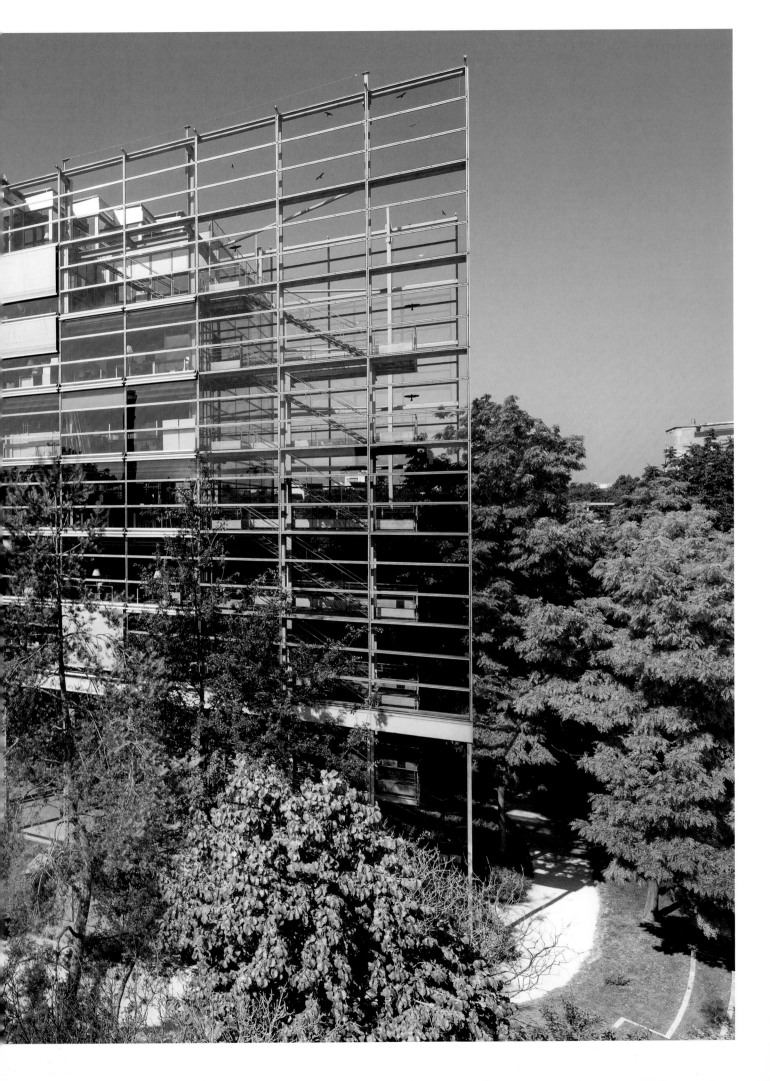

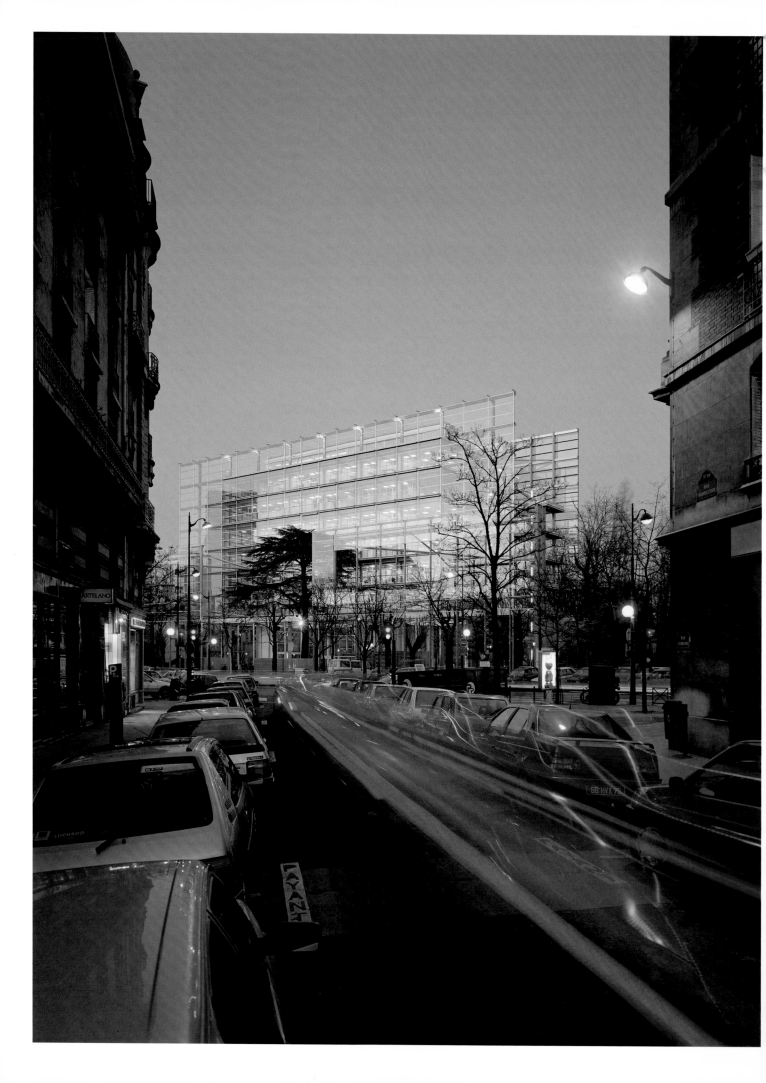

JEAN NOUVEL
AND HANS ULRICH OBRIST
IN CONVERSATION

Fondation Cartier pour l'art contemporain, architect Jean Nouvel, Paris

HANS ULRICH OBRIST:[1] In the early days the Fondation Cartier was located in Jouy-en-Josas. I was given a grant there in 1991, when Marie-Claude Beaud was the director and Jean de Loisy curator. Hervé Chandès was already on the team. The atmosphere was very multidisciplinary, mixing architects and artists. I remember it well because it wasn't common for an institution to really combine all the arts in those days. Before we talk about your building on Boulevard Raspail, we could perhaps discuss the "prehistory" of the Fondation Cartier and your memories of those years in Jouy-en-Josas…

JEAN NOUVEL:[2] You're right; the Fondation Cartier on Boulevard Raspail was born in Jouy-en-Josas. I knew the place because I was good friend with César and other artists who worked there. I had seen some of the big exhibitions, especially the Ferrari one in 1987, which made a real impression.[3] When I first met Alain Dominique Perrin we were going to discuss a project for Jouy-en-Josas: a building on a hill near the Fondation Cartier site, but set back three or four hundred meters from the existing building. The idea was to have the hill set in a glass and steel square (fig. 2 and 3). The project was criticized and rejected by the authorities and politicians and Alain Dominique Perrin decided to leave Jouy-en-Josas.

H. U. O.: It's great to know that! We never hear very much about unrealized projects, and yet it's important to remember them. Are there drawings and photographs of the project?

J. N.: Yes, and it's a project I'm very fond of: a glass and steel square about 80 meters long, built in cross section and covering an interior landscape containing all the Fondation Cartier spaces. A landscape project which, as is often the case, responded to a particular situation. That was the starting point of my relationship with Alain Dominique Perrin: Marie-Claude Beaud gave him my name, he didn't know me. He became a great friend of mine. I later worked for Cartier on factories in Switzerland and designed the Richemont headquarters in Geneva in 2007. And I'm still working with the group today.

H. U. O.: We can therefore say that if there hadn't been this opposition to the first project and those political problems, the Fondation Cartier would still be in Jouy-en-Josas today?

J. N.: Without a doubt.

H. U. O.: In the early 1990s, after my grant at Jouy-en-Josas, I spent a year living at the Hôtel Carlton on Boulevard Raspail and I did a lot of walking round Montparnasse with Raymond Hains, a great local personality, who knew the neighborhood inside out.

J. N.: He was a friend of mine, too.

H. U. O.: He was always talking to me about Chateaubriand, who lived on the current Fondation Cartier site, a figure who haunts that space. It's a place associated with romanticism, you could say.

[1] Art critic, historian and curator, Hans Ulrich Obrist is Co-Director of Exhibitions and Programs and Director of International Projects at the Serpentine Gallery in London

[2] Jean Nouvel is a famous French architect (fig. 1). He designed and executed the building of the Fondation Cartier pour l'art contemporain at 261 Boulevard Raspail in Paris between 1991 and 1994.

[3] A Tribute to Ferrari, Jouy-en-Josas, 1987. See pp. 70–71 and 201.

J. N.: It was Chateaubriand, in 1823, who planted the famous cedar of Lebanon at 261 Boulevard Raspail which, for me, is the real monument here. The site was chosen when the American Center moved from there to the building designed by Frank Gehry over on the Right Bank of the Seine. At the time the developers and the Gan insurance company had a project for this piece of land, mainly office buildings, which were going to occupy most of the site. Local groups were protesting, trying to preserve the cultural function and green space and, in what was quite a turnabout for Paris, the then mayor, Jacques Chirac, canceled the building permit. The Gan knew that Alain Dominique Perrin was looking for a new site and got in touch with him. Alain accepted, but only if he could choose the architect. That's where I came in.

H. U. O.: When Julia Peyton-Jones and I invited you to London to design the Serpentine Gallery Pavilion in 2010, I had a chance to observe your process. When you work, you start with a concept, a very clear idea. Can you tell us about the process of creating the building for the Fondation Cartier as a response to a site and a context?

J. N.: Yes of course, the constraints were very particular. First of all, the site is not very big. It seems today to be much bigger than it actually is because I made use of perceptions of the surrounding trees and scenery, with the Saint-Vincent-de-Paul hospital and Marie-Thérèse nursing home, in order to make them part of our "reading" of the site.

Moreover, after the permit was canceled we could only build on the footprint of the demolished American Center. That meant having a relatively tall building, but then there was a risk that it wouldn't work in relation to the rest of the boulevard. So, I asked myself how we could play on the closeness of the building and the cedar while respecting the context, so that we wouldn't end up with an orphan building that would look completely incongruous in the middle of the boulevard. That's when I had the idea of playing on depth and creating maximum ambiguity by having three successive layers of glass: a play on dematerialization, presence-absence and the absence of limits (fig. 4 to 9). When you just walk past on the boulevard, the first things you see are the two barriers 18 meters high, in line with the Haussmanian buildings opposite, framing and highlighting the cedar. This gives the impression that it is the façade of a building with trees inside it. Only later do you realize that there is something else behind. This ambiguous relation between interior and exterior is heightened by the struts, the very light V-shaped beams whereby the outer walls are supported directly by the building. Hence the extremely fine, immaterial closures.

To cancel out the side limits, I thought about making the façades of the building bigger than the building itself, so they reach beyond it. And after lengthy observation, I realized that this superposition of the

thing observed, and its reflection, created an uncertainty. In other words, if you reflect a cloud in a cloud, if you create the reflection of a tree on a tree, by "trans-appearance," something happens that has to do with emotion, something "unsettling" in every sense of the term. I therefore decided to play on these parameters so that these two walls would reflect the trees standing in front, on the sidewalk, and that this reflection would be imprinted on the trees behind it.

For the building's base, the biggest temporary exhibition space, I opted for total absence thanks to complete transparency over a height of more than 8 meters. Thus, through the façade of the entrance, you can also see the trees behind. And if I add two layers of glass on the sides of the building, I put trees back in. This means my trees can be read in continuity with the neighboring trees; in depth, they multiply or are perturbed by reflections. As a result, the initial impression is of something becoming dematerialized in a space whose limits we cannot gauge, characterized by the perpetual presence of plant life and the sky, which is "supra-present": in the middle, it is there reflected on the offices, on active life; around, we see the sky reflected on itself.

H. U. O.: You have talked about the context and the way the building arose from the constraints of the context. The notion is a bit Oulipo-esque, in the sense that Oulipo speaks of "poetry under constraint."[4] Are there connections between your work and Oulipo or even Situationist poetry?

J. N.: No. I have a real affinity with Oulipo and with some of the people now working in the tradition (such as Jean-François Peyret, with whom I collaborated on a show about Thoreau's *Walden*[5]), but I never really saw any direct connection between Oulipo and this building. For me, it was essentially created by specific considerations. How to locate on this site a building that is not exogenous? How to be in a "natural modernity"? For the context was the time, the period—my creations correspond to today's techniques and attitudes—and the need to fit naturally into the site. Or supernaturally, perhaps.

That said, it's true that you can read it as a play on the different ways to put lines of trees into perspective, a string of reflections, which could indeed call to mind certain literary games by Oulipo: Raymond Queneau, Georges Perec, etc. But that was not on my mind at that time, even though I did evoke this play on perspective with Raymond Hains, who found it all great fun. Naturally, wherever there was a pun to be made on the words "Cartier" and "*quartier*" (neighborhood), he made it.

H. U. O.: Every exhibition at the Fondation Cartier reinvents its spaces. It's interesting because when you build a contemporary art foundation, you don't know what the art of the future will be, the relation it will have to space. And there, you have created two

[4] Oulipo, the Ouvroir de littérature potentielle (workshop on potential literature) was a loose group of writers who shared an interest in using odd verbal rules and games as a way of generating literary texts. Members included Raymond Queneau, Georges Perec, Italo Calvino, Harry Matthews, etc.

[5] *Re: Walden*, after *Walden (Or Life in the Woods)* by Henry Thoreau, directed by Jean-François Peyret. Festival d'Avignon, July 2013.

very different spaces: the ground floor is transformable and open; the basement can become a cinema or conventional gallery.

J. N.: Yes. That thought process was linked to the strong constraints of the site, but also to my experience of temporary exhibitions—from 1971, I was architect for the Biennale de Paris, presenting artists who were shown at the Musée d'Art Moderne de la Ville de Paris, the Centre Pompidou, the Villette, the Parc Floral…

For the Fondation Cartier, it all began with two notions: emptiness and the unity of interior and exterior. In reality, the building plan was extremely simple.

The first decision, which initially came in for a lot of criticism, was the absence of walls in the interior spaces. People were amazed that someone could build a museum without walls. I knew that the main problem you have with a temporary exhibition is working with the existing space. It is actually much easier to put in a new wall than to remove one. Consequently, I chose a hyper-flexible exhibition space, with each very long floor being amenable to any kind of occupation: you can put in as many walls as you want or leave it totally empty. In other words, you're inventing every time, usually quite simply, using freestanding picture walls for example.

The building has no internal circulations (which, to my knowledge, is unique in Paris): the two staircases leading to the upper floors are on the outside, at each end, as are the elevators, which climb up the rear façade. Here I was negotiating with the obligation to follow the footprint of the earlier building: the stairs and elevators weren't part of the building's ground plan.

The ground floor is thus a completely theoretical space, totally empty, 8 meters high. The exterior is an extension of it, because as well as being transparent, the ground can also be totally open. The enormous sliding glass panels of the ground floor, 8 meters by 3 meters, can indeed slide outwards and overlap in the wings, where the façades continue beyond the building. The exhibition space is thus totally open, and the Fondation is built on stilts!

The basement, conversely, is completely opaque. This space is delimited by walls made of concrete and is totally empty, allowing you to exhibit what you want as you want. At first, I made small openings in the ground floor, kinds of windows so that bigger works could be installed in the basement, and to shed light down below. These horizontal windows were not used in the end, and the decision was taken to block them and block the light out completely. I wasn't necessarily convinced by that option, but that was the choice that was made.

What is interesting is the contrast between this closed space surrounded by walls and the first floor, where there is an osmotic relationship between interior and exterior. From one exhibition to the

next, the artists have tried out a great variety of attitudes, going from a building that was completely open to the outside for *La Volière* by Jean-Pierre Raynaud,[6] to the exhibition *By Night*, where everything was closed, so as to give a feeling of occultation in the space.[7] Artists played on the presence of the works in nature, or again on the visibility of the display devices from outside, without a "window display" effect in the traditional sense of the word: you have more a sense of works fitting into a landscape setting.

Flexibility was therefore the first parameter of this option, a rather radical one for a temporary exhibition space, but also a matter of the identity of the place. The Fondation Cartier is not a neutral space. When you are there, you are inside and outside at the same time, and you wonder how the works got there, in the middle of these trees brushing against them.

H. U. O.: That brings us to the question of the garden. I remember a magical moment: the last performance by James Lee Byars, who came to Paris for his final farewell before going to Egypt to die.[8] It was like a kind of apparition: dressed in a gold suit, James Lee Byars left his hotel, crossed the Boulevard Raspail, entered the building, entered the garden and, without a word, went back to the hotel.

J. N.: The presence of the golden sphere was magic, too.[9] That void, that sphere placed in the middle of the scene, the emptiness. It was really surprising.

H. U. O.: That was a great moment in the Fondation Cartier garden. Which was created by Lothar Baumgarten.

J. N.: I asked Marie-Claude Beaud for the garden to be as natural as possible: basically, not designed. In that sense I really loved the approach taken by Lothar Baumgarten. It was exactly what I was looking for and a complete success: a garden including as many natural species as possible, all living together in the space. I was less in phase with the architectural aspect, that kind of artificial hole and the amphitheater with the side of the stone showing. The idea was a kind of pre-existing archeology, which doesn't really suit the site, in my opinion. I gradually got used to those big steps where visitors come and sit, but I never really got used to the hole. I think that in Lothar's mind it is a meditation room.

But I do like everything that is natural in the garden: the fact that it is dry in the winter, that you can sense the coming of spring. You get huge differences over the four seasons.

H. U. O.: That brings us to another opening: apart from the opening onto the garden and the oscillation between interior and exterior, there is also the vertical aspect (think of Patrick Blanc's vertical garden, above the main entrance to the building) and the idea of

[6] Work presented in *Comme un oiseau*, Paris, 1996. See p. 219.

[7] *By Night*, Paris, 1996. Exhibition design by Bruno Moinard.

[8] *Amour*, performance held on September 27, 1996 in Paris.

[9] James Lee Byars, *The Monument to Language*, 1995, collection of the Fondation Cartier pour l'art contemporain, Paris. Exhibition James Lee Byars, *The Monument to Language* and *The Diamond Floor*, Paris, 1995. See p. 115.

ascension linked to transparency. I always remember the first time I visited the Fondation Cartier: there was a reception on the roof. I took the transparent elevator and had this incredible experience of Paris when I arrived on the terrace. I'd like to know how this play on transparency takes us up to the top, vertically. In an earlier interview you told me that the big question for you today is the essence of the material, and knowing how to connect it with transparency. Can you tell me about that?

J. N.: You have to bear in mind that, quantitatively speaking, the program was mainly about office space. True, I bestowed strong symbolic significance on the exhibition space by giving it a height of 8 meters, by the fact that there is not a single post inside, and by the extremely light structure, which I worked on with Ove Arup and Paul Nuttall. On the upper floors, where the offices are, there is a great emptiness. The different offices are delimited by partitions in sanded glass, creating an effect of mist and hiding the people working there. The impression you get is that they are in a dematerialized space. The interiors play on reflections that act at the base of the partitions and also create an effect of levitation above the ground. And when you look at the cedar from the offices, it seems to be standing out against tracing paper. All the interior architecture is based on these effects of dematerialization.

From the upper floors, thanks to the two façades overlapping the building, you pick up reflections of Parisian buildings. This is even more spectacular at night, when they are lit up and you can see two Eiffel Towers, two Montparnasse Towers, two Invalides domes, etc. There is a play on duplication that could also take us back to Oulipo. Another important parameter is that designing a building in clear glass, such as the Fondation Cartier, is theoretically impossible due to the sun. That is why I invented a system of double-rolling external blinds for the big east and west façades, a bit like the film in old cameras, whose tension, and therefore intensity, can be controlled in accordance with the sunlight. In the summer, from the boulevard, you in fact see a façade in fabric, like a grey canvas made up of a succession of squares with an invisible structure. But three quarters of the time, when the blinds are not needed, you just see these little rolls, which you soon forget. Thus, even the sunlight is dematerialized: the building goes from transparency and reflection to a façade that is all fabric, again in a spirit of lightness and immateriality.

The top of the building is a kind of deck where you have the same canvases, this time unfolded horizontally by means of cables. On windy days they vibrate, rather like on a boat. It gives the impression that you are floating above the roofs of Paris, at exactly the same height as the Haussmanian roofs. The view from one side is over

Montparnasse cemetery and, on the other, the adjoining gardens of Saint-Vincent-de-Paul and the Marie-Thérèse nursing home.

I often speak of the way a discipline constantly questions itself in relation to the times, both symbolically and sensitively. And the question of matter—its presence and its ambiguity—but also of light and the relation between the two are indeed some of the big questions of the day, in my view. We try to deal with them using our own modest and inadequate means. Hence the notions of "presence-absence," inside-outside, and all these ambiguities which create uncertainty.

The play on perceptions linked to the seasons is part of this. As soon as it rains, for example, the building is covered with droplets of water that catch the light. As for the plants, at certain times of the year it feels as if you can touch them from the inside, especially the plant wall by Patrick Blanc, which you mentioned. The director of the Fondation Cartier, Hervé Chandès, asked for it to be created for the exhibition *Être nature* in 1998, as a temporary feature. Originally, it was inside and outside, on both sides of the façade, but it was difficult to maintain the part that tumbled down on the bookshop side. That said, the wall has aged very well, and has even adopted a fig tree that must now be sticking out nearly three meters. For me, this green incursion into the building, which is dense and alive, is a superb addition, because it further heightens the ambiguity of the transition between plant and building. Seeing it from inside, from the cedar, or from the sidewalk, it really does look as if part of the building is made of vegetable matter. I can no longer imagine the building without it.

H. U. O.: According to the art historian Erwin Panofsky, our inventions are often based on fragments from the past. You told me that you were greatly inspired by the architecture of light in cathedrals, but also in certain 11th-century churches. Were you inspired by past constructions for this very specific building for the Fondation Cartier?

J. N.: I have always been responsive to the architecture of light. Indeed, my prime ambition is often to make buildings that stand in a spatial continuum, that belong to the air. I believe that we build in the solid, that construction is just a variation of this solid.

Of course, like other projects of mine, the Fondation Cartier is a permanent play on layers of light, both material and immaterial. They proliferate, interfere with each other, pick up reflections or drops of water for refraction, disappear because something intervenes, are printed onto the background (especially the trees), mesh together when overlaid or when you step back … The materials—glass and aluminum—were chosen for their ability to pick up color and light. Paradoxically, this play on dematerialization probably makes the Fondation Cartier the building most permeated by its site that I have managed to create.

At the time I was also designing the Endless Tower for La Défense. This was a cylinder made wholly of glass, colored at the base and transparent at the top, which was meant to start 25 meters underground, emerging from the rock as a solid mass and gradually dematerializing, ending 400 meters above, so that neither its beginning nor its end would be visible. The materiality of the glass also differed, depending on the orientation: some parts were reflective, others extremely clear, etc. For me, these two projects involve the same effect of blurring limits: not knowing exactly what is there and what is not, where it starts and where it ends, being uncertain about the distances between the planes. They both embody the same notions of "trans-appearance," presence-absence, materiality and immateriality. But whereas the Endless Tower extended upwards for over 400 meters, the Fondation Cartier is only 31 meters high, and these effects are definitely more difficult to achieve on a small scale. The illusion is more complete and easier to achieve on a large scale. But you still have to find the conditions to enable you to make that kind of building.

H. U. O.: One of the key ideas of the Fondation Cartier is bringing together all the disciplines, creating bridges between art, architecture, design, and even mathematics.[10] This is something we also find in your practice, not only in the field of architecture, but also through your many collaborations with artists such as Daniel Buren and Bertrand Lavier. We spoke about your unrealized projects in an earlier conversation, but only the architectural ones. There is also your painting, I believe?

J. N.: Yes, in the early days I really wanted to be a visual artist, so my relationships with the art world have always been close. That includes my involvement with the Biennale de Paris. Creating places for art was therefore particularly interesting, notably thanks to my relationship with the directors of the Fondation Cartier, Marie-Claude Beaud and then Hervé Chandès, who have both done outstanding work. They are determined to bring art closer to life, to connect the artistic field and the lived world. Canceling frontiers, getting disciplines to interpenetrate, and bringing a purely artistic and aesthetic perspective to the scientific, technical and pragmatic dimensions—all these things work much better in a space that is itself open, in every sense of the word. Given that the Fondation Cartier is not marked by an excessive presence of historical signs or heavy materials, I think it is a space that empowers that attitude, and I'm very happy about that.

But at the time, there was no way I could imagine what was going to happen. Obviously, the experience at Jouy-en-Josas gave me an idea, but what has occurred since then is extremely impressive. I hope that the place has helped inspire a few people in their approaches and questions. But that's really down to the brilliance of the directors, the curators and, of course, the artists.

[10] Conceived by Hervé Chandès, the exhibition *Mathematics, A Beautiful Elsewhere* (Paris, 2011–12) teamed mathematicians with the Fondation's artist friends, allowing the latter to accompany and visualize the former's concepts and thoughts. See pp. 180–83 and 249.

H. U. O.: We have spoken about the unrealized project for Jouy-en-Josas and the one you built on Boulevard Raspail. But if I'm not mistaken, there is an aspect of the project for the Boulevard Raspail site that was never realized. At the start of the 1990s, as I said, there were residencies at Jouy-en-Josas. It was a wonderful kind of laboratory, for it gave young curators and artists a chance to meet. I was in residence with Absalon, Fabrice Hyber and Huang Yong Ping, who had just arrived from China, and it changed my life. I vaguely remember people telling me at the time that the Fondation Cartier was planning to develop a similar project with you in Paris: beside the exhibition building, an entire hotel in which each room would be occupied by an artist in residence. I suppose the project never happened for financial reasons, but I haven't been able to find out much about it. Do you remember this?

J. N.: That project never got beyond an abstraction. The idea was linked to the new location: Montparnasse. A few steps from the building, on Rue Boissonade, there were a whole series of artists' studios representative of the quarter, whose history is intimately bound up with that of 20th-century Parisian art. It would have been fitting to have an open space alongside it linked to the exhibition site. But that never happened.

H. U. O.: And you would have been the one transforming the hotel?

J. N.: We talked about it, but never got as far as envisaging a concrete site. We also started working on a project for the Île Seguin, which fell through in the end. And then there are projects for the future: the transformation and extension of the site on Boulevard Raspail, and the prospect of another place in Paris that could house the kind of structure you mention.

H. U. O.: You have completed so many projects that I'd be curious to know the number of realized and unrealized projects. Do you have any idea?

J. N.: Ah! That's a good question… I'd say I design at least four or five projects before I actually work on one. There was a time when I would win one competition I entered in thirteen or fourteen. But that must have been when I was good, because they say that the more competitions you win, the more you are "toeing the line," so to speak. Now, I'd say it's one in eight.

H. U. O.: What are you working on at the moment?

J. N.: I am very busy with Chinese matters, as I'm working on the big project for the National Art Museum of China (NAMOC) in Beijing and on another, very interesting NAMOC project, with the creation of a big museum, a hotel and a garden for artists, studios, a marina, shops, and a huge park giving onto the sea. I'm also very busy building the Paris Philharmonia, which is running into a few practical problems. I'm working very hard on the Abu Dhabi Louvre, which is roaring ahead,

and on the National Museum of Qatar in Doha, the structure of which is now fully built. All these projects should be completed in 2015.

H. U. O.: Doha, Abu Dhabi, China are all museums. A lot of your projects in 2014 are cultural institutions, am I right?

J. N.: That's right, most of them are for cultural programs. But I am also very busy with a big project in Netherlands, near The Hague, for the headquarters of a European institution that deals with industrial property.

H. U. O.: Abu Dhabi, Doha and Cartier are very different projects. The first two have a link with the sea, which is not the case with Cartier.

J. N.: Yes. There is something of Cartier in the Dutch project, but on a bigger scale. It's a glass building 100 meters high and 150 meters long, as slender as a blade, standing in the landscape like a ship, like a flagship. The funny thing is that these two buildings have a natural east-west orientation, like boats at anchor lying parallel to each other because of the wind. You get this analogy between buildings and ships, both as vessels.

H. U. O.: In 2007 we had a chance to discuss Greater Paris, which raised a number of questions. You seemed rather dubious about the city's future.

J. N.: The projects for Greater Paris raised a major question: how to define the strategies for the city's mutation. In the meantime, this question has simply been canceled, just like that. Now we're back to purely administrative and technocratic strategies, applying rules that we already know, which for me is a disaster for the future of the capital.

Greater Paris is not a city that is built or can be decreed: it is a city that already exists and is being transformed. Originally, the studios working on Greater Paris kicked off a great wave of strategic, architectural and cultural reflection on the evolution of Paris. This approach could have been extremely useful for the international urban history of metropolises and big cities. It brought real hope of getting away from the simplistic system of paralyzing rules and regulations. Today, that hope has simply vanished.

H. U. O.: And the future of the world? In June 2005 you wrote the *Louisiana Manifesto* in which you spoke of the danger of computers manipulating and homogenizing the whole context. It was a kind of manifesto for context. How do you see the future now? Are you working on a "post-Louisiana Manifesto"?

J. N.: I think that the Louisiana diagnosis is still right, and that unfortunately what has happened since then has not contradicted me. I think that there are more and more buildings that don't know where they are, that have no roots. Preconceived buildings, in the sense that they are conceived without knowing where they're going to stand. I believe more than ever in the need for architecture to belong to settings that are as precise as possible—the prime setting being time—and the

need to realize that you are becoming part of a slow transformation, invention and complexification of the world. It seems more and more obvious that this is where the poetry of our urban world comes from.

H. U. O.: We have already talked about the places where you work: often outside your office, especially in cafés. Another important thing in art is the music a painter listens to when he's working. For example, Gerhard Richter listened to John Cage and that gave rise to his famous *Cage* series (2006). So, when you are working, what kind of music inspires you?

J. N.: I have no musical education and I'm not someone who chooses his own musical environment. Generally, it's the people I frequent who bring me music. I float, you might say. So I don't program the music I work with at all.

H. U. O.: And yet in an interview for *Designboom* in 2007 you spoke of 11th-century polyphony and the chants of ecstasy from the 12th century, which I found very interesting in relation to the architecture of the 11th century, to the churches.

J. N.: Yes, that is music that lifts me and which I discovered thanks to people around me.

H.U.O.: One last question. Umberto Eco has observed that handwriting is disappearing in the age of the Internet. A lot of teenagers don't develop a handwriting, or maybe don't even use it at all. Rather than just regretting this phenomenon, I have launched a movement on the Internet: every day I post on Instagram and Twitter a handwritten sentence by an artist, an architect or a writer. This decline is also affecting drawing by hand. Eco has written a text on "the disappearance of handwriting," as you might call it.[11] Can the same evolution, which I find alarming, be observed in architecture?

[11] Umberto Eco, "The Lost Art of Handwriting," *The Guardian*, September 21, 2009.

J. N.: For sure. In my case, I stopped working by hand a long time ago, in the sense that I no longer draw in the traditional sense. Not only because I don't have the time any more, but also because it's not something I massively enjoy. I always say that I don't draw, I "claw": when words won't do, when I can't explain, I just have to "claw."

This inspires me to think that, at the end of the day, we can never transcribe all the material of our thoughts. My way of working involves spending two hours every morning in absolute silence, thinking precisely about a certain number of subjects. It's a kind of centered meditation, which is a bit of an oxymoron. I have always hated writing down what I'm thinking at those moments because it breaks up the dynamic of thought: if I write, I lose the thread of my thoughts, a lot of ideas slip away. They are already replaced by the next ones. I think the same kind of thing happens when you take photographs: you walk around and, suddenly, you decide to take a picture. Immediately, your gaze changes.

You are no longer steeped in the original thing because you've started looking for the photograph.

Thinking can therefore be enriched by always thinking of more and more things, even if you don't keep them. In the same way, I do have this quite extraordinary capacity to forget. In fact, I trust my memory—even if it is increasingly unreliable—to keep what is most important. But this decantation has its dangers. Which is why, yes, from time to time I do take a sheet of paper so as not to forget the important things. But I regret it.

Interview held in Paris, February 2014.

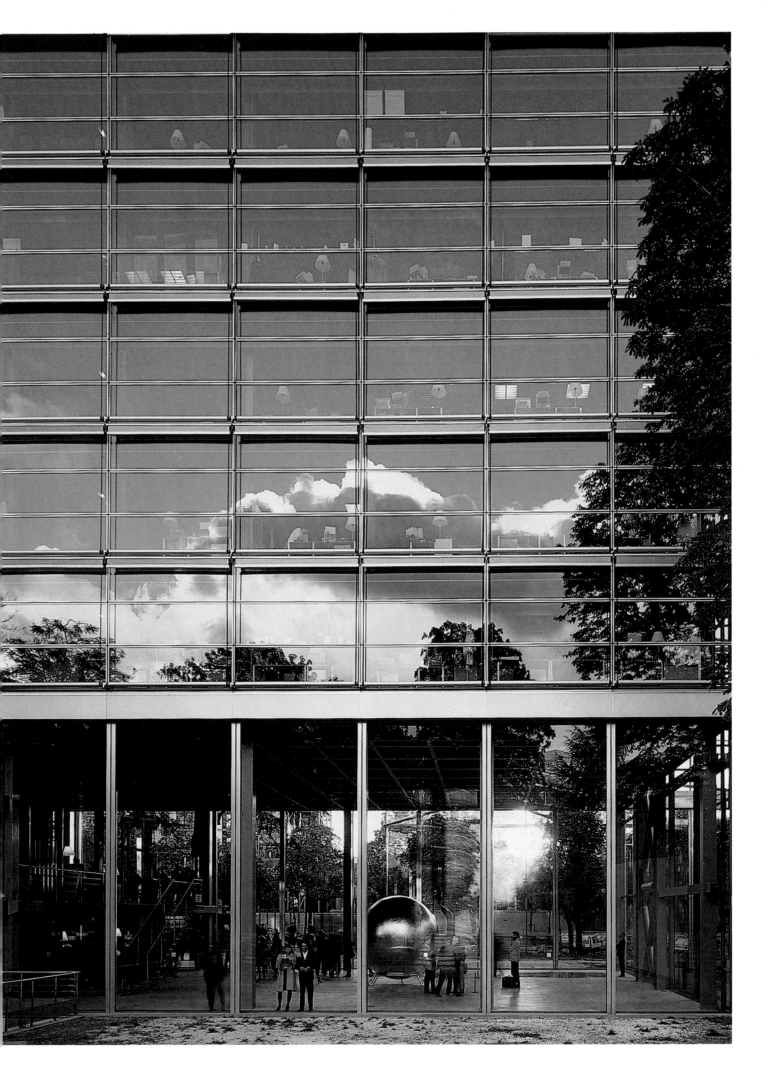

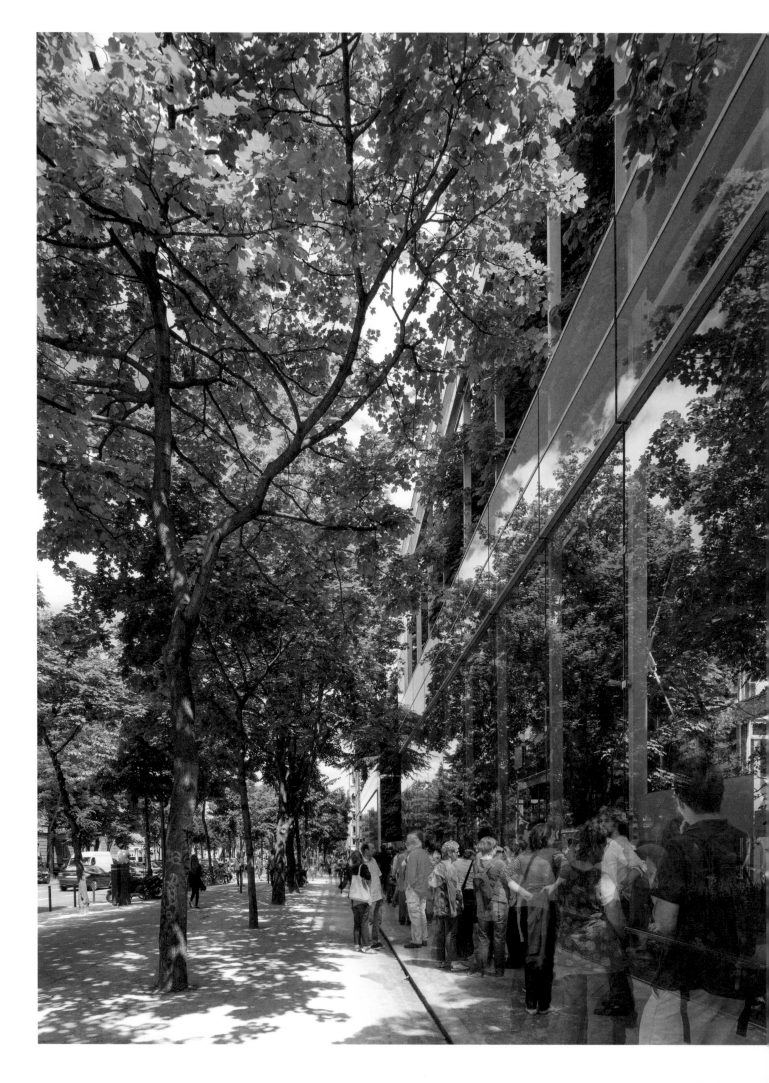

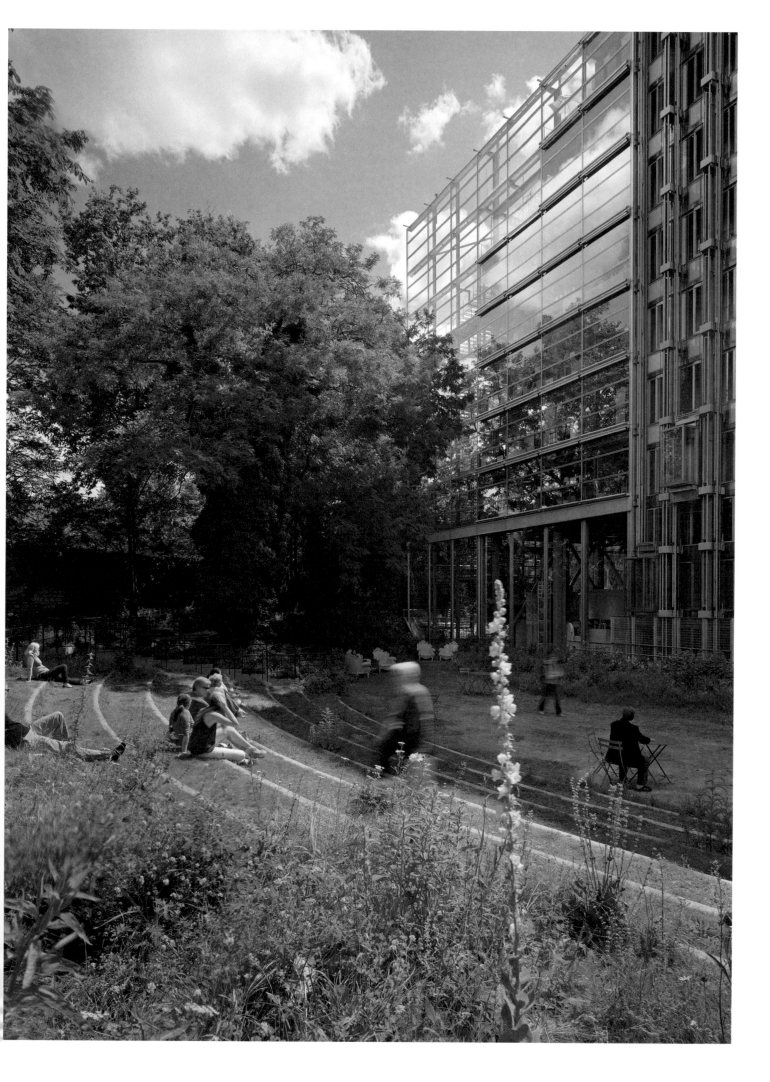

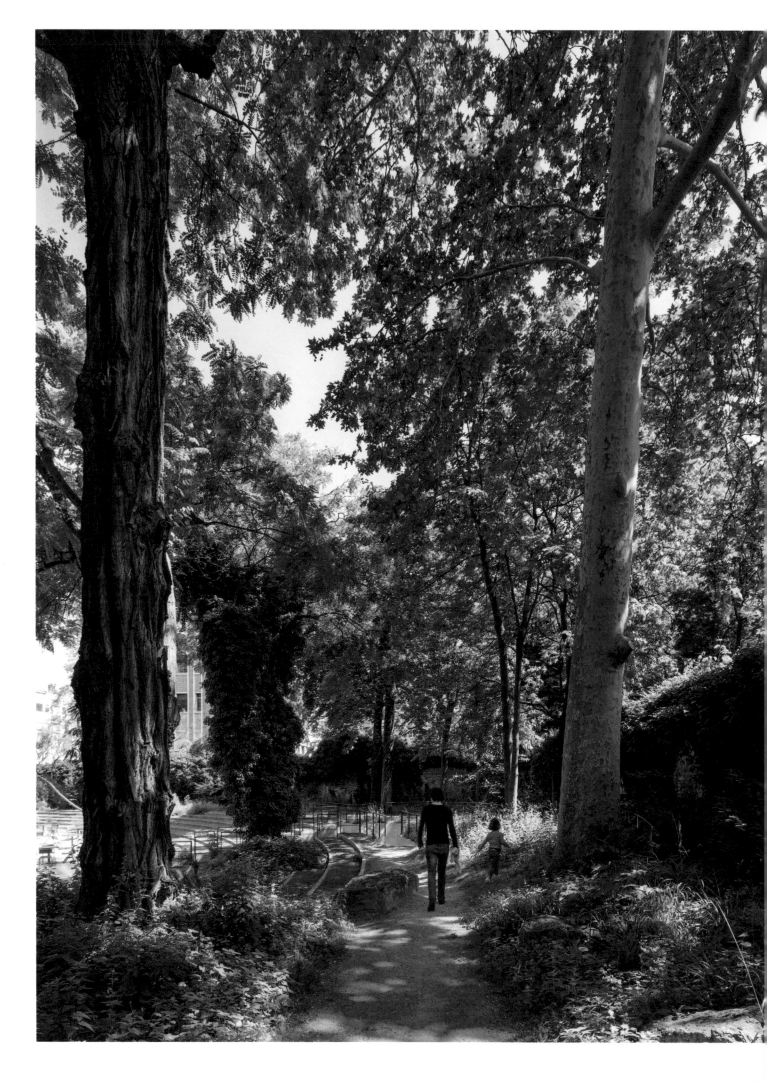

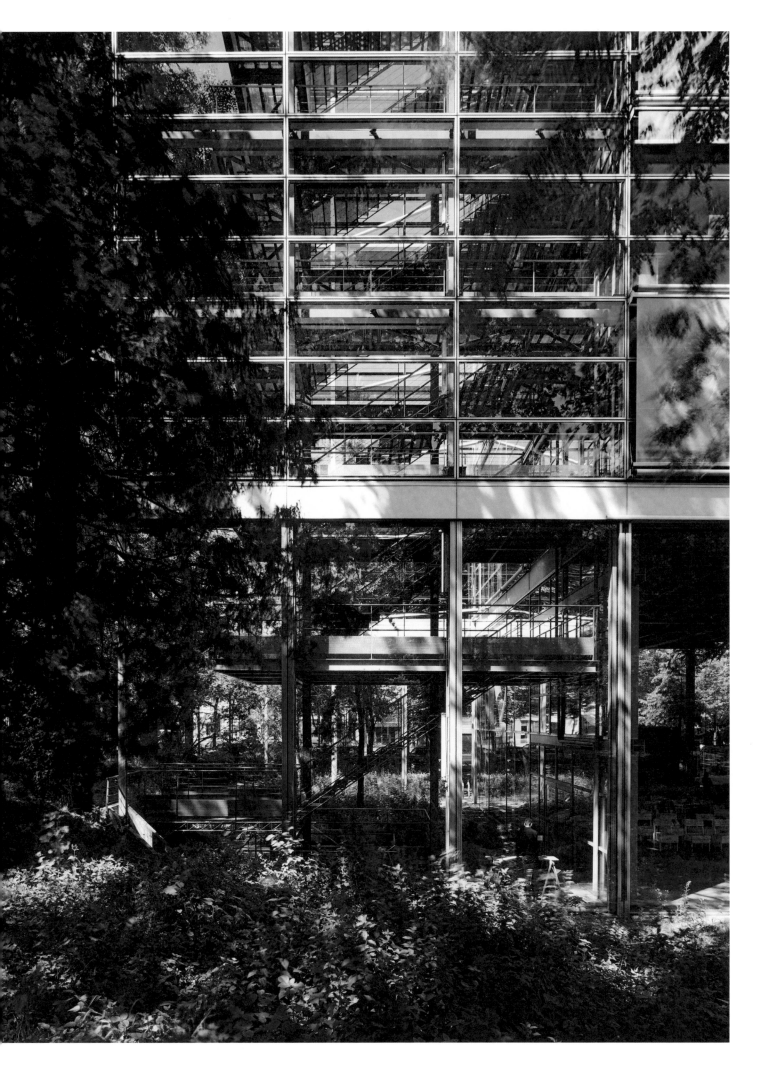

2ème ESCALE SUR PHARAGONÉCIA

A BEAUTIFUL ELSEWHERE

INTERVIEW WITH HERVÉ CHANDÈS GENERAL DIRECTOR OF THE FONDATION CARTIER POUR L'ART CONTEMPORAIN

Mœbius, *Escale sur Pharagonescia*, 1989

"I am the son of my friends." Raymond Hains

STÉPHANE PAOLI: I'd like to begin with the idea of characters. For the past thirty years, one of the major features of the Fondation Cartier pour l'art contemporain has been its ability to gather together an assortment of personalities.

HERVÉ CHANDÈS: Of course, bringing together sundry people and voices has been the dynamic of the Fondation Cartier from the start (fig. 1 to 6). From William Eggleston to Mœbius, Marc Newson to Cai Guo-Qiang, and Adriana Varejão to Daido Moriyama, there has indeed been quite an unexpected crew on board! Over time groups formed and turned up here and there in the programs; that is how things are built. The characters you mentioned are artists hailing from different backgrounds, Yanomami Indians, philosophers, scientists. When we were holding discussions ahead of the *Mathematics* exhibition,[1] nobody could have guessed that we would end up with David Lynch interacting with mathematician Misha Gromov and shaman Davi Kopenawa Yanomami (fig. 7 and 8),[2] or anthropologist Bruce Albert mingling with astrophysicist Michel Cassé and mathematician Cédric Villani.[3] And yet, there they were, sharing their thoughts on the creative process (fig. 9).

Creative individuals who have contributed include British explorer Sir Wilfred Thesiger,[4] who took part in *The Desert*,[5] and Russian cosmonaut Sergei Krikalev,[6] who participated in *Un monde réel*, not to mention Ibã, shaman of the Amazonian Huni Kuĩ tribe, who took part in the *Histoires de voir, Show and Tell* exhibition, as well as Gilberto Chateaubriand, who generously and open-mindedly introduced us to Brazilian artists. Jacques Kerchache,[7] with whom we worked closely since the *À visage découvert* exhibit, also comes to mind.[8] We exhibited his fabulous collection of insects,[9] and then entrusted Enzo Mari with his collection of voodoo statues.[10]

Geography too has held pride of place. Sites are characters as well: the beaches of Saint-Malo with Raymond Hains,[11] the Toji Temple in Kyoto with Marc Couturier,[12] the Forbidden City in Beijing with Jean-Pierre Raynaud's *Pot doré*,[13] the Watorikɨ village in Amazonia and the forest surrounding it, where Raymond Depardon filmed a hunt,[14] the garden of the Fondation photographed by Patti Smith, not to mention Idem, the Montparnasse fine art printing studio which David Lynch turned into his very own Parisian atelier.

S. P.: Today a systemic approach dominates all things cultural. This wasn't the case 30 years ago, however; how did the Fondation Cartier manage to adopt such a multidisciplinary approach at such an early stage—and well before anyone else?

H. C.: To be open, to mix and to share—thanks to Alain Dominique Perrin and Marie-Claude Beaud, this approach was already in place in 1984 in

[1] *Mathematics, A Beautiful Elsewhere*, Paris, 2011–12. Exhibition directed by Jean-Pierre Bourguignon, Michel Cassé and Hervé Chandès. See pp. 180–83 and 249.

[2] Shaman and spokesperson of the Yanomami Indians in Brazil, Davi Kopenawa Yanomami is recognized the world over as one of the great aboriginal leaders at the forefront of the struggle for Amazon rainforest conservation. He participated in the *Yanomami, Spirit of the Forest* exhibition (Paris, 2003).

[3] Anthropologist and Research Director at the Institut de recherche pour le développement (IRD), Bruce Albert is a committed advocate of the Yanomami. He participated in the exhibitions *Yanomami, Spirit of the Forest*, and *Histoires de voir, Show and Tell* (Paris, 2012, see pp. 144–45 and 251).

[4] Sir Wilfred Thesiger (1910-2003) was a British explorer and writer who spent more than 50 years exploring the deserts of the Arabian Peninsula. He wrote *Arabian Sands* (London: Longman's, 1959).

[5] *The Desert*, Paris, 2000. See p. 227.

[6] Sergei Krikalev is currently the administrator of the Yuri Gagarin Cosmonauts Training Center in Moscow. He holds the record for the most time spent in space with 747 days. In 1996, he is the main character of the film *Out of the Present* by director Andrei Ujica. His mission equipment was presented in the exhibition *Un monde réel* (Paris, 1999, see pp. 162–65).

[7] Jacques Kerchache (1942-2001) was a French collector who specialized in primitive art. He initiated the Pavillon des Sessions in the Louvre, dedicated to African and Oceanic arts.

[8] *À visage découvert*, Jouy-en-Josas, 1992. See pp. 65–67.

[9] *Être nature*, Paris, 1998.

[10] *Vodun: African Voodoo*, Paris, 2011, collection of Anne and Jacques Kerchache. See p. 142–43.

[11] In *Les 3 Cartier. Du Grand Louvre aux 3 Cartier* (Paris, 1994–95), Raymond Hains exhibited 15 bulkheads "combed" from the beach of Saint-Malo.

[12] *Marc Couturier*, Toji Temple, Kyoto, 1995.

p. 124 *The Hand of Nature, Butterflies, Beetles and Dragonflies*, Collection of insects Anne and Jacques Kerchache, exhibition *Être nature*, Paris, 1998.

Jouy-en-Josas. It was the initial vision of the Fondation Cartier, which is in a constant process of reinvention. It springs from a desire to communicate with the public, to articulate the notions of seeing, thinking and learning. When the Fondation Cartier moved to Paris in 1994, this approach was strengthened, most notably with Paul Virilio's shows, such as *Unknown Quantity*.[15] "The world has turned into what we exhibited!"[16] And later on, *Native Land* and *Mathematics* featured a constant back and forth between showing and expressing. Certain exhibits are literally joint creations between artists and researchers.

I also believe that Jean Nouvel's architecture plays a fundamental role throughout. Its sheer transparency sets curiosity in motion. The play on lighting, the ambiguous contrast between interior and exterior—all of this creates illusion, and the impermanence of feeling. The uncertainty is stimulating and productive, a source of inspiration. "A Beautiful Elsewhere," the subtitle of the *Mathematics* exhibition, is an apt description of the spirit of the Fondation Cartier.

s. p.: This is almost word for word what Jean Nouvel said when asked to describe the building: the effect of uncertainty, the play on appearances and the notion of reality…

h. c.: Yes, of course, architecture always raises the question of the materiality and immateriality of what is seen. We explored this idea by recording the experiences of the Huni Kuĩ Indians from Brazil, who are currently taking part in an extraordinary experiment: they are transcribing their chants through drawing, thus transforming the immateriality of music into visual matter. The exhibition *Un monde réel*, which was based on the notion of what is and what isn't real, echoed this question. Actually, a whole new group was formed at that time, which included Mœbius, filmmaker Andrei Ujica, architects Elizabeth Diller and Ricardo Scofidio, Panamarenko, Chris Burden, Fabrice Domercq and Vincent Beaurin…

s. p.: In other words, you are turning the criticism that has sometimes been aimed at Jean Nouvel's building on its head, notably the paradox of an exhibition site that has no walls on which to hang works: you say that the building's very design allows for a multidisciplinary spirit, making it almost possible to forget it's even there…

h. c.: Again, the building is the perfect place for welcoming all sorts of approaches. We have continually explored all different manners of inhabiting it, playing on it or overcoming it. The architecture suggests a permanent to and fro between the garden side and the city side, day and night, the "nave" (the ground floor) and the "crypt" (the basement). I'm thinking in particular of the exhibition *Making Things*, in which Issey Miyake set his clothes in motion.[17] I should also mention *By Night*, for which we covered the Fondation with black tarpaulin, to recreate nighttime.[18] For Raymond Depardon and Claudine Nougaret's

[13] Created in 1985 for the park of the Fondation Cartier in Jouy-en-Josas, Jean-Pierre Raynaud's *Pot doré* was shown in 1996 in Berlin, then in Beijing's Forbidden City, before being donated to the Centre Pompidou (Paris) in 1998. See pp. 4, 44, 78–79 and 197.

[14] Located in the heart of the Yanomami forest, in the Brazilian state of Roraima, Watoriki is Davi Kopenawa's native village.

[15] Paul Virilio oversaw or participated directly in the following exhibitions: *La Vitesse*, Jouy-en-Josas, 1991, see pp. 78–79; *Unknown Quantity*, Paris, 2002–03, see p. 231; *Native Land, Stop Eject*, Paris, 2008–09, see pp. 166–69 and 243.

[16] Paul Virilio, about the exhibition *Un monde réel*.

[17] *Issey Miyake Making Things*, Paris, 1998-99. See p. 140–41.

[18] *By Night*, Paris, 1996. Exhibition design by Bruno Moinard.

P. 127 Adriana Varejão, *Cadernos de viagem: Yakoana*, 2003.

Virola

[19] The film *Hear Them Speak*, made in 2008 for the Fondation Cartier by Raymond Depardon and Claudine Nougaret, is dedicated to endangered languages. See pp. 166–67.

[20] Created in 1994, Nomadic Nights are dedicated to performing arts.

[21] *Pain Couture by Jean Paul Gaultier*, Paris, 2004. See pp. 147–49.

[22] Alessandro Mendini, Vincent Beaurin, Fabrice Domercq, *Fragilisme*, Paris, 2002. See pp. 178–79.

[23] Beat Takeshi Kitano, *Gosse de peintre*, Paris, 2010. See p. 154–55 and 247.

[24] *Seydou Keita*, Paris, 1994; *Malick Sidibé*, Paris, 1995; *J.D. 'Okhai Ojeikere*, Paris, 2000.

[25] Bruce Albert, Davi Kopenawa Yanomami, *The Falling Sky: Words of a Yanomami Shaman*, Cambridge, Massachusetts: The Belknap Press, 2013.

P. 128 Tadanori Yokoo, art work created for the exhibition *Mathematics, A Beautiful Elsewhere*, Paris 2011–12.

film *Hear Them Speak*, we used darkness to make optimal use of the huge ground floor.[19]

There is an exchange between the various ways of grasping architecture and the works that are exhibited, with the building being both a source of inspiration and an influence from whose sway one must free oneself. In this respect, the *Effondrement des enseignes lumineuses* exhibit by Jean-Michel Alberola in 1995, which questioned the place given to painting in such a space, is paradigmatic.

s. p.: You often use the words "orchestra" and "play"…

h. c.: The idea of the orchestra is a reflection of harmony of feeling, intuition and friendship that a story needs in order to be told. Exchange lies within encounters. We are "tellers of encounters!"

As for the "playful" aspect, this is all about having a rock and roll exhibition one day and a pop art show the next. It is the Nomadic Nights dedicated to performing arts.[20] Or bringing nature and environmental issues into the Fondation Cartier via the garden. I am thinking mostly of *Être nature*, *Comme un oiseau*, and naturally, *Native Land*, a visual meditation on migration. Playing is based on a kind of disorientation, and giving uncertainty its day in the sun! Going against one's own taste. Inviting Jean Paul Gaultier to transform the Fondation into a bakery and present a line of clothing made of bread.[21] It's *Fragilisme* by Alessandro Mendini.[22] Not to mention the extravagant *Gosse de peintre* exhibition by Japanese artist Beat Takeshi Kitano, which was designed for children.[23] For me, a sense of play is necessary to lend a show an open form that encourages questions while being visually stimulating, thus turning spectators into performers.

s. p.: It would appear through what you say, that uncertainty is human.

h. c.: Yes, and human beings are the authors. So when in the mid-1990s we showed with André Magnin the work of photographers Seydou Keita, Malick Sidibé and J.D. 'Okhai Ojeikere—who at the time were practically unknown—we gave them individual shows rather than take the risk of seeing their work lost in the swirl of an exhibit on African photography as a whole.[24] In the same manner, we thought it inconceivable to organize a show on Shamanism and Brazil's Yanomami Indians without their direct involvement: the show was thought out with them, and shaped by journeys, meetings, and dialogue. Our approach was based on the notion of the "gift of knowledge" that Bruce Albert put forth in his book *The Falling Sky*: a reciprocal exchange of knowledge between artists and shamans, between a small community of Indians living in the rainforest and a space given over to contemporary creation in Paris.[25] When the forest artists returned home they were able to bear witness to the interaction between the show and their community. The fact that an artist belongs to a community with its own rules and traditions forces us to reinvent our

relationships with artists and their works. This collective dimension was for us a new and rewarding experience.

In my opinion, when all is said and done, the word "community" best defines the spirit of the Fondation Cartier. The collection is a community of works, and the spirit of the Fondation Cartier. It tells the story of the experiences, the programming, the relationships with artists, the commissions, the ateliers. This is what makes the Fondation Cartier unique! Your question reminds me of the "human hypersensitivity" of self-taught artists from all over the world presented in the exhibition *Histoires de voir, Show and Tell.*[26]

130

S. P.: James Lee Byars' *Monument to Language* is practically a synthesis of both approaches: showing and allowing voices to express themselves.

H. C.: I met James Lee Byars in Germany a few years before he died in Cairo. That's when he mentioned a gold-leafed bronze sphere measuring three meters wide; he wanted someone to be able to enter the sphere and read a text by Roland Barthes. In England, we located a foundry able to follow his instructions, and create it in one piece.

Byars' sphere and its title—*The Monument to Language*—are brilliantly in tune with the Fondation Cartier's programming. We are exhibiting it again in September and are inviting Patti Smith, Matthew Barney, Huang Yong Ping, Roger Penrose and Alain Connes to interact with it.[27] Byars' sphere makes me think of the Paul Virilio anthology of texts written over the years for the Fondation Cartier, *La Pensée exposée*.[28] As well as David Lynch's *Big Vibrating Zero* that was used for the mathematician Misha Gromov's *Library of Mysteries*. And of course it also reminds me of the bird song—the subject of an upcoming show.

S. P.: If the Fondation Cartier changed venues—the idea has already been broached—have you given any thought to how your approach might then change?

H. C.: The exhibition spaces of the Fondation Cartier—on Boulevard Raspail in Paris—are somewhere between earth and sky. They are continuously evolving, extraordinarily evocative and "hypersensitive," to quote the words of Alessandro Mendini. Artists are very attached to our building. Right now we are considering the possibility of expanding, which could bring a sense of calm and permanence to the institution, providing it with a place for its permanent collection, for artists' residencies, for a movie theater… This change of scale could enhance the reputation of the Fondation, beyond the place where it is located. In my opinion, this change of scale could help us find a balance between continuous mobility and its opposite—immobility.

Interview by Stéphane Paoli, journalist and host of the Nights of Uncertainty at the Fondation Cartier pour l'art contemporain, Paris, March 2014.

[26] Alessandro Mendini, extract of the exhibition *Histoires de voir, Show and Tell.*

[27] Roger Penrose, British mathematician and physicist, revolutionized the study of relativity. He gave his name to a tiling system, which inspired Beatriz Milhazes and BUF's animated film, *Mathematical Paradises,* broadcast during the exhibition *Mathematics, A Beautiful Elsewhere.* Alain Connes, winner of the Fields Medal in 1982, teaches at the Institut des hautes études scientifiques and the Collège de France. He participated in the exhibition *Mathematics, A Beautiful Elsewhere.*

[28] Paul Virilio, *La Pensée exposée,* Paris: Fondation Cartier pour l'art contemporain/Arles: Actes Sud, 2012.

p. 130 Jean-Michel Alberola, *Un ciel mathématique – Henri Poincaré* (detail), 2011.

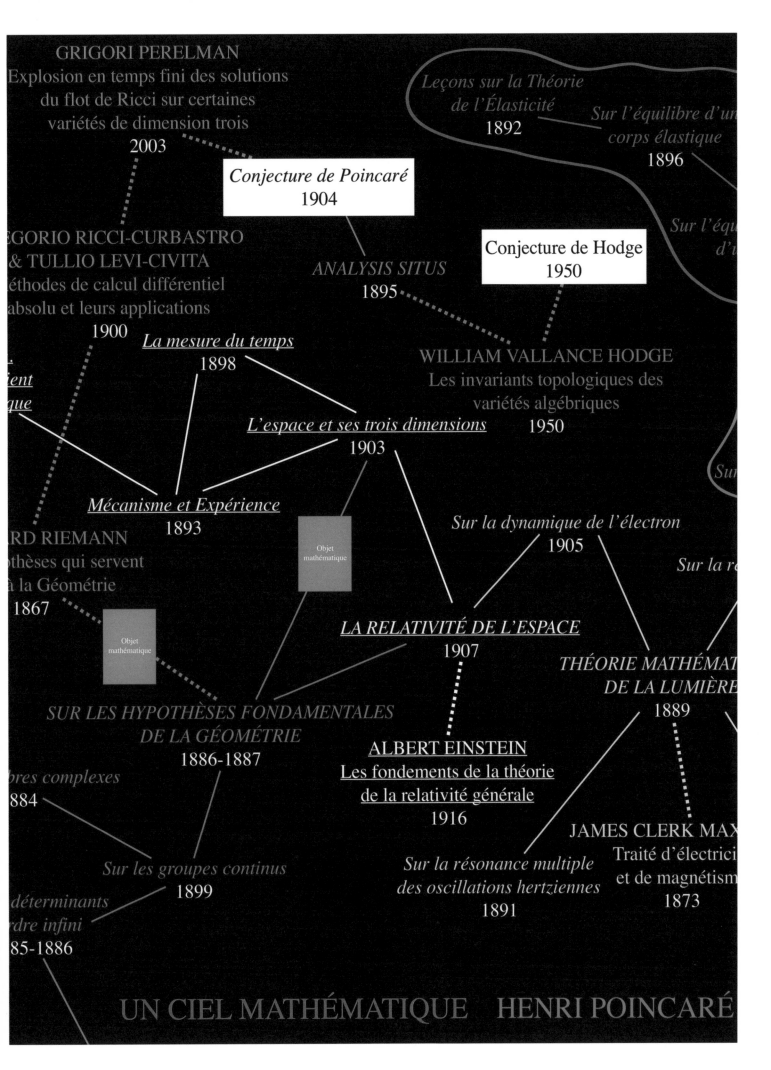

GRIGORI PERELMAN
Explosion en temps fini des solutions
du flot de Ricci sur certaines
variétés de dimension trois
2003

*Leçons sur la Théorie
de l'Élasticité*
1892

*Sur l'équilibre d'un
corps élastique*
1896

**Conjecture de Poincaré
1904**

*Sur l'équ
d'u*

GORIO RICCI-CURBASTRO
& TULLIO LEVI-CIVITA
éthodes de calcul différentiel
absolu et leurs applications
1900

**Conjecture de Hodge
1950**

ANALYSIS SITUS
1895

*ient
que*

<u>La mesure du temps</u>
1898

WILLIAM VALLANCE HODGE
Les invariants topologiques des
variétés algébriques
1950

<u>L'espace et ses trois dimensions</u>
1903

<u>Mécanisme et Expérience</u>
1893

Objet
mathématique

Sur la dynamique de l'électron
1905

Sur la r

RD RIEMANN
othèses qui servent
à la Géométrie
1867

Objet
mathématique

<u>LA RELATIVITÉ DE L'ESPACE</u>
1907

*THÉORIE MATHÉMAT
DE LA LUMIÈRE*
1889

*SUR LES HYPOTHÈSES FONDAMENTALES
DE LA GÉOMÉTRIE*
1886-1887

<u>ALBERT EINSTEIN</u>
<u>Les fondements de la théorie
de la relativité générale</u>
1916

bres complexes
884

JAMES CLERK MAX
Traité d'électrici
et de magnétism
1873

Sur les groupes continus
1899

*Sur la résonance multiple
des oscillations hertziennes*
1891

*déterminants
rdre infini*
85-1886

UN CIEL MATHÉMATIQUE HENRI POINCARÉ

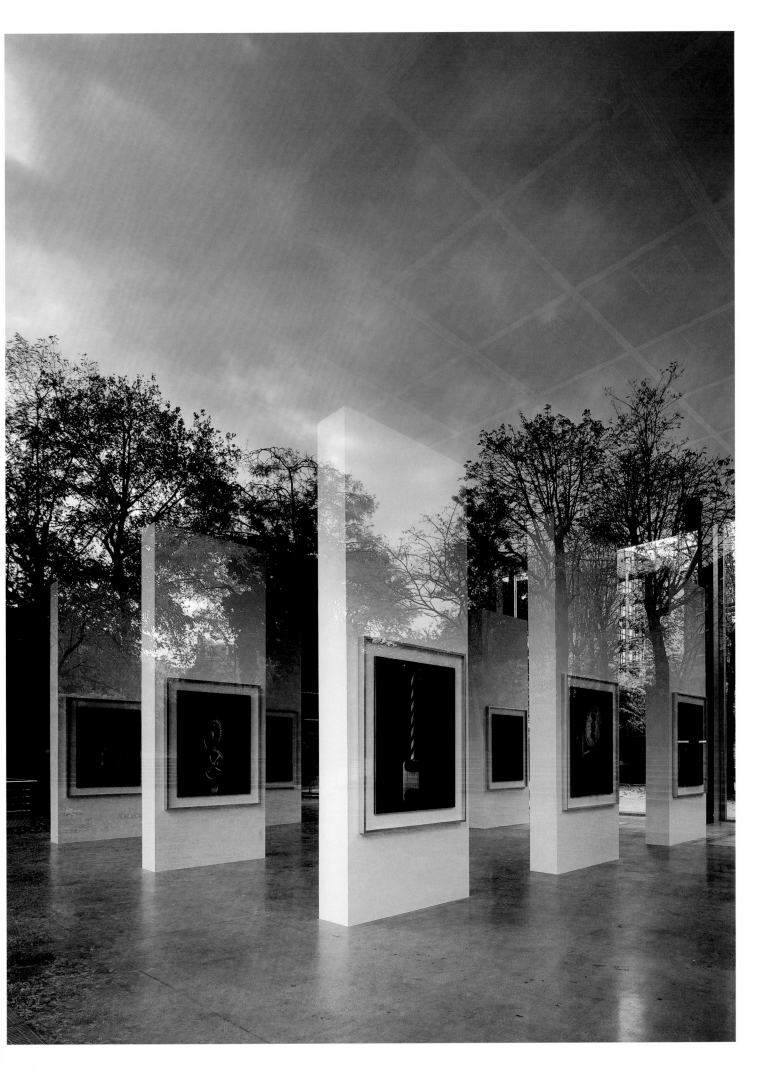

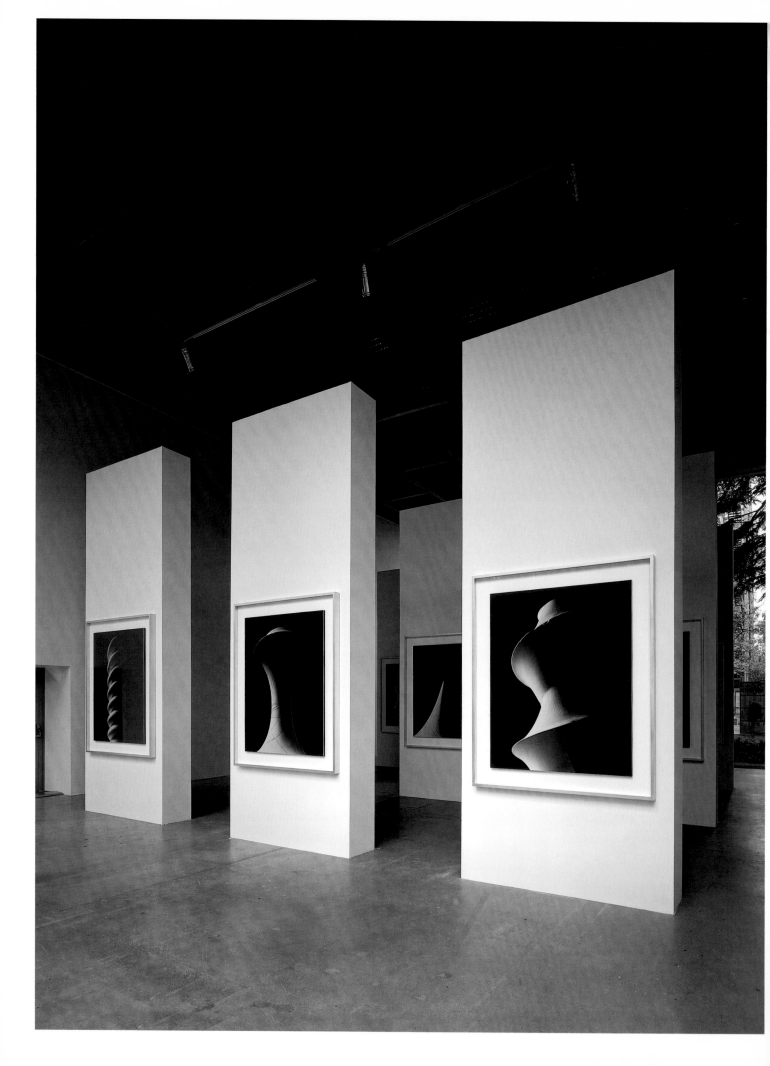

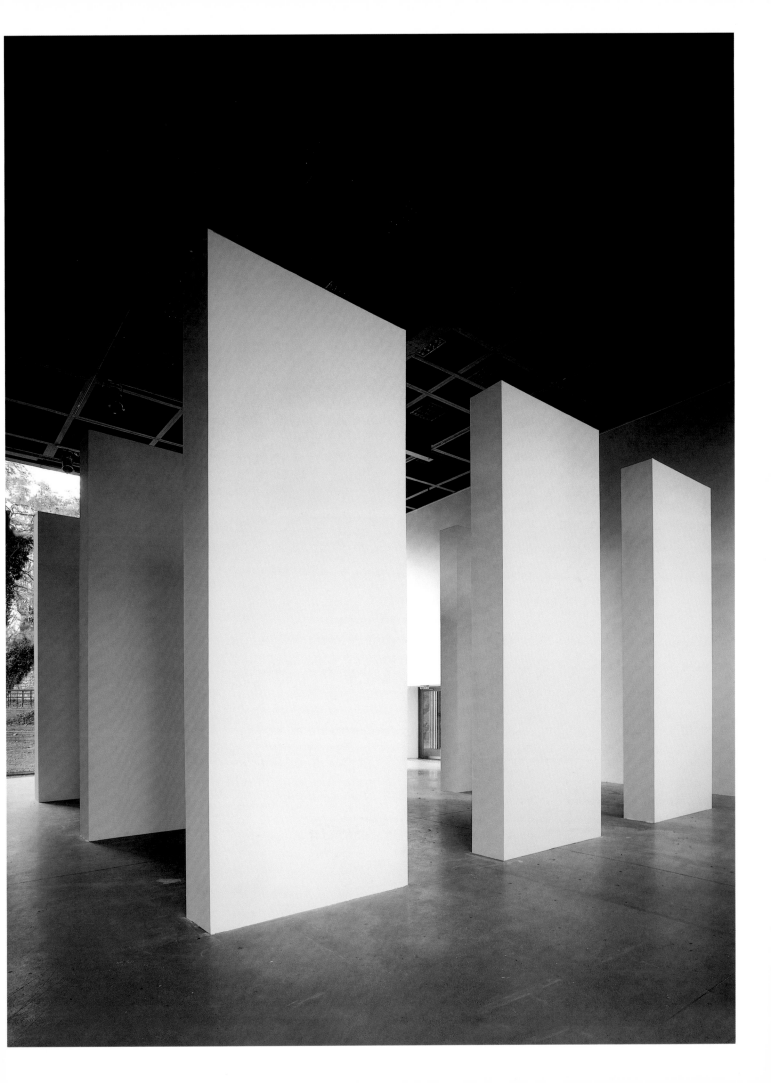

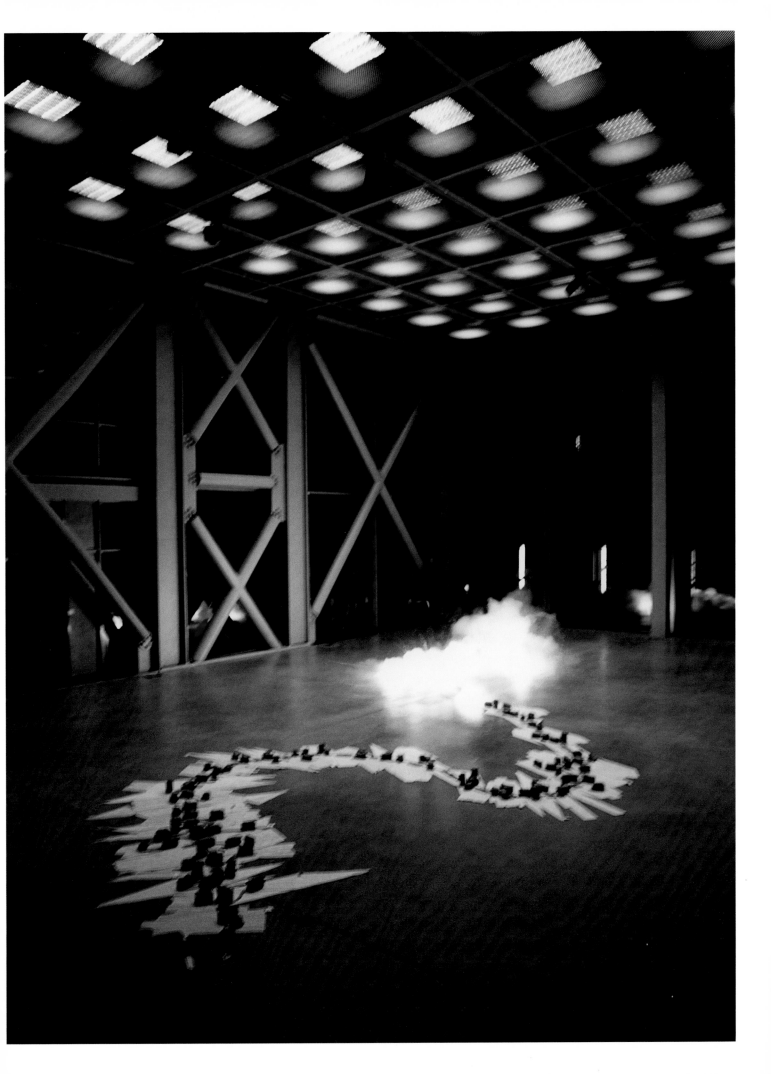

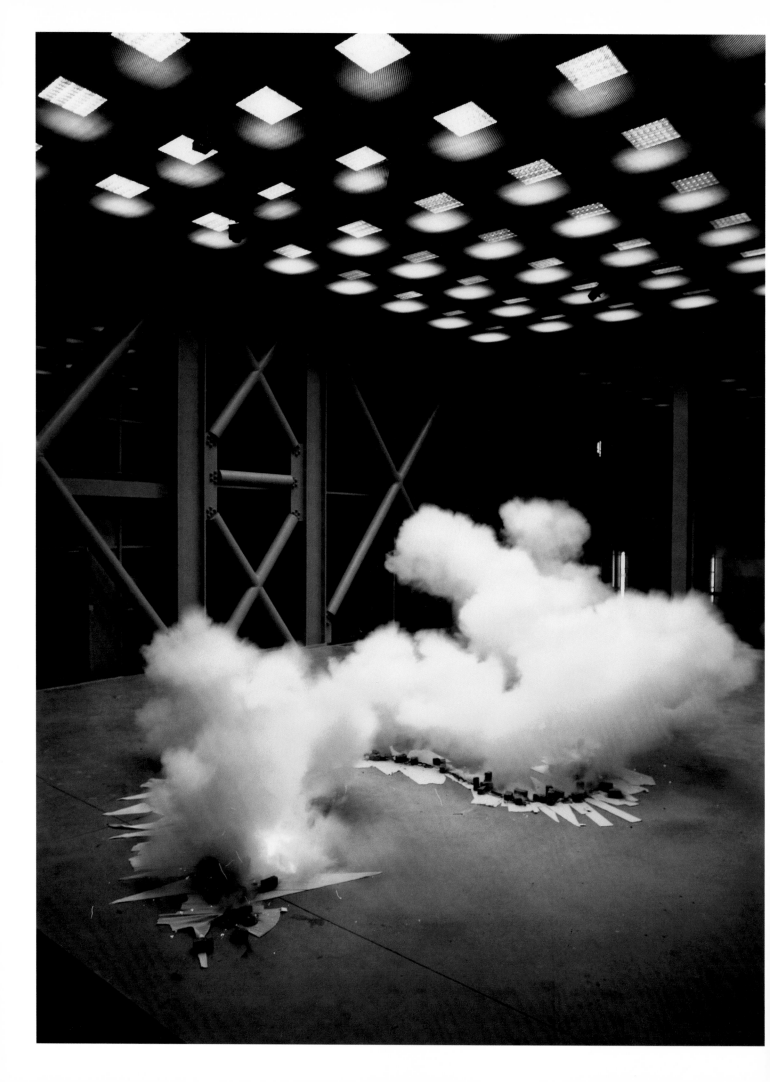

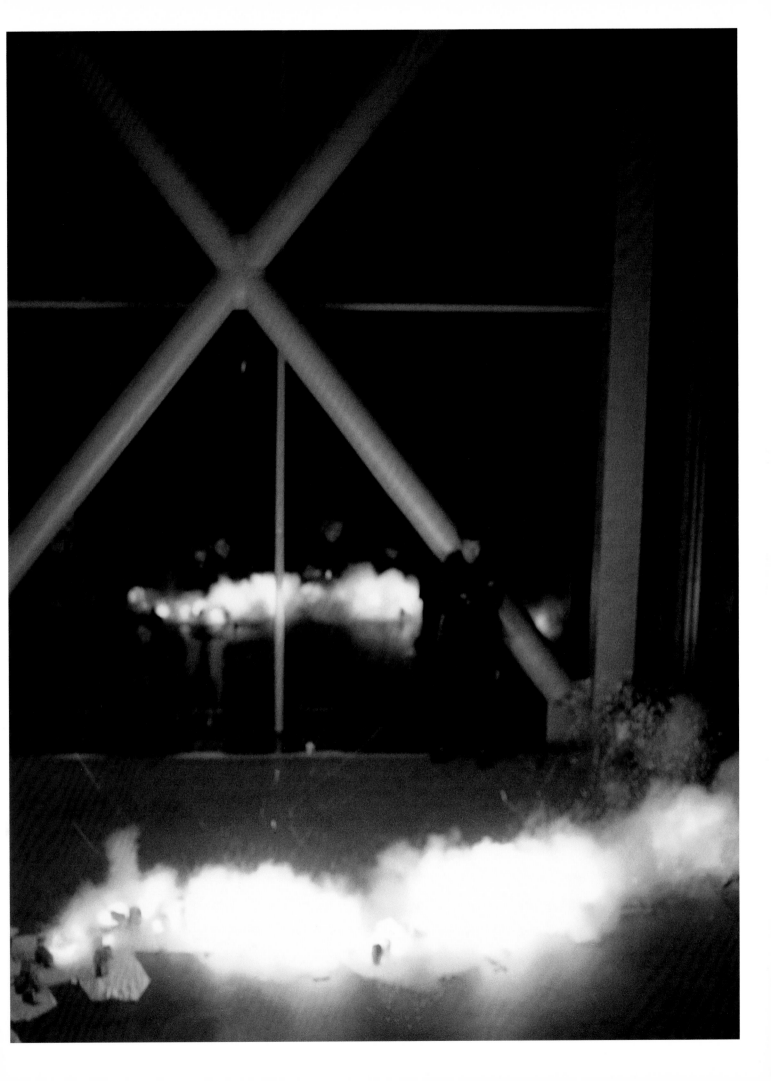

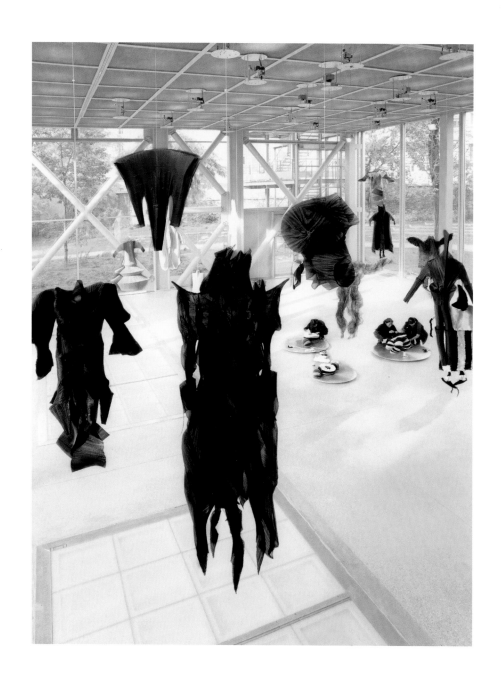

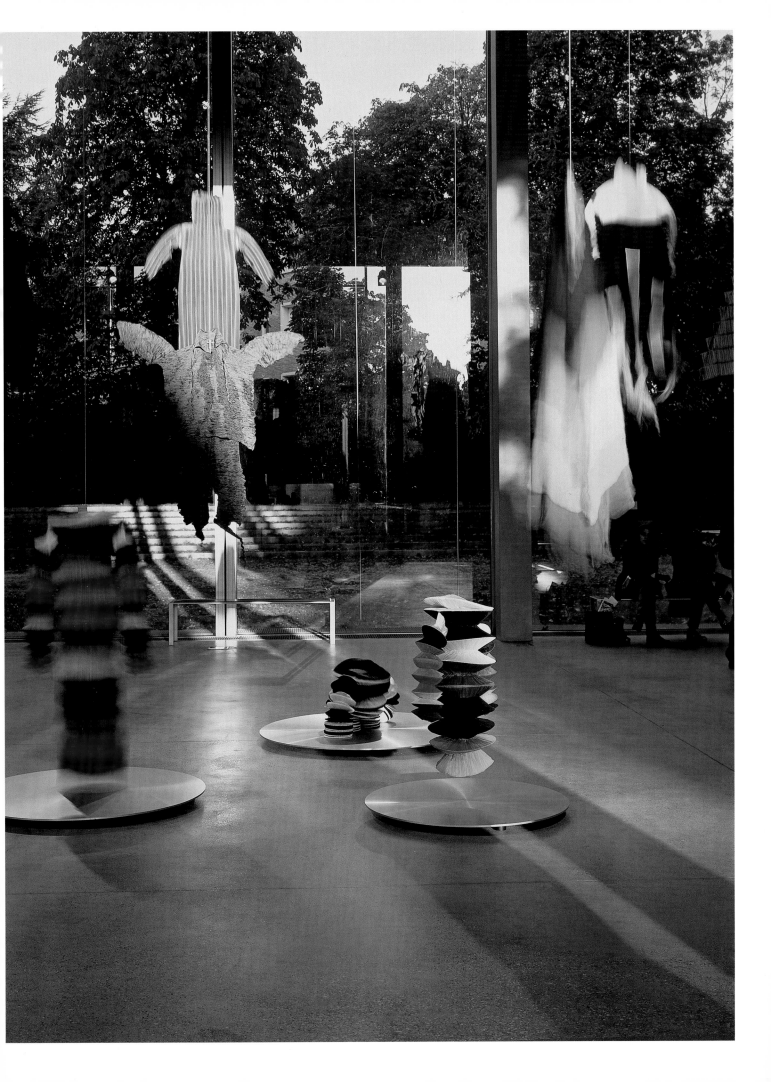

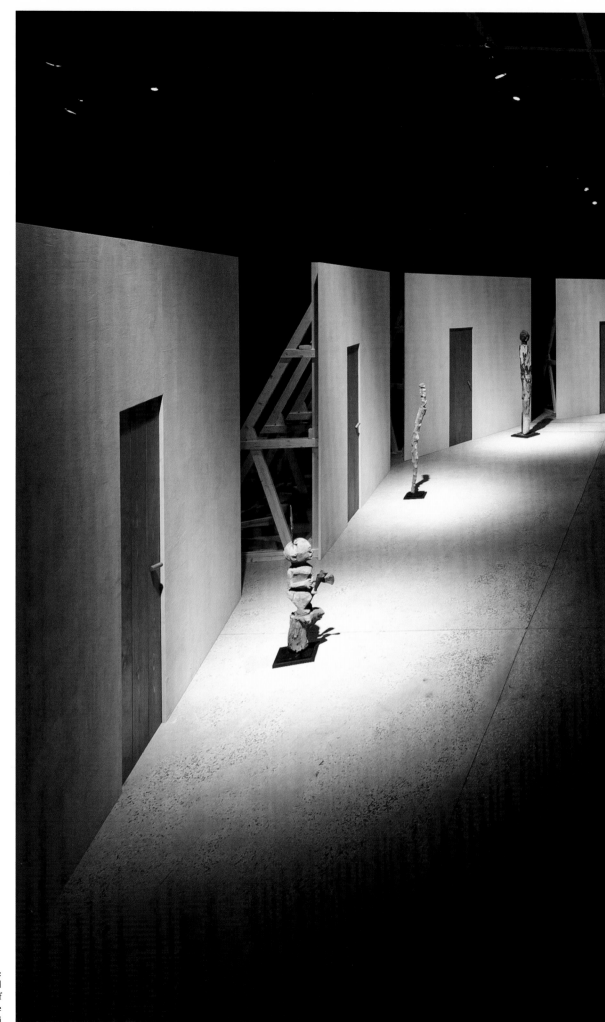

EXHIBITION VODUN:
AFRICAN VOODOO, 2011
Collection of
Anne and Jacques Kerchache
Exhibition design by Enzo Mari

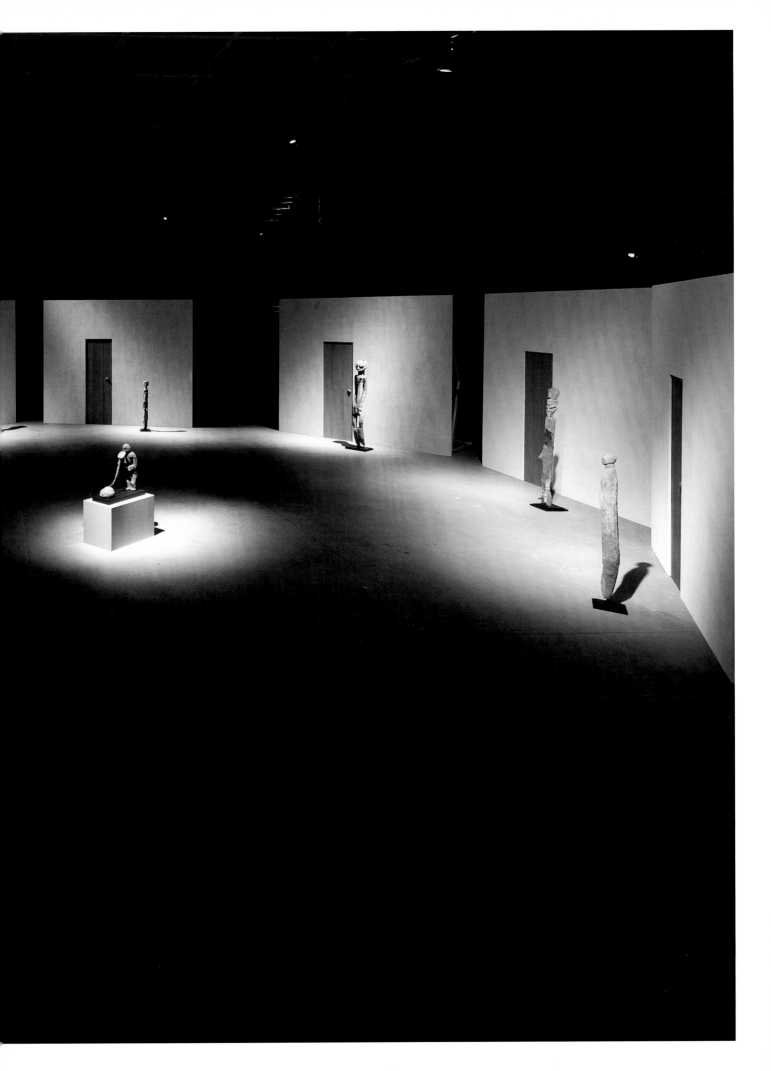

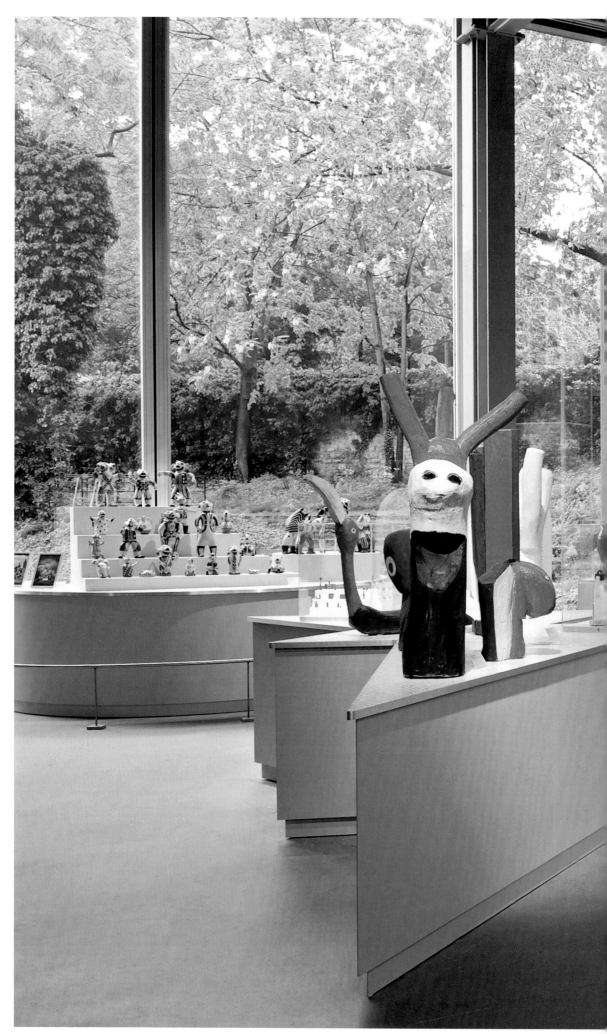

EXHIBITION
HISTOIRES DE VOIR,
SHOW AND TELL, 2012
Exhibition design by
Alessandro Mendini

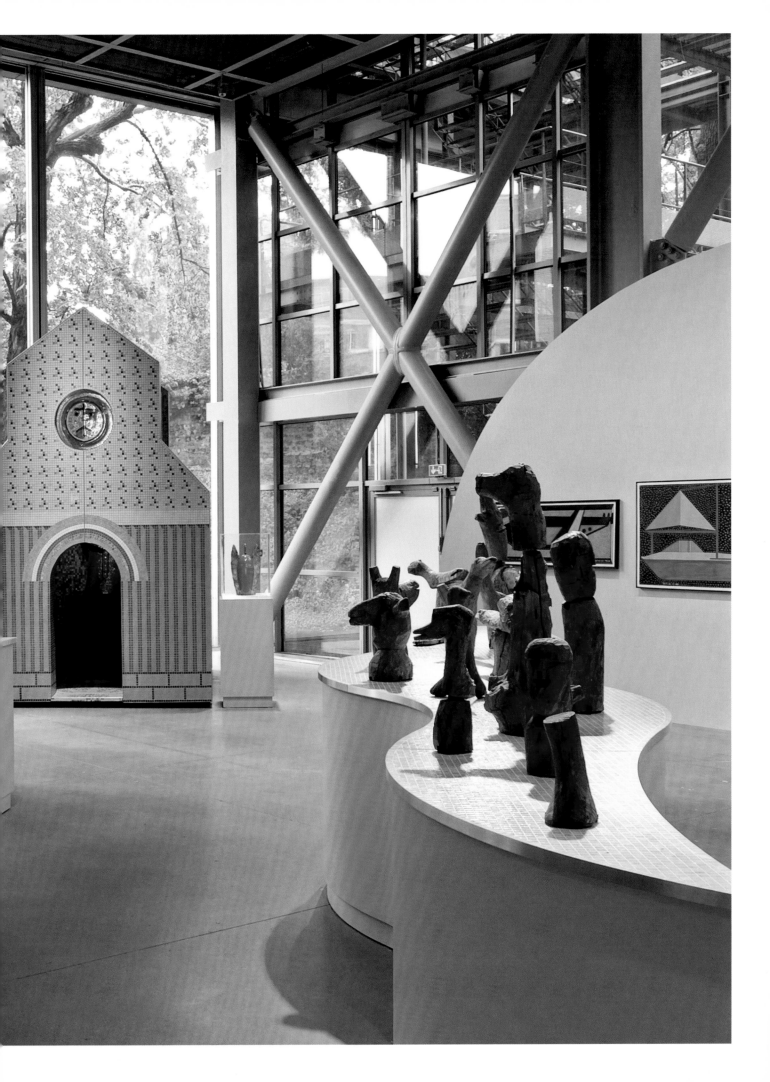

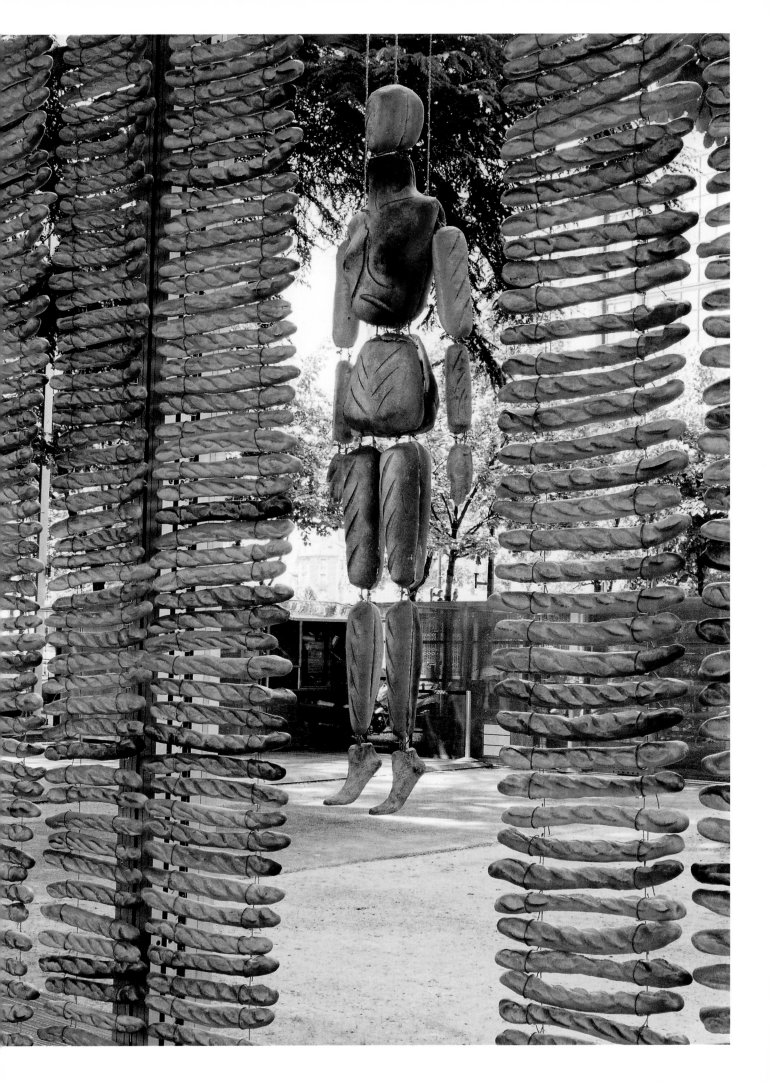

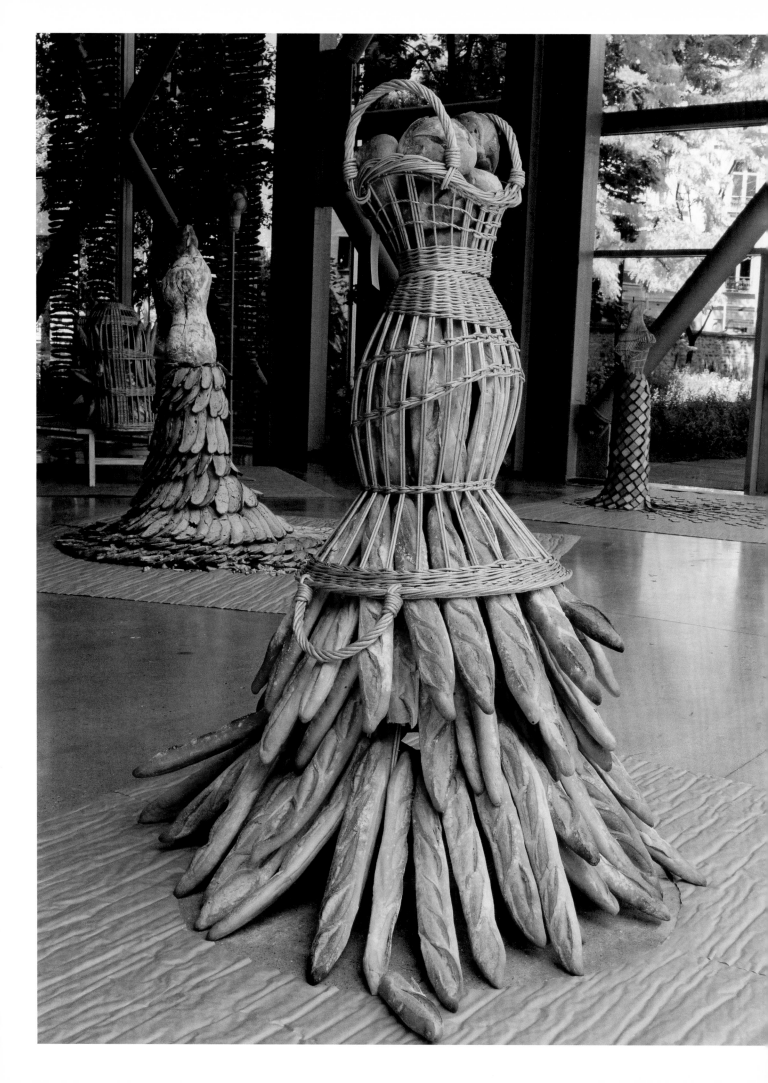

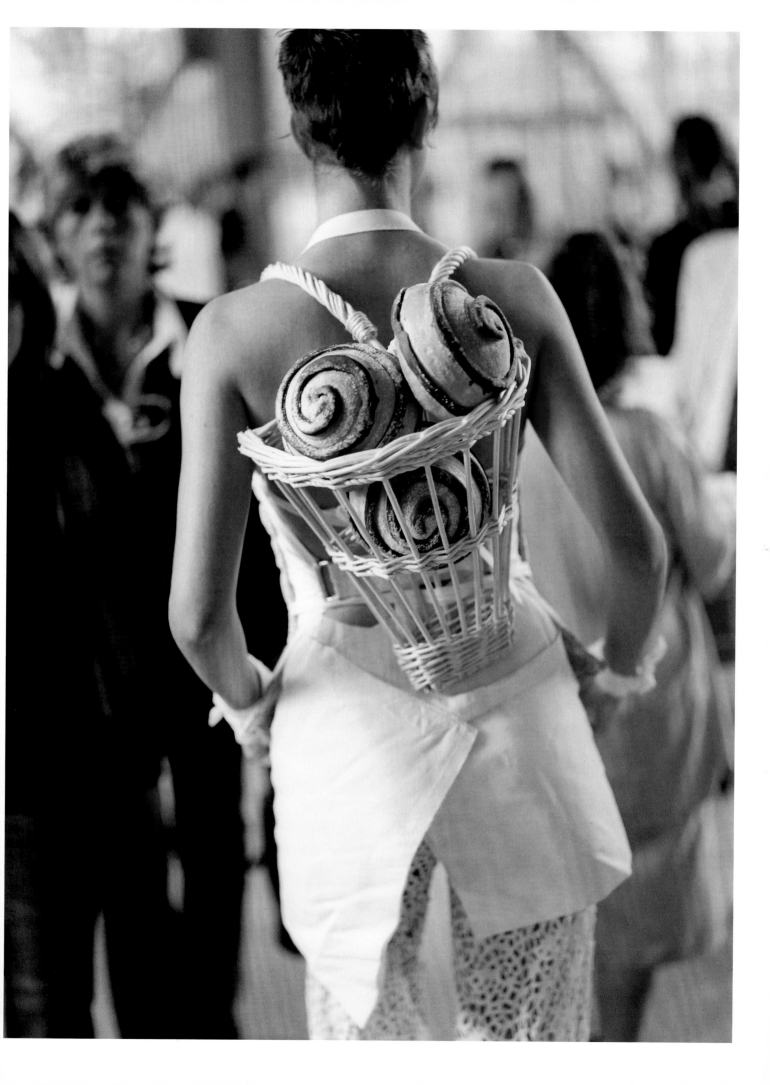

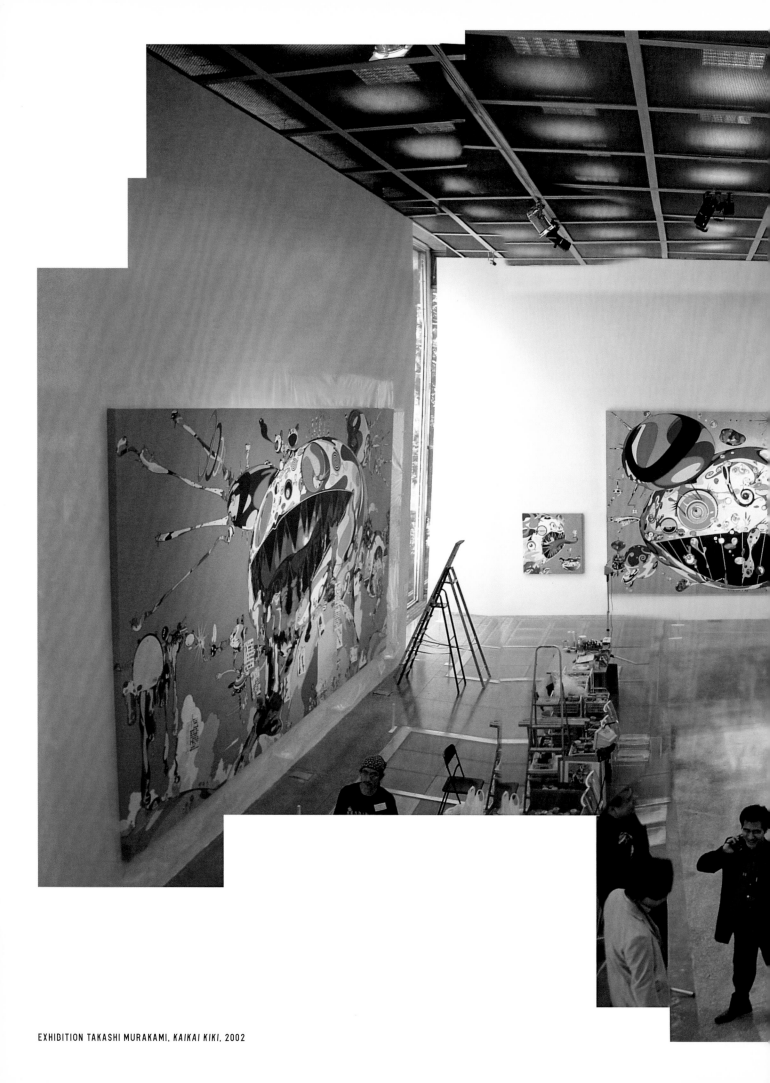

EXHIBITION TAKASHI MURAKAMI, *KAIKAI KIKI*, 2002

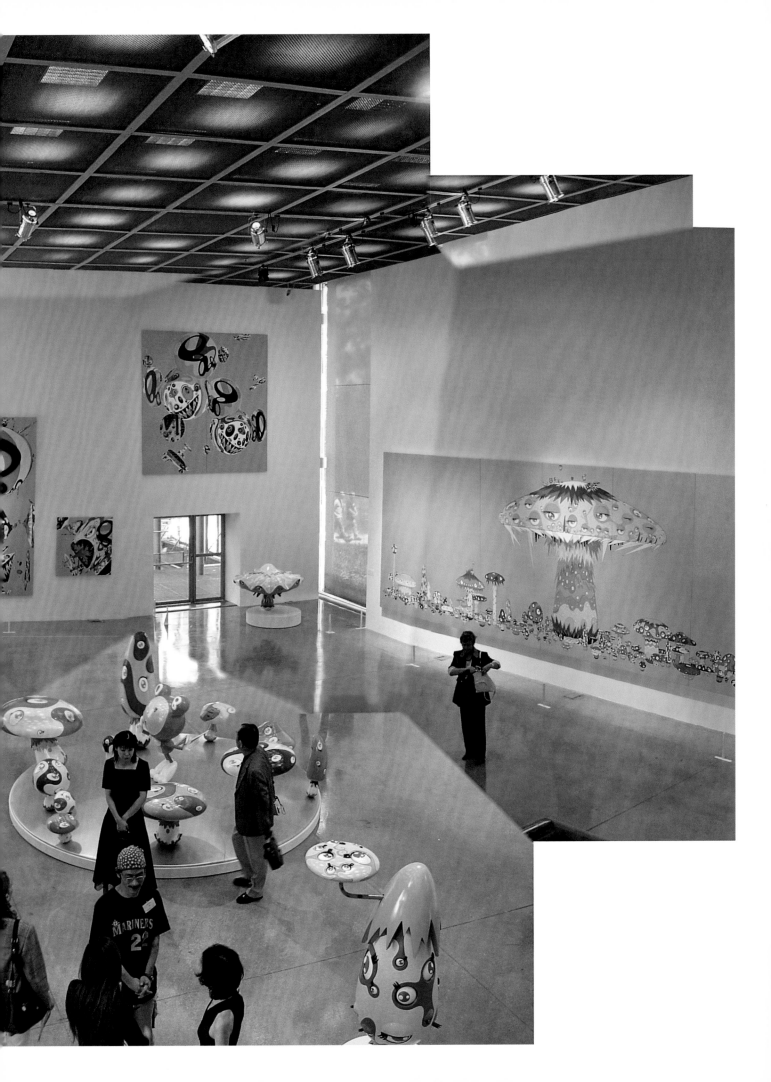

EXHIBITION
BORN IN THE STREETS—
GRAFFITI, 2009–10
Shepard Fairey,
OBEY GIANT,
Global Warning Paris, 2009

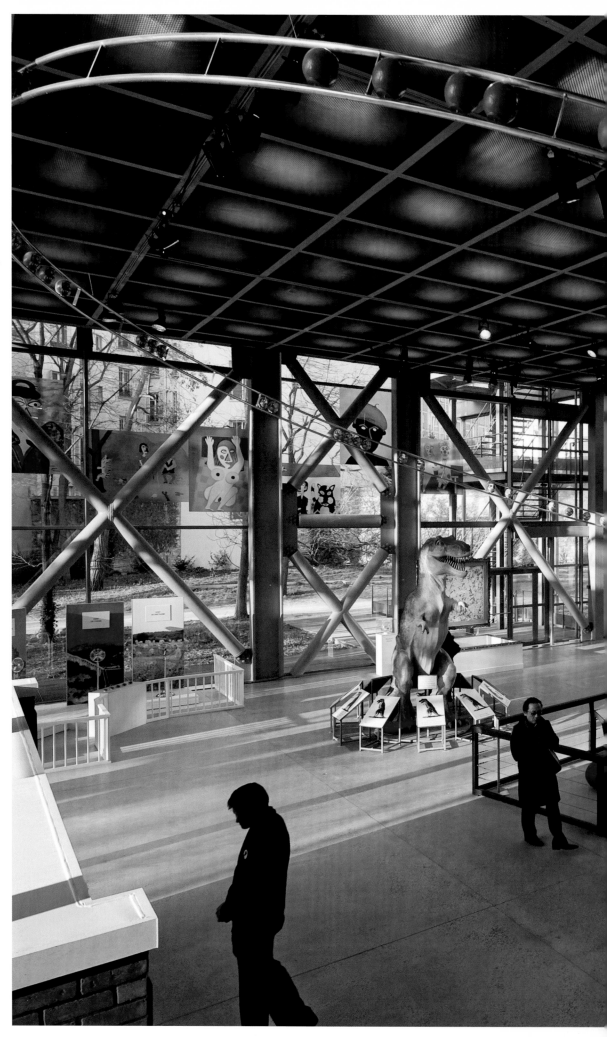

EXHIDITION
DEAT TAKESHI KITANO.
GOSSE DE PEINTRE, 2010

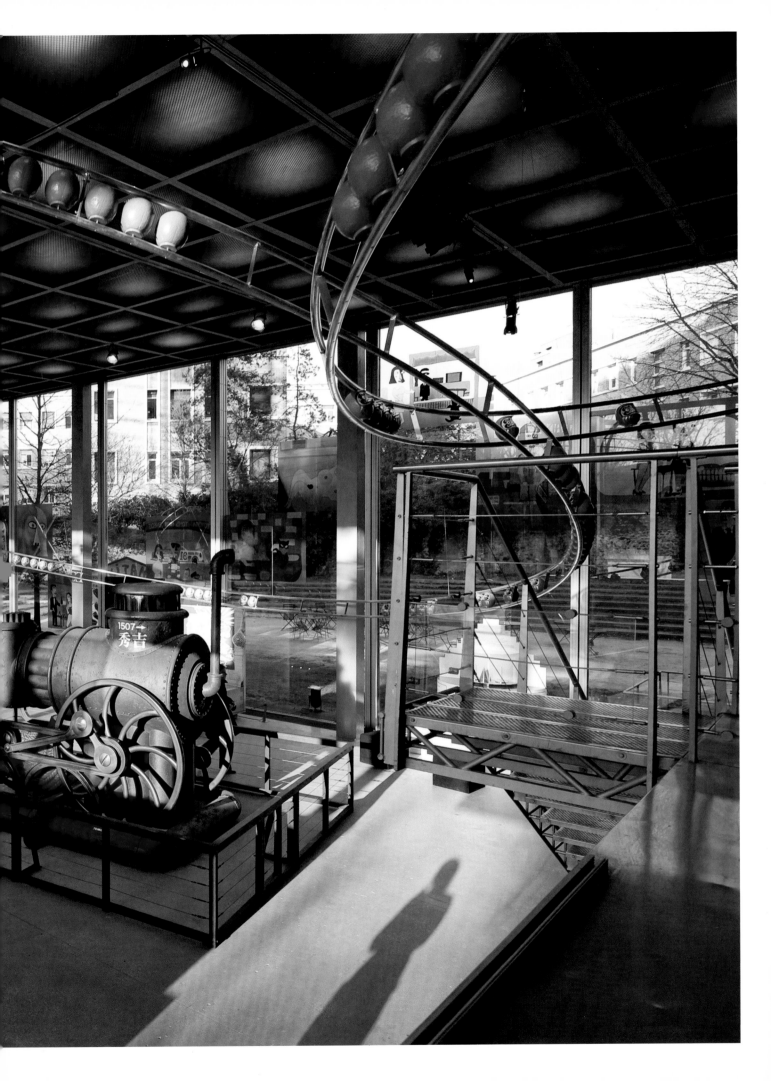

EXHIBITION
MŒBIUS-TRANSE-FORME.
2010—11
Mœbius, *La Planète encore,*
2009

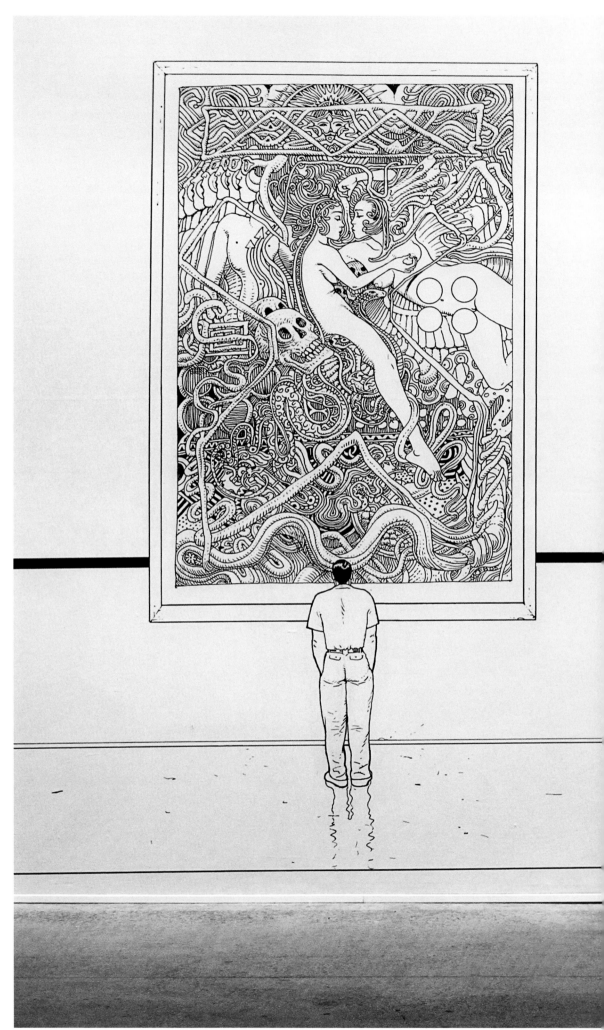

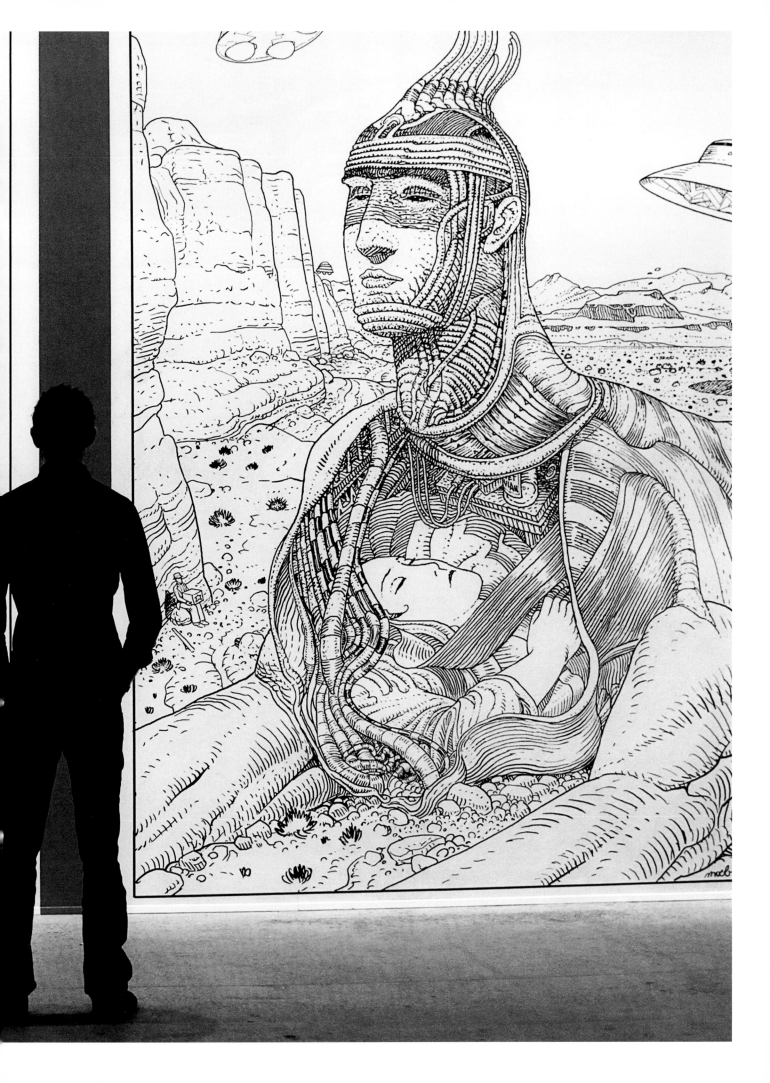

EXHIDITION
TADANORI YOKOO, 2006

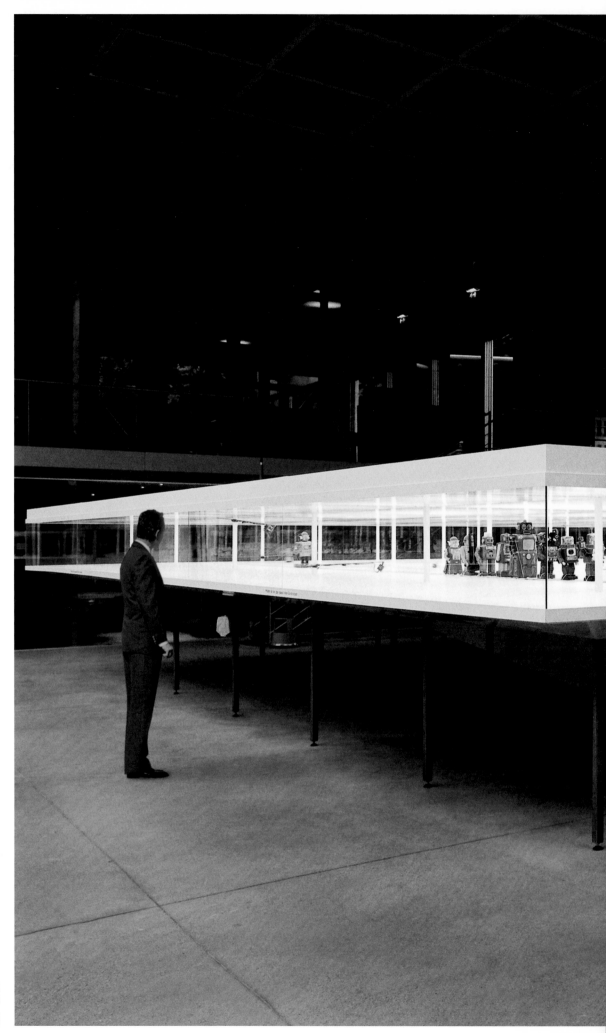

EXHIBITION
UN MONDE RÉEL, 1999
Diller + Scofidio,
Master/Slave, 1999

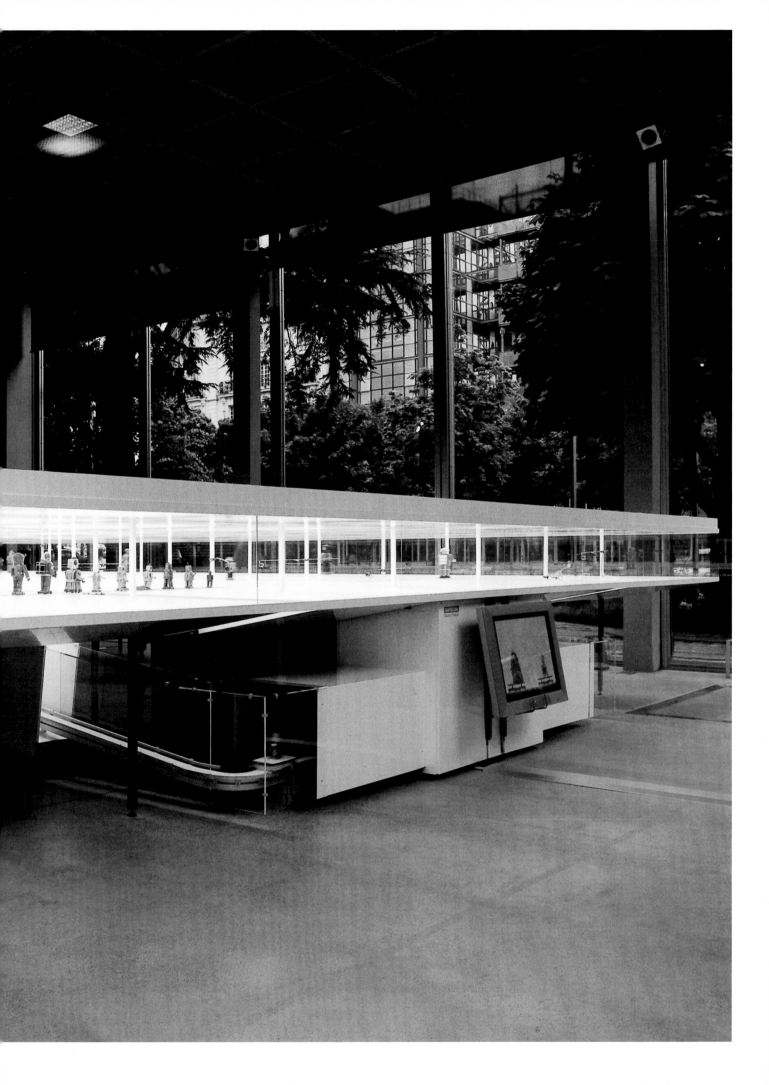

EXHIBITION
UN MONDE RÉEL, 1999
Chris Burden,
Medusa's Head, 1990

Burden
read, 1990
es et Gagosian Gallery, New York

EXHIBITION
NATIVE LAND, STOP EJECT,
2008–09
Raymond Depardon and
Claudine Nougaret,
Hear Them Speak, 2008

"Pourquoi protège-t-il la forêt ?"

EXHIBITION
NATIVE LAND. STOP EJECT.
2008–09
Diller Scofidio + Renfro,
Mark Hansen, Laura Kurgan,
Ben Rubin and inspired
by Paul Virilio, *Exit*, 2008–09

EXHIBITION
PANAMARENKO,
LA GRANDE EXPOSITION
DES SOUCOUPES
VOLANTES, 1998

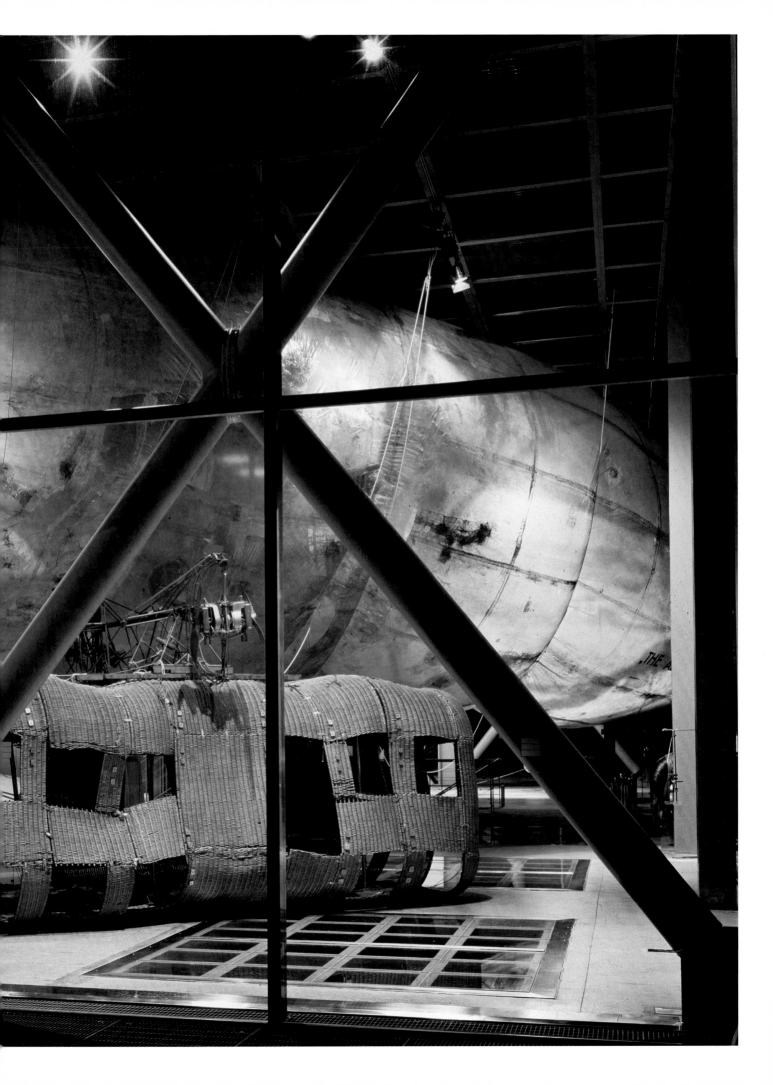

EXHIDITION
THOMAS DEMAND, 2000—01

EXHIBITION
MARC NEWSON.
KELVIN 40, 2004

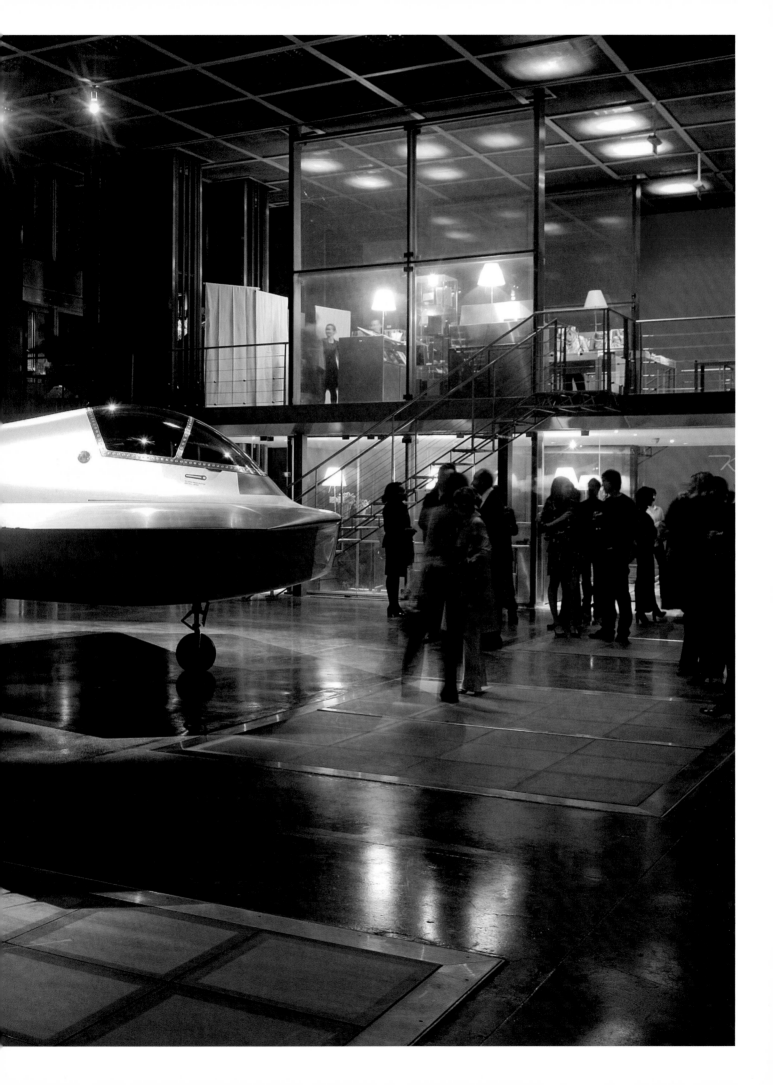

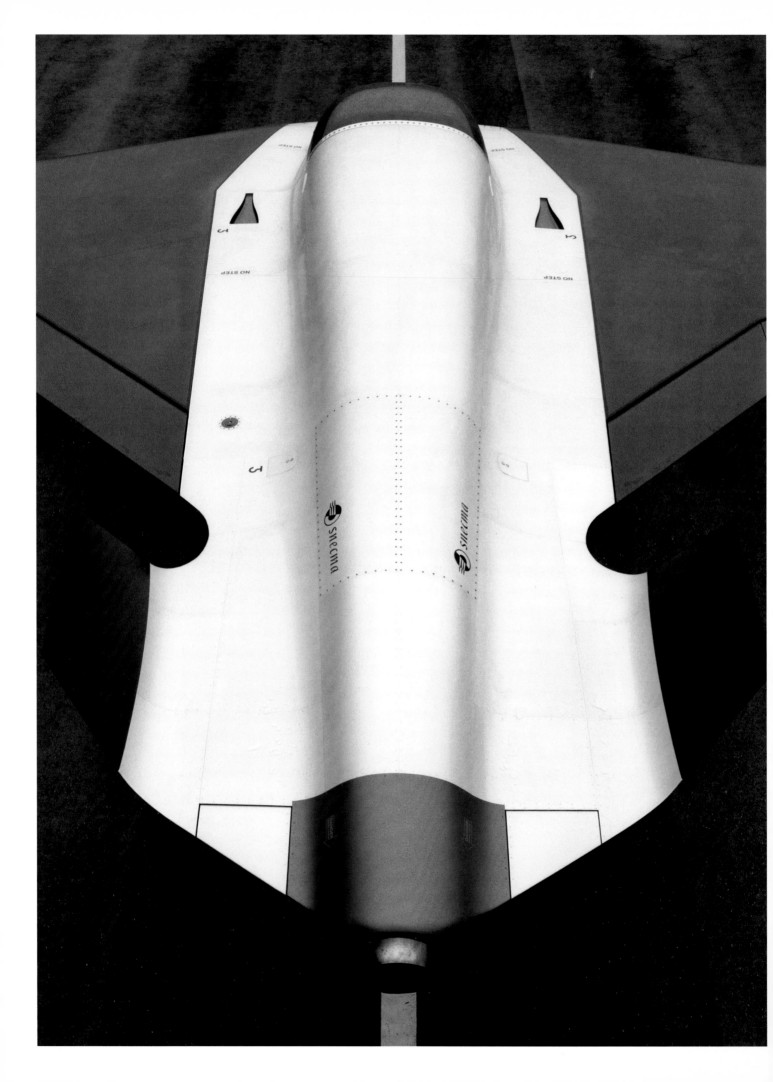

EXHIDITION
FRAGILISME, 2002
Vincent Beaurin,
Animal sans tête, 2002

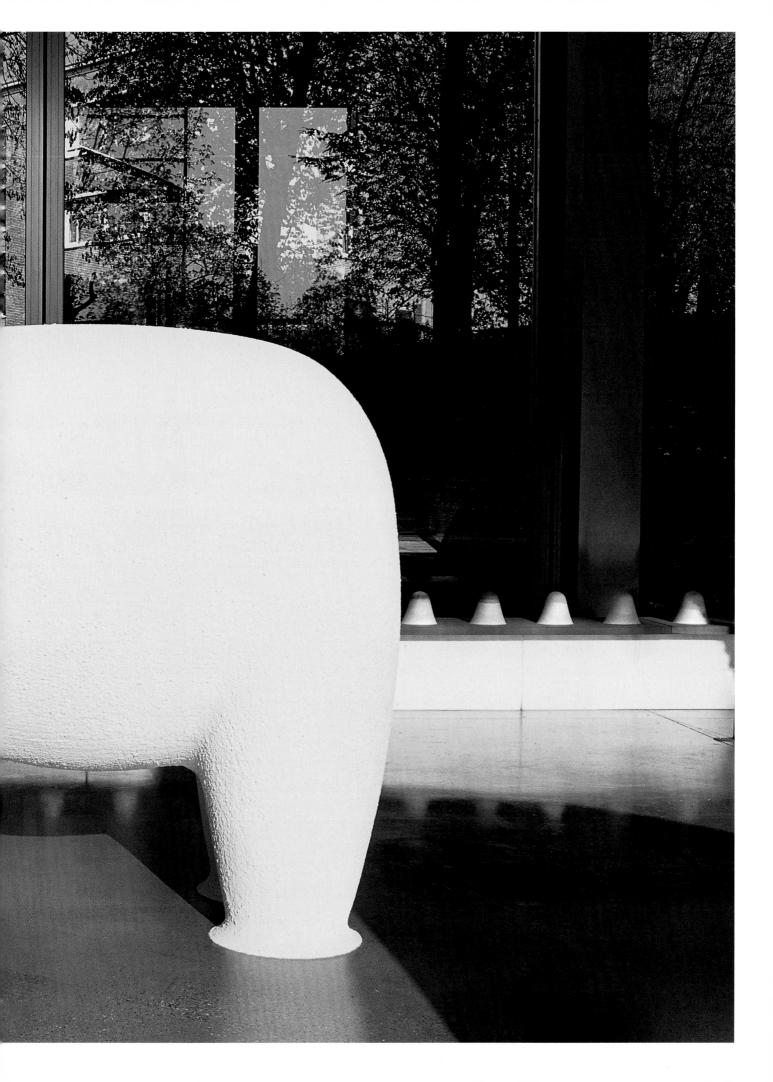

EXHIBITION
MATHEMATICS.
A BEAUTIFUL
ELSEWHERE, 2011–12
Raymond Depardon
and Claudine Nougaret,
Au Bonheur des Maths, 2011

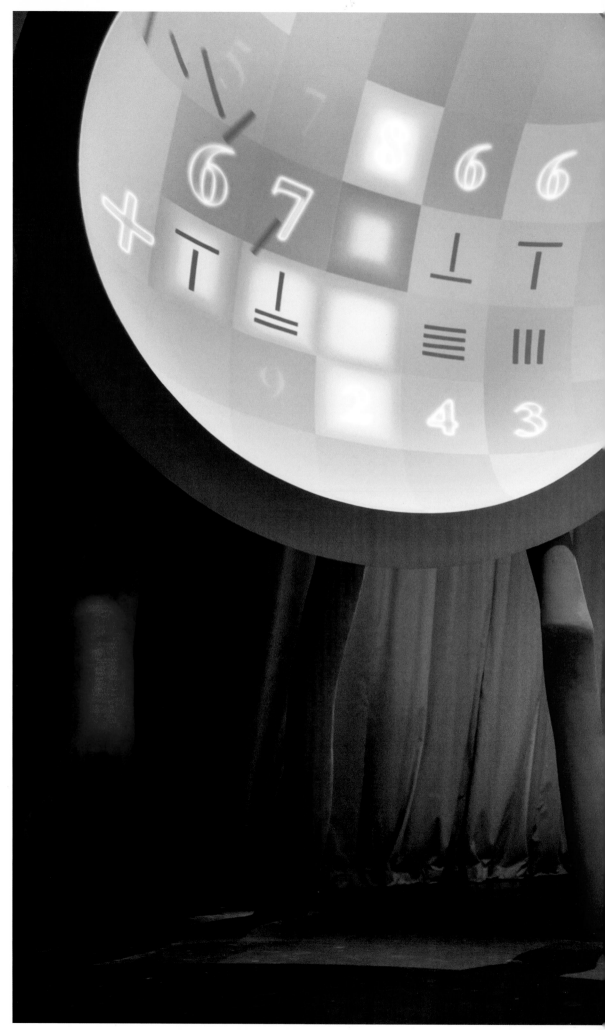

EXHIBITION
MATHEMATICS,
A BEAUTIFUL
ELSEWHERE, 2011–12

Now this is the g...l gr..h which represents ...son, its decay, the production of ...

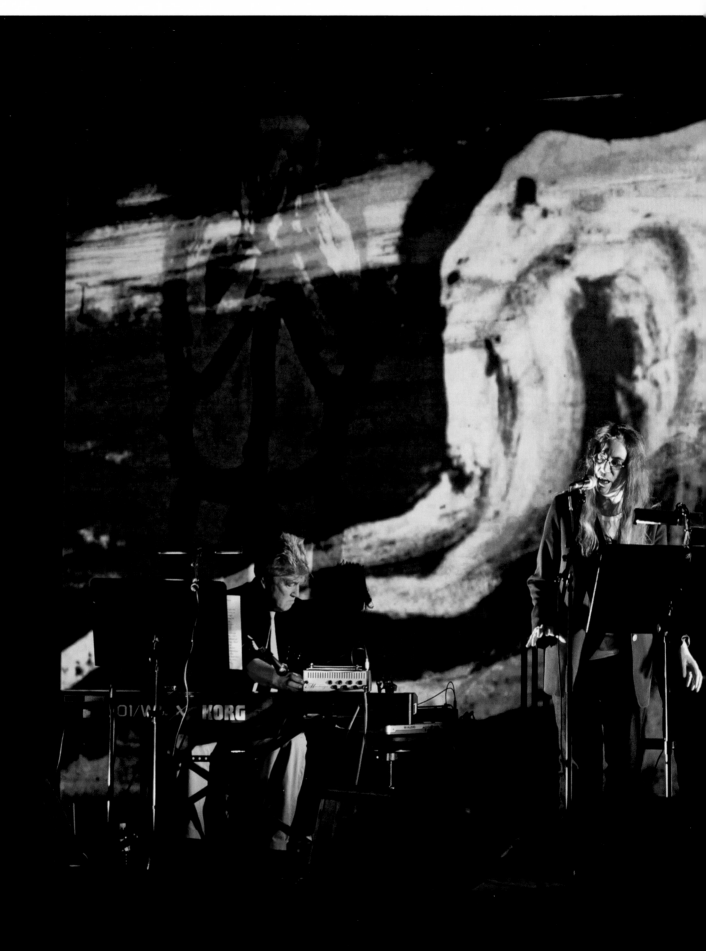

LIVE CONCERT
AND READING
BY PATTI SMITH
AND DAVID LYNCH,
OCTOBER 28, 2011

EXHIDITION
DAVID LYNCH,
THE AIR IS ON FIRE, 2007

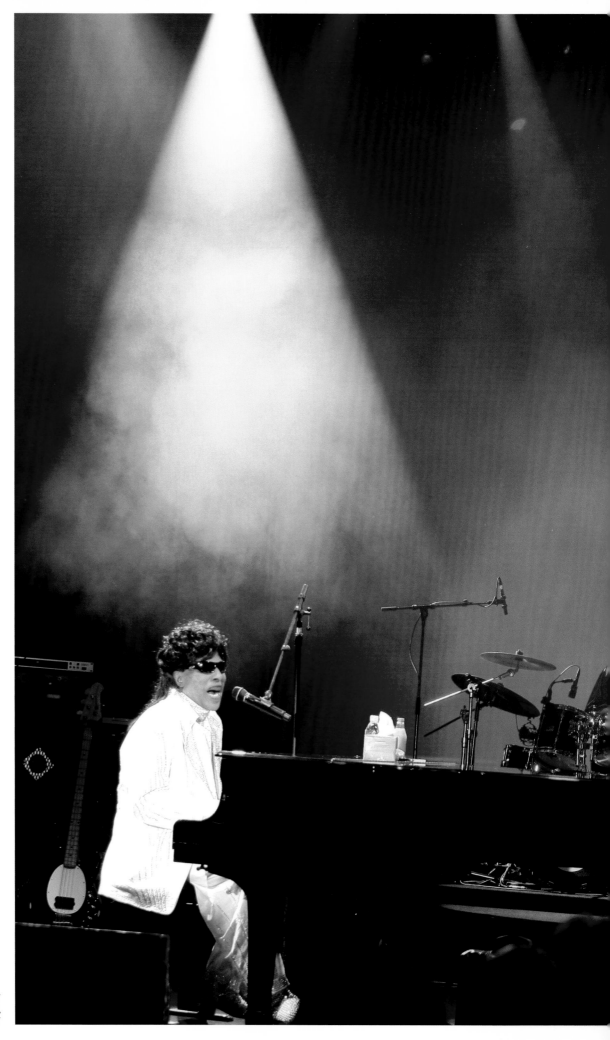

CONCERT BY
LITTLE RICHARD,
JUNE 20, 2007

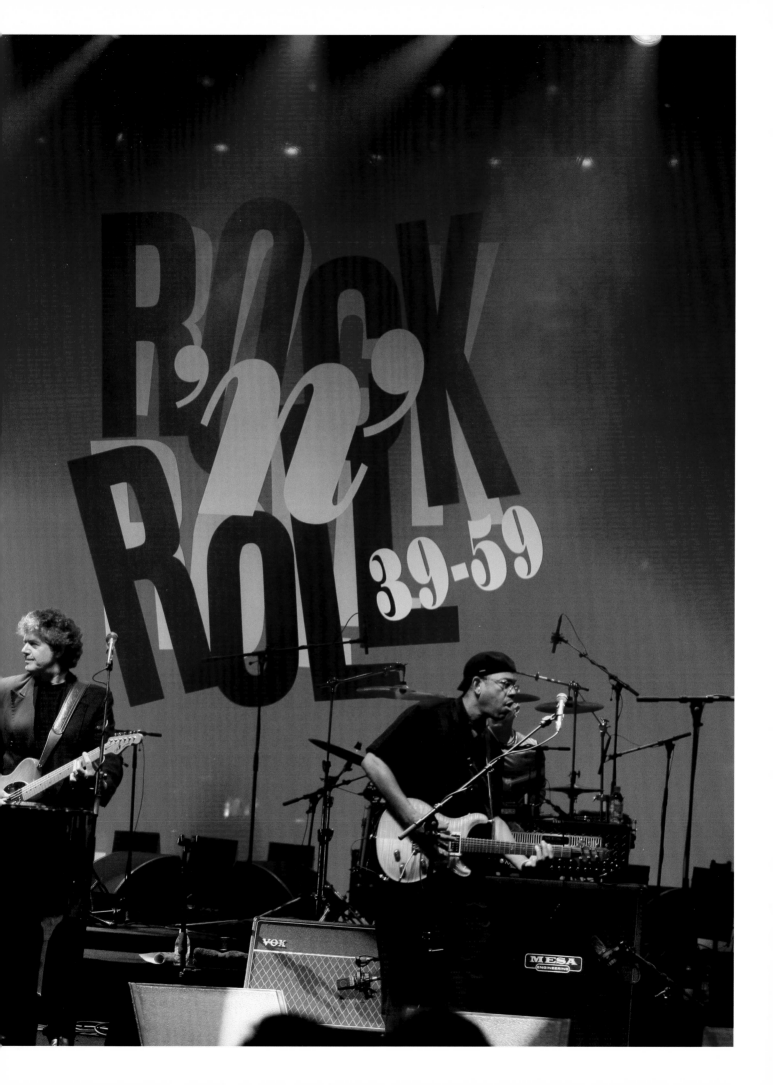

EXHIBITION *BEATRIZ MILHAZES*, 2009

30 YEARS FOR CONTEMPORARY ART 1984–2014

1984

EVENT

OCTOBER 20

Alain Dominique Perrin inaugurates the Fondation
Cartier pour l'art contemporain in Jouy-en-Josas,
in presence of the artist César and Jack Lang,
Minister of Culture and Communication

EXHIBITIONS

OCT. 21, 1984-JAN. 7, 1985
Les Fers de César

Lisa Milroy

Julian Opie

PUBLICATIONS

Les Fers de César

Lisa Milroy

César, *Tiroir*, 1962,
exhibition *Les Fers de César*

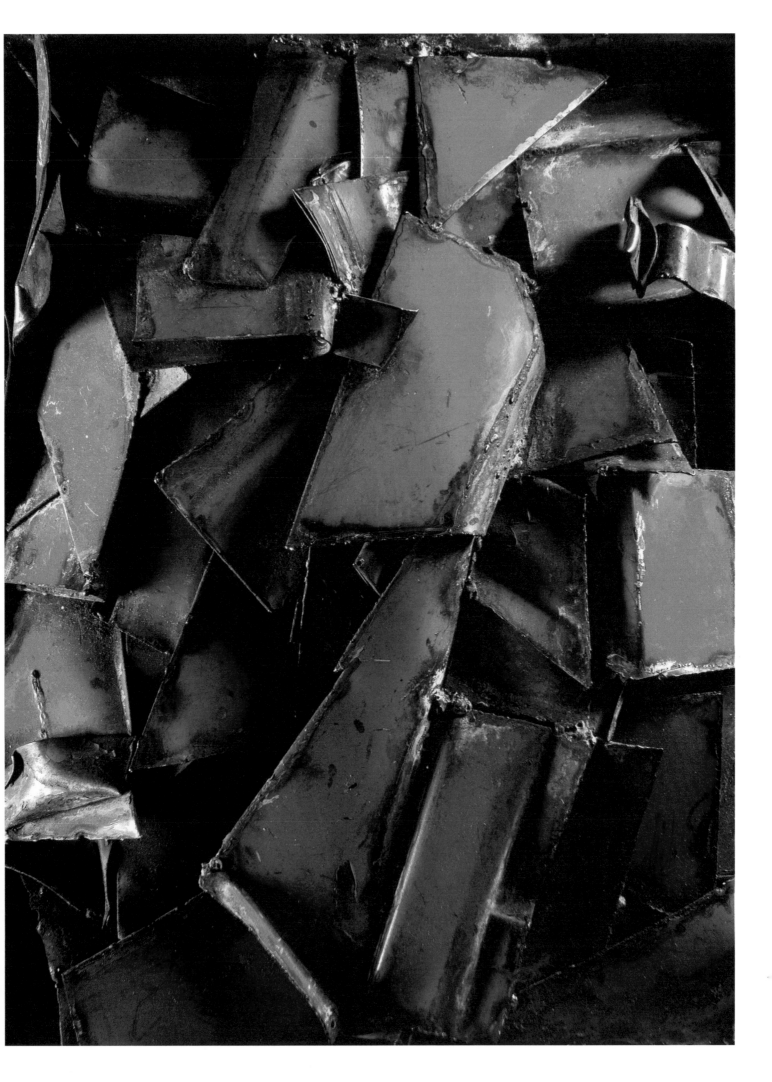

1985

EXHIBITIONS

FEB. 23-APR. 28

Vivre en couleur

With François Bauchet, Yves Cordier, Élisabeth Garouste
and Mattia Bonetti, Pascal Mourgue, Nemo,
Nestor Perkal, Pierre Sala, Philippe Starck, Totem

JUNE 15-SEPT. 1

Natures de rêves

Les Bonsaïs de Rémy Samson

Jean-Pierre Raynaud, *Histoire du Pot*

OCT. 6, 1985-JAN. 5, 1986

*Sculptures, première approche
pour un parc*

Including Arman, Max Bill, César, Barry Flanagan,
François Morellet, Giuseppe Penone,
Jean-Pierre Raynaud, Daniel Spoerri, Richard Tuttle

PUBLICATIONS

Vivre en couleur

Jean-Pierre Raynaud, *Archétypes*

Sculptures, première approche pour un parc

WORKSHOPS: ARTISTS INVITED

Christine Ankaoua, Le Prince Esspé, Sabine Giraud,
Pascal Kern, Alain Lopez, Virginie Mounicot,
Patrick Tosani

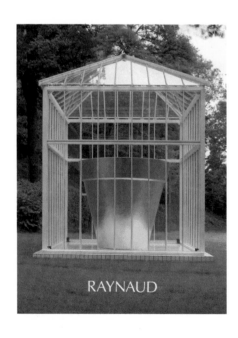

Jean-Pierre Raynaud, *La Serre*, 1985,
park of the Fondation Cartier pour l'art contemporain, Jouy-en-Josas

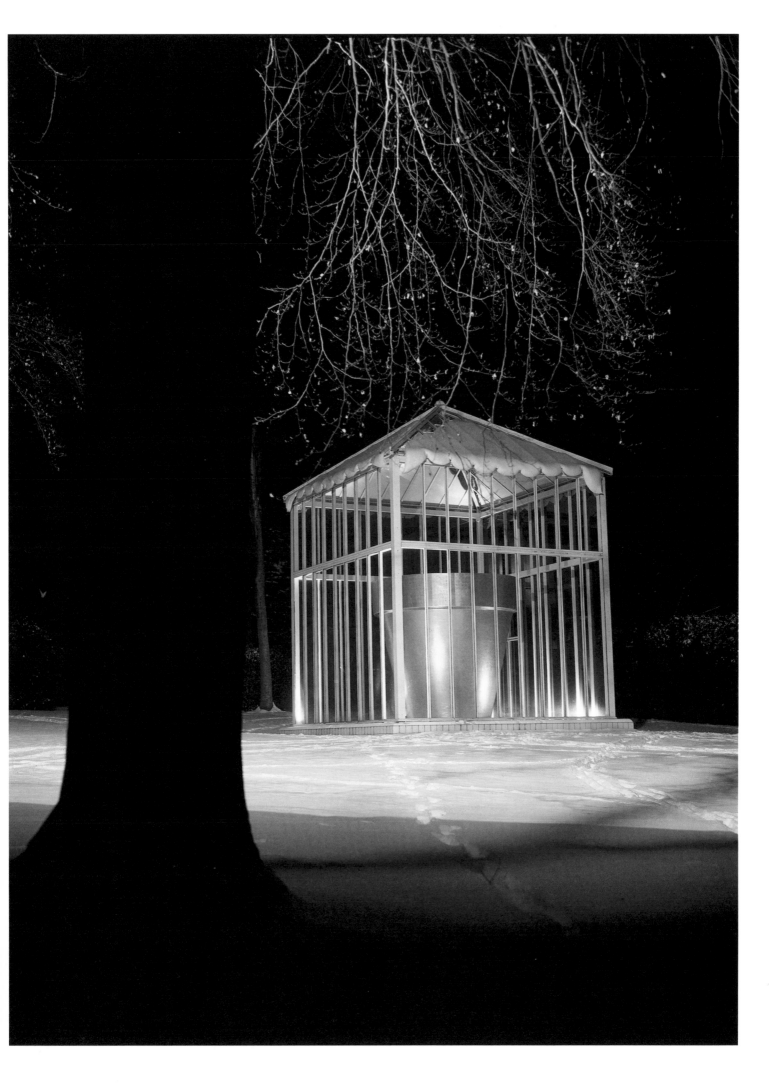

1986

EXHIBITIONS

FEB. 23-MARCH 4

Sur les murs

Including Rémi Blanchard, Philippe Cognée, Robert Combas, Patrick Tosani

L'Art fun ou l'Enfance de l'art

Including Buddy Di Rosa, David Finn, Présence Panchounette, Nicole Stenger

Raymond Hains, Hommage au marquis de Bièvre

JUNE 1-SEPT. 30

Les Années 60 : 1960-1969, La Décade triomphante

Including Sam Francis, Joan Mitchell, Edward Ruscha, Tom Wesselmann

OCT. 9, 1986-JAN. 5, 1987

Peintres et sculpteurs espagnols 1981-1986

Evergon

Les Championnes de César

PUBLICATIONS

Sur les murs, L'Art fun ou l'Enfance de l'art, Ateliers en liberté

Les Années 60 : 1960-1969, La Décade triomphante

Peintres et sculpteurs espagnols 1981-1986

Les Championnes de César

Alain Dominique Perrin, *Mécénat français*

WORKSHOPS: ARTISTS INVITED

Joël Étendard, Laurent Joubert, Carlos Kusnir, Patrick Rétif, Florence Valay

EVENT

Commission of a report on patronage from Alain Dominique Perrin—President of the Fondation Cartier pour l'art contemporain—by François Léotard—Minister of Culture and Communication

André Courrèges with his models, exhibition *Les Années 60 : 1960-1969, La Décade triomphante*

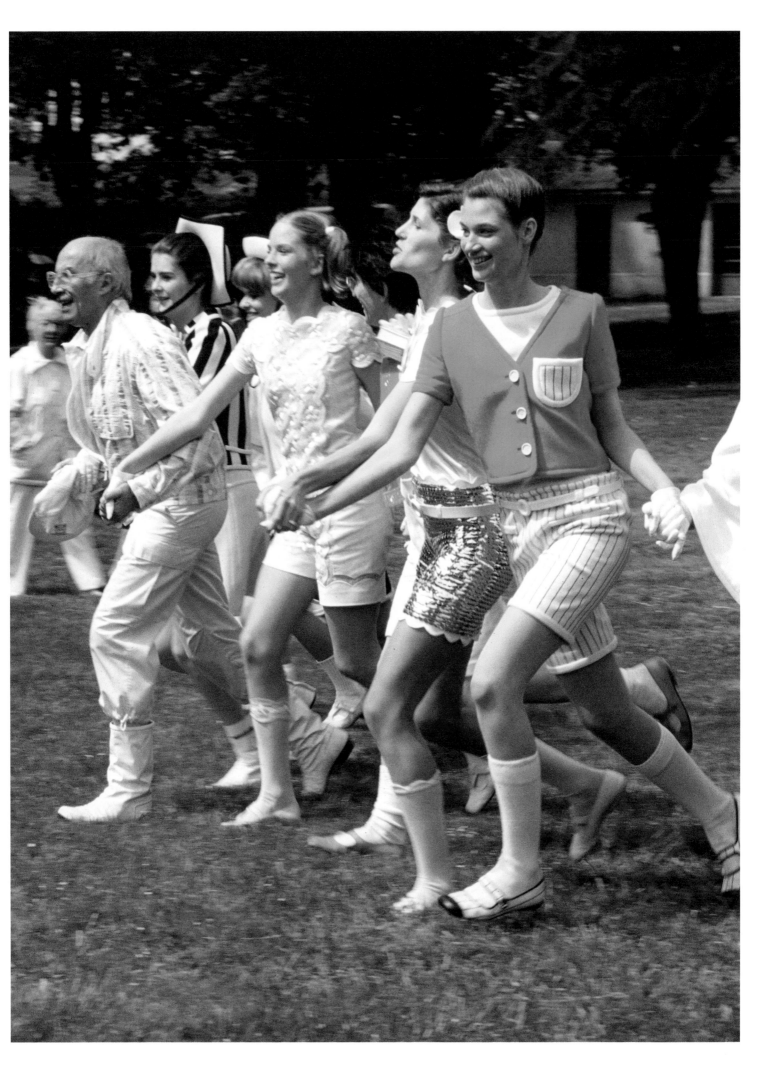

1987

EXHIBITIONS

Dominique Gauthier

François Boisrond

Shirley Jaffe

Les Stars de la photo vues par les éditions Condé Nast

A Tribute to Ferrari

Exhibition design by Andrée Putman

Emmanuel Pereire, Peintures 1983–1987

Ian Hamilton Finlay, Poursuites révolutionnaires

Daniel Boudinet, Un paysage ou Neuf vues du jardin de Ian Hamilton Finlay

PUBLICATIONS

Enzo Ferrari, *Piloti, che gente…*

Emmanuel Pereire

Ian Hamilton Finlay, *Poursuites révolutionnaires*

Daniel Boudinet, *Un paysage ou Neuf vues du jardin de Ian Hamilton Finlay*

WORKSHOPS: ARTISTS INVITED

Jean-Philippe Aubanel, Anne Barbier, Paul Collins, Marc Couturier, Jerome Mazerat, Steven Pollack, Frank Royon Le Mée, Laurent Sauerwein, Vassiliki Tsekoura

EVENT

Publication of the law on cultural patronage, known as the "Loi Léotard"

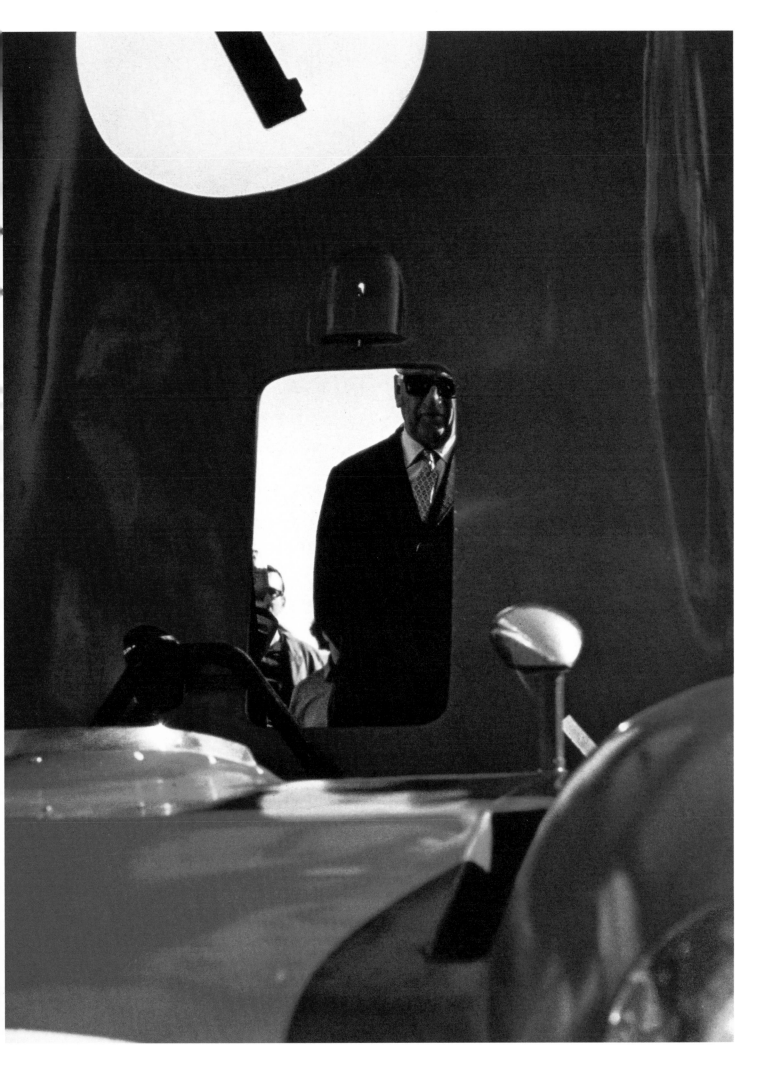

1988

EXHIBITIONS

MARCH 6-APR. 17

Danemark 88 : Robert Jacobsen et Jean Clareboudt. Rencontre de deux générations

17 artistes danois

Alain Bizos, *Portraits*

APR. 24-MAY 22

M.D.F. : Des créateurs pour un matériau

Including François Bauchet, Sylvain Dubuisson, Olivier Gagnère, Éric Jourdan, Pascal Mourgue, Elizabeth de Portzamparc, Andrée Putman, Martin Szekely

JUNE 11-SEPT. 18

Vraiment faux

Exhibition design by Élisabeth Garouste and Mattia Bonetti

OCT. 2-DEC. 18

Gérard Garouste, *Les Indiennes*

La Mode, une nouvelle génération

With Nathalie Cesbron, Maïté Julian, José Lévy, Frédéric Molenac, Pascale Risbourg, Elisabeth Verrimst

OCT. 23-DEC. 18

Scènes de mode : Ouka Lele pour Philippe Model

PUBLICATIONS

Jean Clareboudt, *Question d'espace*

Robert Jacobsen, *Dessins*

Danemark 88 : 17 artistes danois

M.D.F. : Des créateurs pour un matériau

Vraiment faux

Georges Wolinski, *Faux Bijoux*

Gérard Garouste, *Les Palais de la mémoire*

La Mode, une nouvelle génération

Ouka Lele pour Philippe Model

WORKSHOPS: ARTISTS INVITED

Nathalie Cesbron, Laurent Faulon, Maïté Julian, José Lévy, Claire Lucas, François Mendras, Judy Milner, Frédéric Molenac, Osman, Pascale Risbourg, Rudolf Schäfer, Élisabeth Verrimst

INTERNATIONAL PROGRAM

Jochen Gerz, *Une exposition / An Exhibition*, Kunstsammlung Nordrhein-Westfalen, Düsseldorf, Germany

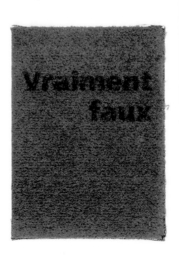

Exhibition Gérard Garouste, *Les Indiennes*

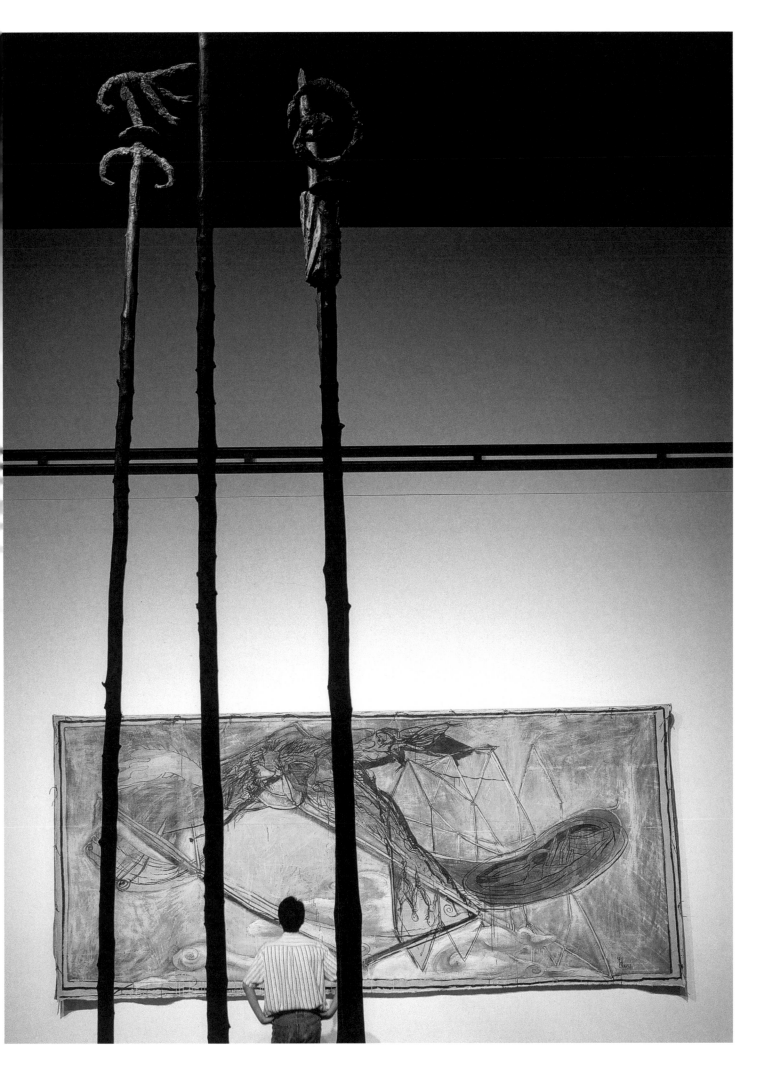

1989

EXHIBITIONS

PUBLICATIONS

Judith Bartolani and Claude Caillol,
Ni rond, ni carré, ni pointu

Ateliers en liberté. Aspects de la jeune sculpture européenne

Jochen Gerz, *Une exposition / An Exhibition*

Nos années 80

WORKSHOPS: ARTISTS INVITED

Élisabeth Ballet, Sylvie Blocher, Jérôme Bost,
Eugenio Cano, Grenville Davey, Alain Diot,
Thomas Grünfeld, Philip Heying, Marin Kasimir,
Simon Levy, Jean-Michel Othoniel, Eve Sonneman,
Ghislaine Vappereau

INTERNATIONAL PROGRAM

Jochen Gerz, *Une exposition / An Exhibition*,
Hamburger Kunsthalle, Hamburg, Germany

EVENT

JUNE 16

Inauguration of César's *Hommage à Eiffel*

Shirley Jaffe, *Sans serre* (detail), 1985,
exhibition *Collection Peinture*

1990

EXHIBITIONS

Apr. 1-May 20
Bill Viola, *The Sleep of Reason*

Lignes de mire – 1

With Absalon, Richard Baquié, Bernard Bazile,
James Coleman, Fischli & Weiss, Philippe Perrin,
Markus Raetz, Thomas Ruff, Alain Séchas,
Hiroshi Sugimoto, Patrick Tosani, James Turrell

June 15-Sept. 9
Andy Warhol System: Pub–Pop–Rock

Success is a Job in New York

The Prints of Andy Warhol

Sur les traces acharnées du Velvet

Oct. 7, 1990-Feb. 24, 1991
Carnet de voyages – 1

Including David Boeno, Massimo Kaufmann,
Klaus Kehrwald

Dec. 11, 1990-Jan. 11, 1991
Monique Frydman, *Éphéméride*

PUBLICATIONS

Bill Viola, *The Sleep of Reason*

Success is a Job in New York

The Prints of Andy Warhol

*Superstars – Guide maniaque du Velvet
Underground et de la Factory d'Andy Warhol*

Carnet de voyages – 1

Monique Frydman, *Éphéméride*

WORKSHOPS: ARTISTS AND CRITICS INVITED

Absalon, David Amico, Nicos Baikas, David Boeno,
Tony Brown, Marie José Burki, François Duconseille,
Rabbie Dumfries, Ling Fei, Wolfgang Georgsdorf,
Huang Yong Ping, Fabrice Hyber, Alain Jacquet,
Marc Leonardo, Alexandre Melo, Richard Monnier,
Hans Ulrich Obrist, Philippe Perrin, Fiona Rae,
David Rees, Michael Reisch, Chéri Samba,
Jérôme Schlomoff, Gaetano Sgambati, Joanna Skipwith,
Pauline Stella Sanchez, Thanassis Totsikas,
Ijsbrand van Veelen

EVENT

June 15

The Velvet Underground on stage, with Lou Reed,
John Cale, Sterling Morrison, Maureen Tucker

**Huang Yong Ping,
park of the Fondation Cartier
pour l'art contemporain, Jouy-en-Josas**

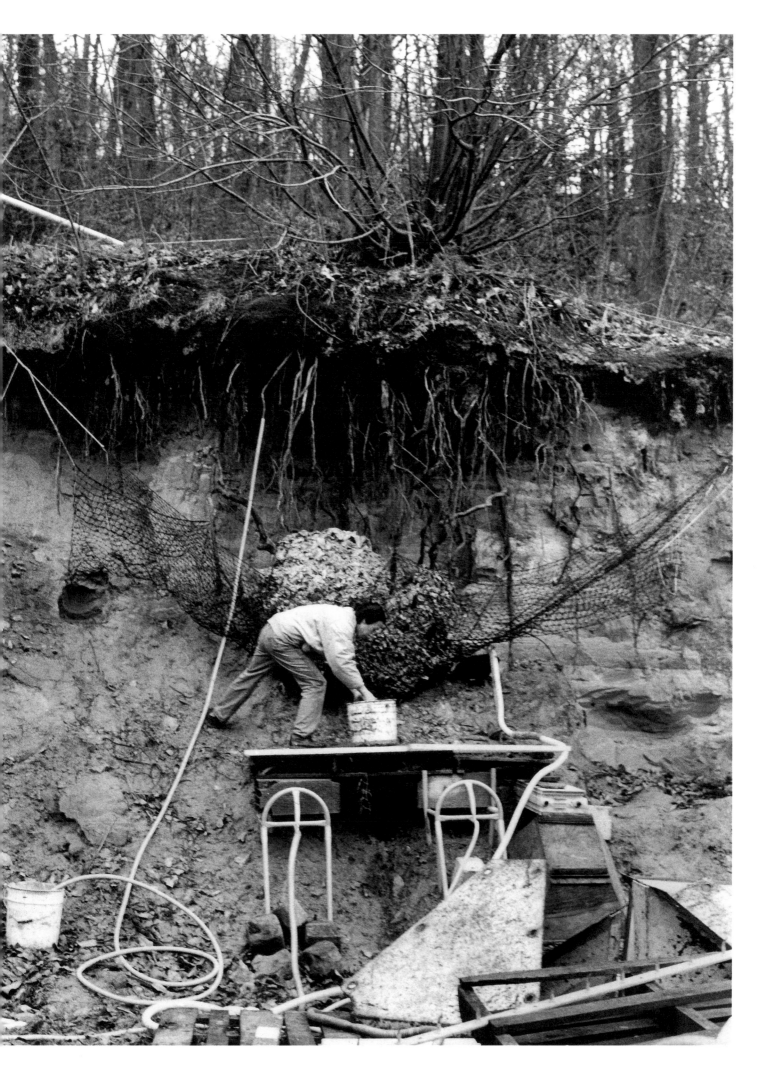

1991

EXHIBITIONS

Richard Baquié, *Constats d'échec*

Lignes de mire – 2

With Jean-Michel Alberola, Nicos Baikas,
Jean-Pierre Bertrand, Ashley Bickerton, David Boeno,
Fischli & Weiss, Toni Grand, Massimo Kaufmann,
Allan McCollum, Moshe Ninio, Beat Streuli, Jeff Wall

JUNE 7-SEPT. 30

La Vitesse

Exhibition design by Kristian Gavoille
Including Bazilebustamante, William Klein,
Étienne-Jules Marey, Edward Ruscha

DEC. 5-23

Jean-Bernard Métais

PUBLICATIONS

Richard Baquié, *Constats d'échec*

La Vitesse

WORKSHOPS: ARTISTS AND CRITICS INVITED

Pep Agut, Alice Aycock, Ute Meta Bauer,
Melanie Counsell, François Curlet, Orshi Drozdik,
François Duconseille, Markus Hansen, Martin Honert,
Massimo Kaufmann, George Lappas, Didier Marcel,
Lisa-Ann Mc Manus, Jean-Bernard Métais, Idit Porat,
Pedro Romero, Franck Scurti, Arno Vriends

INTERNATIONAL PROGRAM

Too French, Hong Kong Museum of Art, Hong Kong
Including César, Gaston Chaissac, Raymond Hains,
Simon Hantaï, Joan Mitchell, Jean-Michel Othoniel,
Bernard Piffaretti

Richard Baquié, *Tout projet commence par une histoire*, 1985,
exhibition Richard Baquié, *Constats d'échec*

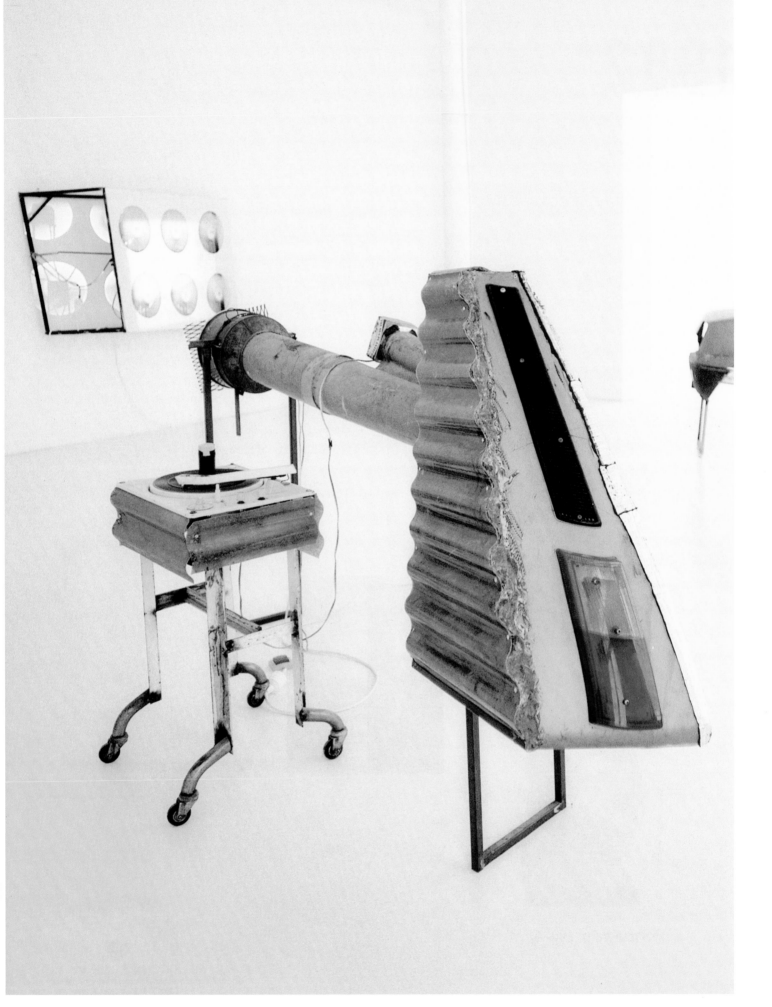

1992

EXHIBITIONS

FEB. 2-APR. 21
Machines d'architecture

JUNE 19-OCT. 4
À visage découvert

Including John Baldessari, Jean-Michel Basquiat, Christian Boltanski, Chuck Close

PUBLICATIONS

Machines d'architecture

À visage découvert

Too French

WORKSHOPS: ARTISTS AND CRITICS INVITED

Louis Brown, Jose Miguel Cortez, Laura Cottingham, Frédéric Coupet, François Curlet, Suzan Etkin, Noritoshi Hirakawa, Emiko Kasahara, Frédérique Lucien, José Maldonado, Stéphanie Marshall, Jorge Molder, Nancy Spector, Beat Streuli, Nahum Tevet, Thomas Wullfen

INTERNATIONAL PROGRAM

Too French, Hara Museum of Contemporary Art, Tokyo, Japan
Including César, Gaston Chaissac, Raymond Hains, Simon Hantaï, Joan Mitchell, Jean-Michel Othoniel, Bernard Piffaretti

EVENT

Donation of César's *The Flying Frenchman* to the city of Hong Kong

Daniel Libeskind, *Intermundium Machine XVIII*, 1988, exhibition *Machines d'architecture*

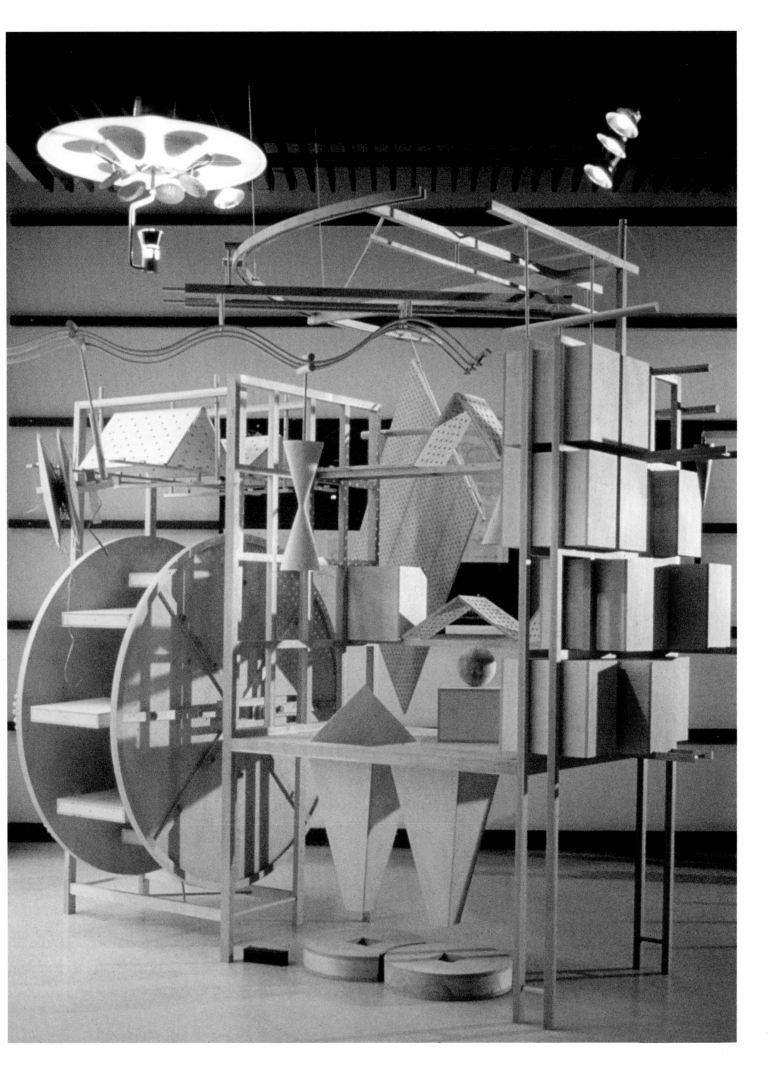

1993

EXHIBITIONS

MARCH 8-APR. 25

Marc Couturier,
Les Dessins du troisième jour

Yasumasa Morimura, *9 visages*

Jeff Wall

MAY 28-SEPT. 12

Azur

Including Frédéric Bruly-Bouabré, James Lee Byars,
Vija Celmins, Cai Guo-Qiang, On Kawara,
Tatsuo Miyajima, James Turrell

PUBLICATIONS

Marc Couturier, *Les Dessins du troisième jour*

Yasumasa Morimura, *9 visages*

Azur

WORKSHOPS: ARTISTS AND CRITICS INVITED

Mary Corse, Fei Dawei, Deborah Drier, Jarg Geismar,
Cai Guo-Qiang, Fariba Hajamadi, Hou Hanru,
Claire-Jeanne Jézéquel, Mark Kremer,
Hiroshi Minamishima, Viktor Misiano,
Tatsuo Miyajima, Lucia Nogueira, Philippe Richard,
Antonella Russo, Lin Yilin

EVENT

Donation of Christian Boltanski's *The Reserve of Dead Swiss* to the Tate Modern, London, United Kingdom

JUNE 23

A tribute to Joan Mitchell

James Turrell, *Skeet,* **1990,
exhibition** *Azur*

1994

EVENT

May 10-11

Inauguration of the new building of the Fondation Cartier pour l'art contemporain designed by architect Jean Nouvel, and of the garden created by artist Lothar Baumgarten (*Theatrum Botanicum*), at 261 Boulevard Raspail in Paris

EXHIBITIONS

May 11-Sept. 4

Ron Arad

Richard Artschwager

May 11-June 12

Pierrick Sorin

June 17-July 17

Carole Benzaken

July 29-Sept. 4

Matej Kren, *Histoire de l'art*

Huang Yong Ping, *Devons-nous encore construire une grande cathédrale ?*

Chuck Close, *8 peintures récentes*

Sept. 24, 1994-Feb. 19, 1995

Raymond Hains, *Les 3 Cartier. Du Grand Louvre aux 3 Cartier*

Oct. 28- Nov. 27

Seydou Keita

Dec. 2, 1994-Jan. 15, 1995

Shinzo and Roso Fukuhara, *Photographies 1913-1941*

PUBLICATIONS

Richard Artschwager

Pierrick Sorin, *Avant la bataille*

Carole Benzaken

Raymond Hains, *Les 3 Cartier. Du Grand Louvre aux 3 Cartier*

Seydou Keita

Shinzo and Roso Fukuhara, *Photographies 1913-1941*

NOMADIC NIGHTS

Including Marco Berrettini, Éric Duyckaerts, Esther Ferrer, Grand Magasin, Steve Lacy, Xavier Le Roy, Stuart Sherman

INTERNATIONAL PROGRAM

Fondation Cartier: A Collection, The National Museum of Contemporary Art, Seoul, South Korea

Seydou Keita

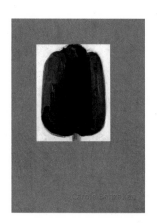

Chuck Close 8 peintures récentes

Exhibition *Ron Arad*

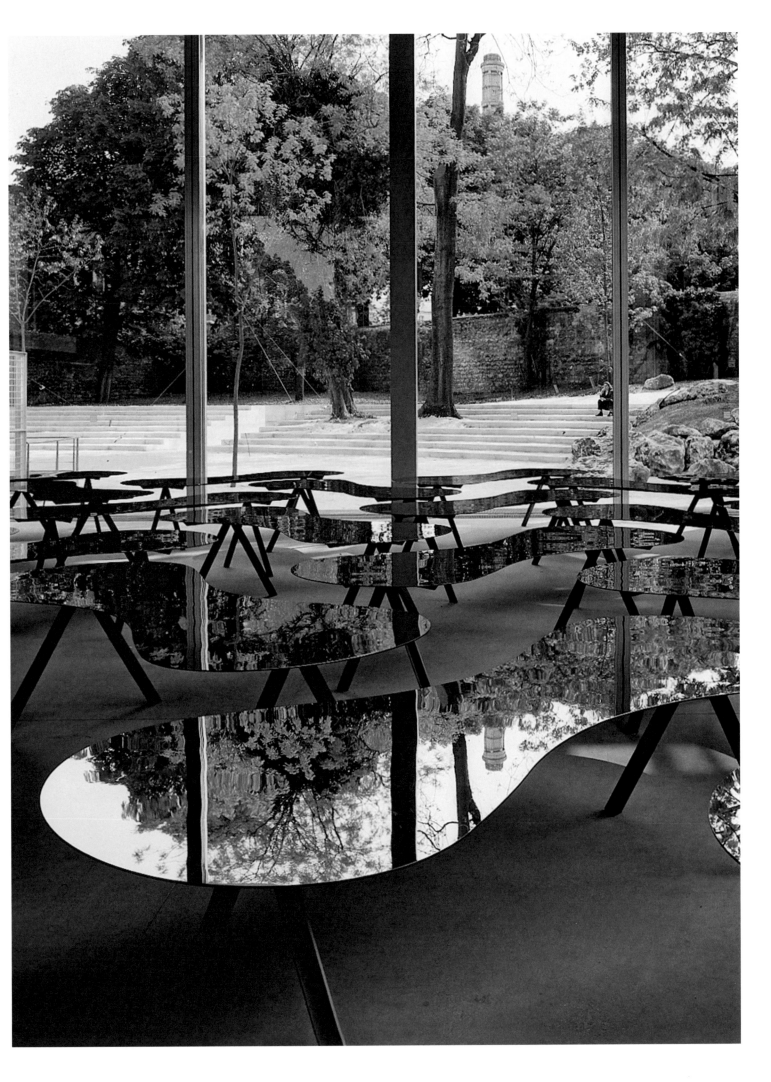

1995

EXHIBITIONS

JAN. 20-FEB. 19

Herbert Zangs, *Œuvres 1952–1959*

MARCH 3-APR. 16

Jean-Michel Alberola, *L'Effondrement des enseignes lumineuses*

Marc Newson, *Bucky, de la chimie au design*

Matthew Barney, *Cremaster 4*

APR. 30-JUNE 11

Nobuyoshi Araki, *Journal intime, 1994*

Malick Sidibé

Jérôme Deschamps and Macha Makeïeff, *Vestiaire (et Défilé)*

JUNE 22-SEPT. 10

Tom Wesselmann

Bodys Isek Kingelez

Jean Tinguely, *Tombeau de kamikaze*

SEPT. 28-DEC. 10

James Lee Byars, *The Monument to Language* and *The Diamond Floor*

Thierry Kuntzel, *Nostos III*

Vija Celmins

PUBLICATIONS

Herbert Zangs, *Œuvres 1952–1959*

Jean-Michel Alberola, *L'Effondrement des enseignes lumineuses*

Matthew Barney, *Cremaster 4*

Nobuyoshi Araki à la Fondation Cartier pour l'art contemporain

Malick Sidibé, *Bamako 1962-1976*

Bodys Isek Kingelez

James Lee Byars

Vija Celmins

NOMADIC NIGHTS

Including the Balanescu Quartet, Matthew Barney, James Lee Byars, Patrick Corillon, Jérôme Deschamps and Macha Makeïeff, Jean-Michel Othoniel, Philippe Sollers

INTERNATIONAL PROGRAM

Fondation Cartier: A Collection, Taipei Fine Arts Museum, Taipei, Taiwan

Seydou Keita, Kunsthalle Taidehalli, Helsinki, Finland

Marc Couturier, Toji Temple, Kyoto, Japan

Bodys Isek Kingelez at the Fondation Cartier pour l'art contemporain, exposition *Bodys Isek Kingelez*

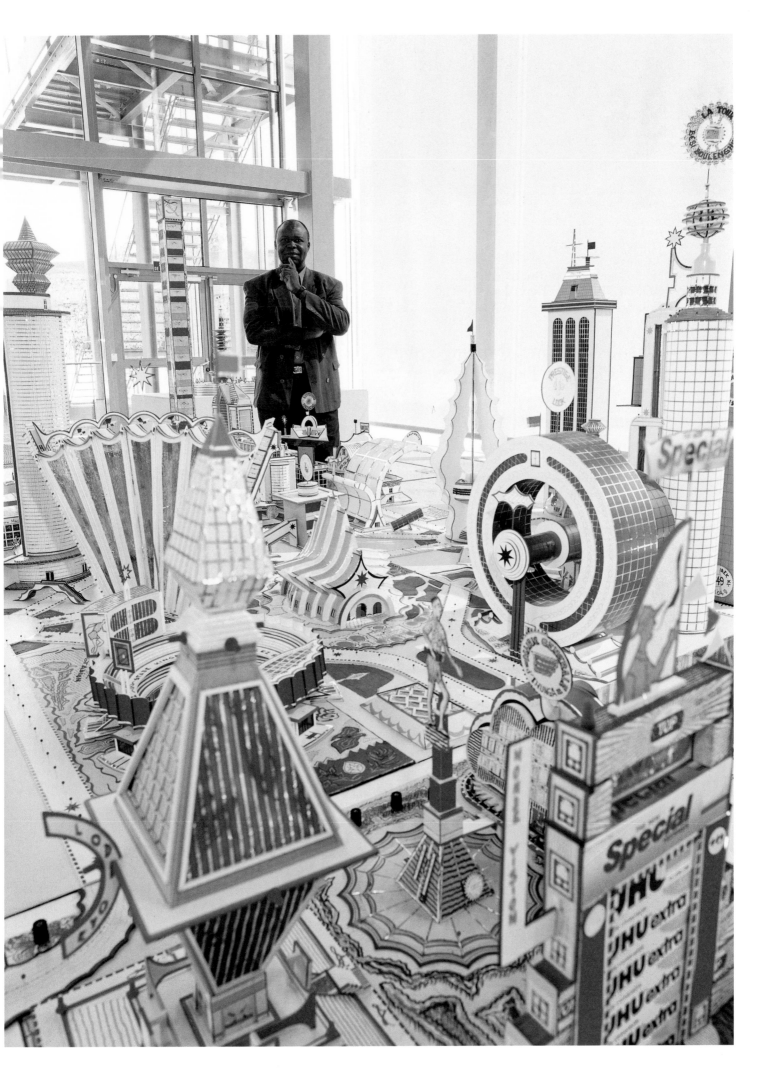

1996

EXHIBITIONS

Feb. 2-May 19

By Night

Exhibition design by Bruno Moinard
Including Raymond Depardon, Nan Goldin,
Douglas Gordon, Hergé, Wolfgang Tillmans, Bill Viola

Apr. 12-May 19

Tatsuo Miyajima, *Running Time (U-CAR)* and *Time Go Round*

June 19-Oct. 13

Comme un oiseau

Exhibition design by Bruno Moinard
Including Jean-Jacques Audubon, Georg Baselitz,
Balthasar Burkhard, Merce Cunningham, Robert Frank,
David Hammons, Claude Lévi-Strauss, Annette Messager,
Panamarenko

Nov. 1, 1996-March 16, 1997

Double vie, Double vue

Including Diane Arbus, Roger Ballen, Lee Friedlander,
Rebecca Horn, Seydou Keita, Felten Massinger,
Helmut Newton, Martial Raysse, Cindy Sherman

PUBLICATIONS

By Night

Comme un oiseau

Double vie, Double vue

NOMADIC NIGHTS

Including Matthew Barney, Boris Charmatz,
Pascal Comelade, Dominique A, Raymond Hains
and Michel Onfray, Emmanuelle Huynh, Joëlle Léandre
and Pascal Contet, Tatsuo Miyajima, Ryuichi Sakamoto

INTERNATIONAL PROGRAM

Exhibition of Jean-Pierre Raynaud's *Le Pot doré*
at Daimler-Benz, Potsdamer Platz, Berlin,
and then at The Forbidden City, Hall of Supreme
Harmony, Beijing

James Lee Byars, *The Monument to Language,*
The Henry Moore Institute, Leeds, United Kingdom

Seydou Keita, Houston Fotofest, Houston, Texas,
United States/Minneapolis Institute of Arts,
Minneapolis, Minnesota, United States

EVENT

September 27

Amour by James Lee Byars (performance)

Jean-Pierre Raynaud in front of *La Volière,*
exhibition *Comme un oiseau*

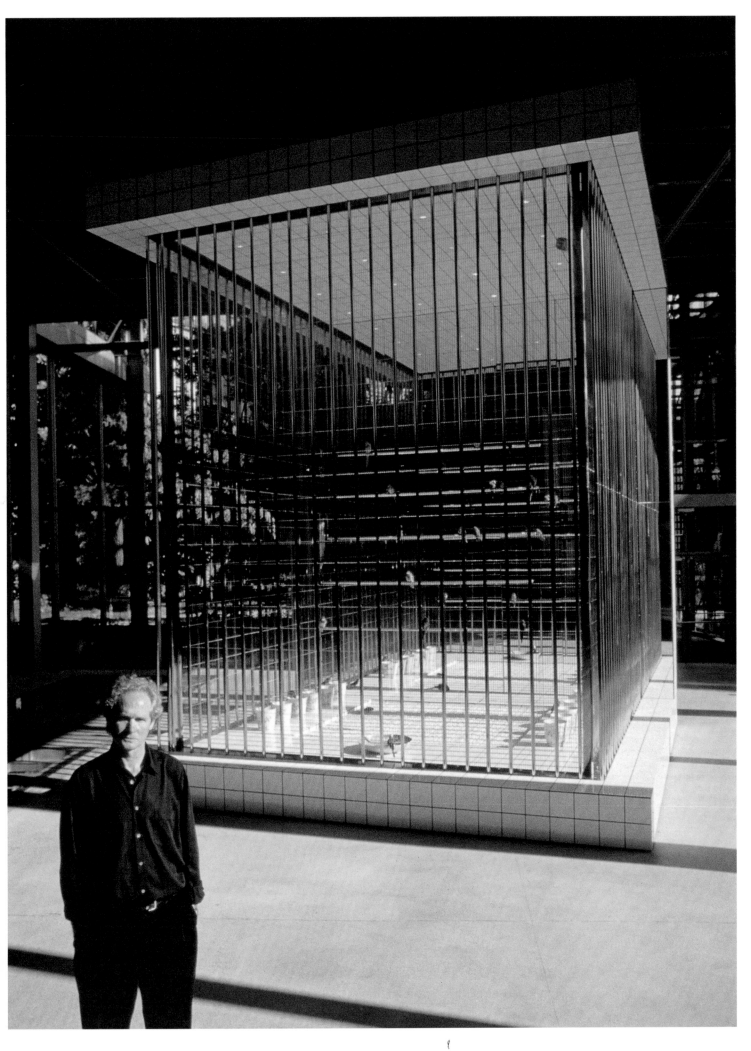

1997

EXHIBITIONS

Jan. 10-March 16

Patrick Vilaire, *Réflexion sur la mort*

Huang Yong Ping, *Péril de mouton*

Apr. 4-May 18

Alain Séchas

Alain Diot

Coïncidences

Including Pierre Bismuth, Pierre Huyghe, Xavier Veilhan

June 5-Nov. 2

Amours

Exhibition design by Bruno Moinard
Including Olivier Assayas, Claire Denis,
Raymond Depardon, Thierry Kuntzel,
Ana Mendieta, Francesca Woodman

PUBLICATIONS

Patrick Vilaire, *Réflexion sur la mort*

Coïncidences

Amours

Anne Bertrand, *Quelques motifs de déclaration*

*La Collection de la Fondation Cartier
pour l'art contemporain*

NOMADIC NIGHTS

Including the Bal Moderne, John Baldessari,
the Ballets C de la B, Pierre Bastien and Pierrick Sorin,
DJ Cam, the Gavin Bryars Ensemble, Pierre Henry,
Ingo Maurer, Rachid Ouramdane, Charlemagne Palestine

INTERNATIONAL PROGRAM

Seydou Keita, San Francisco Museum of Modern Art,
San Francisco, California, United States/Pinacoteca do
Estado de São Paulo, Brazil

Exhibition Huang Yong Ping, *Péril de mouton*

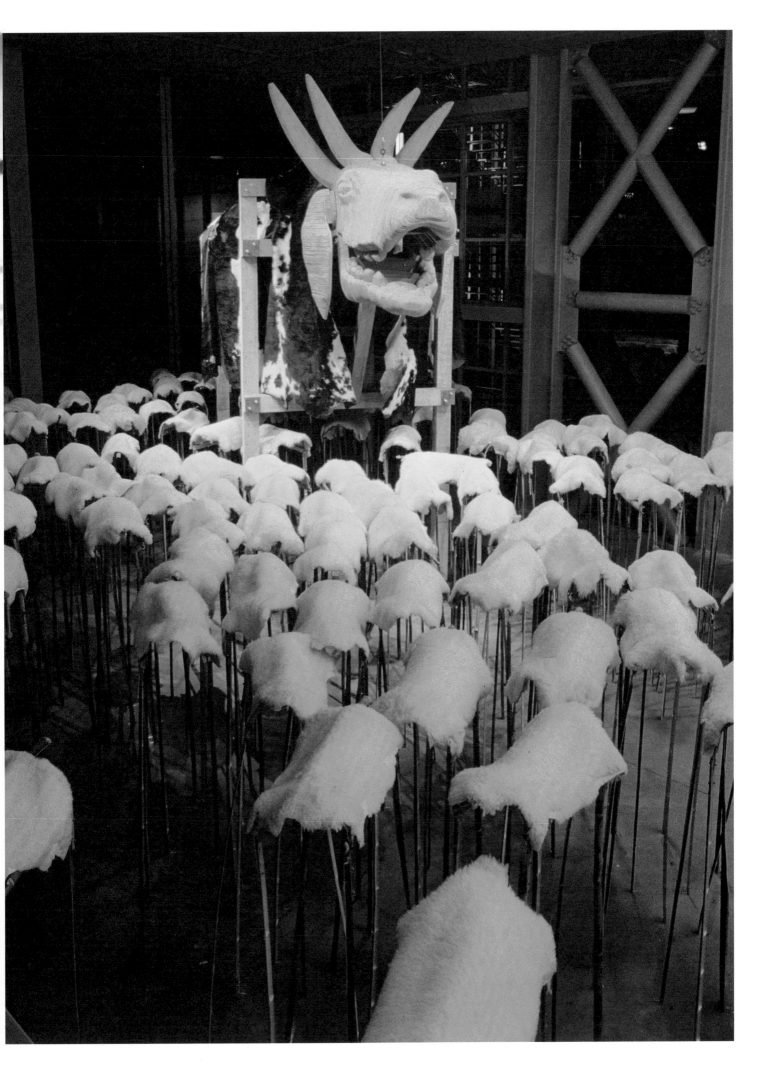

1998

EXHIBITIONS

APR. 11-MAY 31

Gérard Deschamps, *Homo Accessoirus*

Panamarenko, *La Grande Exposition des soucoupes volantes*

Francesca Woodman

JUNE 17-SEPT. 20

Être nature

Including Patrick Blanc, Vija Celmins, Hubert Duprat, David Hammons, Ana Mendieta, Yukio Nakagawa, Tunga and Jacques Kerchache's collection of insects

OCT. 13, 1998-FEB. 28, 1999

Issey Miyake Making Things

PUBLICATIONS

Gérard Deschamps, *Homo Accessoirus*

Panamarenko, *La Grande Exposition des soucoupes volantes*

Francesca Woodman

Être nature

Issey Miyake Making Things

Jacques Kerchache, *Nature démiurge, insectes*

Jean-Pierre Raynaud, *Un jardinier dans la ville*

NOMADIC NIGHTS

Including Charles Atlas, Vanessa Beecroft and Doug Aitken, Myriam Gourfink, Matthew Herbert, Tom Johnson, Sam Samore, Yann Tiersen, Loïc Touzé

INTERNATIONAL PROGRAM

The Collection of the Fondation Cartier pour l'art contemporain, Fundació Joan Miró, Barcelona, Spain

Regards croisés : Raymond Depardon/Seydou Keita, Demirdjian Center, Beirut, Lebanon

Francesca Woodman, Kunsthal Rotterdam, Netherlands

EVENT

Donation of Jean-Pierre Raynaud's *Le Pot doré* to the Centre Pompidou, Paris

Francesca Woodman, *Space²*, Providence, Rhode Island, 1975–78 exhibition *Francesca Woodman*

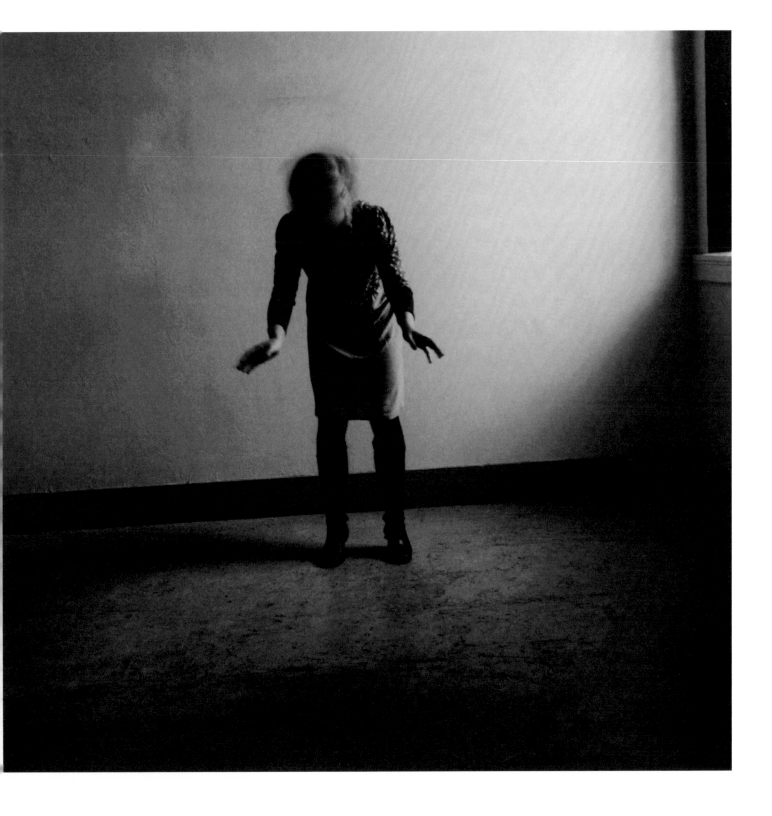

1999

EXHIBITIONS

MARCH 1-MAY 1
Beaurin Domercq

APR. 2-MAY 31
Gottfried Honegger, *Métamorphose*

Radi Designers, *Fabulation*

Stan Douglas, *Pursuit, Fear, Catastrophe: Ruskin B.C.*

JUNE 30-NOV. 14
Un monde réel

Including Jean-Michel Alberola, Chris Burden, Tacita Dean, Diller + Scofidio, Bodys Isek Kingelez, Mœbius, Mikhail Romadin, Andrei Ujica

DEC. 11, 1999-MARCH 12, 2000
Herb Ritts

Sarah Sze

PUBLICATIONS

Beaurin Domercq

Gottfried Honegger, *Métamorphose*

Radi Designers, *Réalité fabriquée*

Un monde réel

Robots

Mœbius, *Une jeunesse heureuse*

Herb Ritts

Sarah Sze

NOMADIC NIGHTS

Including William Forsythe, John Giorno, Gob Squad, Raymond Hains, Mouse on Mars, Pan Sonic, La Ribot, Claudia Triozzi

INTERNATIONAL PROGRAM

The Collection of the Fondation Cartier pour l'art contemporain, Centro Cultural de Belém, Lisbon, Portugal/Centro d'Arte Contemporanea, Palazzo delle Papesse, Siena, Italia

Francesca Woodman, Centro Cultural Tecla Sala, L'Hospitalet, Barcelona, Spain/ The Photographers' Gallery, London, United Kingdom

Issey Miyake Making Things, Ace Gallery, New York, United States

Exhibition *Sarah Sze*

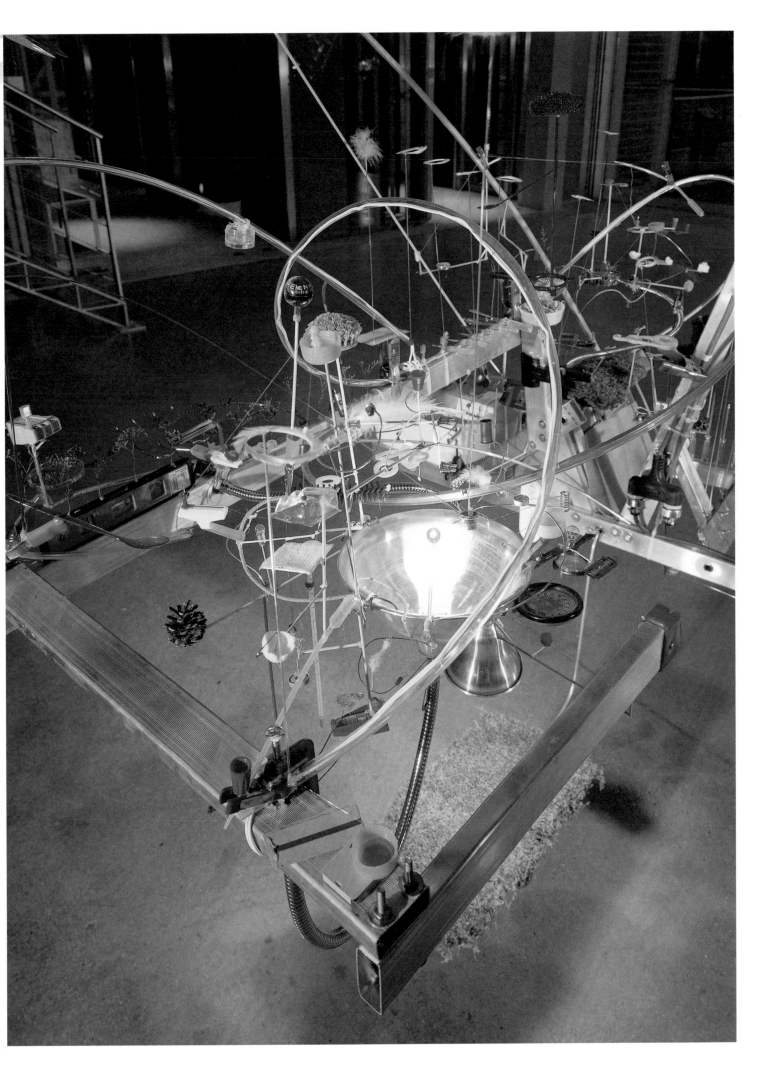

2000

EXHIBITIONS

APR. 5-MAY 28

Cai Guo-Qiang

Guillermo Kuitca, *Œuvres récentes*

J.D. 'Okhai Ojeikere

JUNE 21-NOV. 5

The Desert

Including William Eggleston, Lee Friedlander,
Sir Wilfred Thesiger, Andrei Ujica

NOV. 24, 2000-FEB. 4, 2001

Thomas Demand

Bernard Piffaretti, *Va-et-vient,
Come and Go*

PUBLICATIONS

Cai Guo-Qiang

Guillermo Kuitca

J.D. 'Okhai Ojeikere, *Photographs*

The Desert

Raymond Depardon, Titouan Lamazou, *Rêve de déserts*

Thomas Demand

Bernard Piffaretti, *Va-et-vient, Come and Go*

NOMADIC NIGHTS

Including 4 Walls, Pierre Alferi and Rodolphe Burger,
Ambitronix, Glen Baxter, Valérie Belin, the Compagnie
Lubat de Gasconha, Bernard Heidsieck, Gary Hill,
Fabrice Hyber, Gilles Jobin, Sylvain Prunenec

William Eggleston,
Deserts of California, Arizona and Utah series, 2000,
exhibition *The Desert*

2001

EXHIBITIONS

March 15-June 3

Pierrick Sorin,
261 Bd Raspail, Paris XIV
Alair Gomes

June 21-Nov. 4

Un art populaire

Including Arthur Bispo do Rosàrio,
Mike Kelley, Liza Lou, Alessandro Mendini,
Moke, Takashi Murakami, Virgil Ortiz,
Artavazd Achotowitch Pelechian

Nov. 20, 2001-Feb. 24, 2002

William Eggleston
Gérard Garouste, *Ellipse*

PUBLICATIONS

Pierrick Sorin, *261 Bd Raspail, Paris XIV*

Alair Gomes

Un art populaire

William Eggleston

Gérard Garouste, *Ellipse*

NOMADIC NIGHTS

Including Blixa Bargeld, Eugene Chadbourne
and Jimmy Carl Black, Chicks on Speed, Cuqui Jerez,
Miss Kittin, Valérie Mréjen, Orlan, Peaches
and Gonzales, Jacques Roubaud

INTERNATIONAL PROGRAM

El Desierto, Fundació la Caixa, Barcelona, Spain

Bernard Piffaretti, Sara Hildén Museum, Tampere,
Finland

Herb Ritts, Nrw-forum, Düsseldorf, Germany

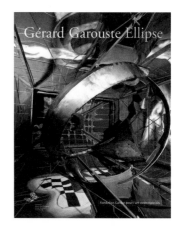
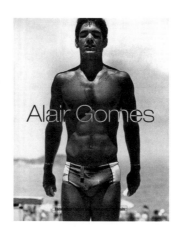
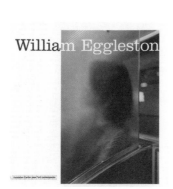

Pierrick Sorin, *L'Homme qui a perdu ses clefs*, 1999,
exhibition Pierrick Sorin, *261 Bd Raspail, Paris XIV*

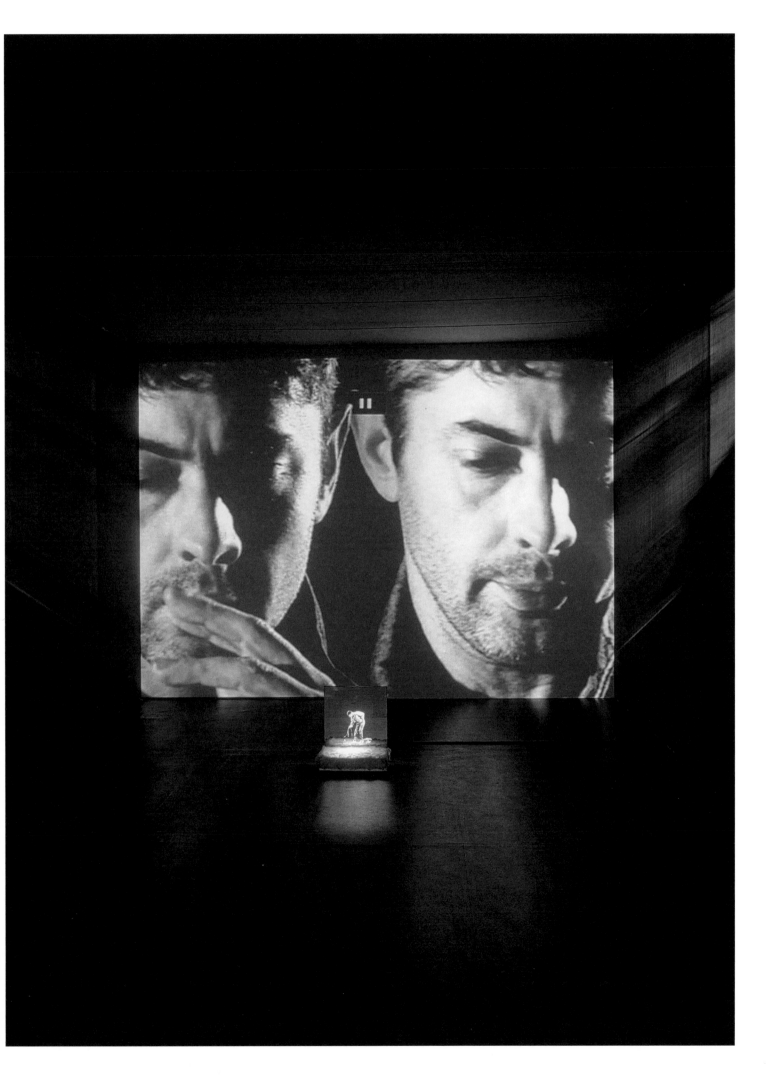

2002

EXHIBITIONS

MARCH 28-JUNE 9
Alessandro Mendini, Vincent Beaurin, Fabrice Domercq, *Fragilisme*

JUNE 27-OCT. 27
Takashi Murakami, *Kaikai Kiki* and *Coloriage*

NOV. 29, 2002-MARCH 30, 2003
Paul Virilio, *Unknown Quantity*

Including Peter Hutton, Jonas Mekas, Aernout Mik, Artavazd Achotowitch Pelechian, Nancy Rubins, Andrei Ujica, Lebbeus Woods

PUBLICATIONS

Alessandro Mendini, Vincent Beaurin, Fabrice Domercq, *Fragilisme*

Takashi Murakami, *Kaikai Kiki*

Paul Virilio, *Unknown Quantity*

NOMADIC NIGHTS

Including Georges Aperghis, Atlas Group and Walid Raad, Boredoms, Simone Forti, Fred Frith, Meredith Monk, Suicide, Gaspard Yurkievich

INTERNATIONAL PROGRAM

William Eggleston, Hayward Gallery, London, United Kingdom

Pierrick Sorin, Avinguda Marquès de Commillas, 6-8, 08038 Barcelona, Fundació la Caixa, Barcelona, Spain

Takashi Murakami, *Kaikai Kiki*, Serpentine Gallery, London, United Kingdom

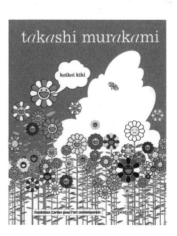

Paul Virilio in front of *La Chute* created by Lebbeus Woods, exhibition *Unknown Quantity*

2003

EXHIBITIONS

MAY 14-OCT. 12

Yanomami, Spirit of the Forest

Including Bruce Albert, Claudia Andujar,
Vincent Beaurin, Raymond Depardon, Gary Hill,
Davi Kopenawa Yanomami, Adriana Varejão,
Volkmar Ziegler

OCT. 31, 2003-JAN. 11, 2004

Daido Moriyama

Jean-Michel Othoniel, *Crystal Palace*

PUBLICATIONS

Yanomami, Spirit of the Forest

Jean-Michel Othoniel, *Crystal Palace*

Daido Moriyama

NOMADIC NIGHTS

Including Black Dice, Boris Charmatz,
Décosterd & Rahm, Tim Etchells and Matthew Goulish,
Rebecca Horn, Philippe Katerine, Christian Rizzo,
Paul Virilio and Michel Cassé, Stephen Vitiello
and Scanner

Jean-Michel Othoniel, *L'Unicorne*, 2003,
exhibition Jean-Michel Othoniel, *Crystal Palace*

2004

EXHIBITIONS

Jan. 24-May 2

Marc Newson, *Kelvin 40*

J'aime Chéri Samba

June 6-Oct. 10

Pain Couture by Jean Paul Gaultier

Nov. 13, 2004-Feb. 6, 2005

Raymond Depardon,
7x3, An Exhibition of Films

Hiroshi Sugimoto,
Étant donné : Le Grand Verre

PUBLICATIONS

Marc Newson, *Kelvin 40*

J'aime Chéri Samba

Pain Couture by Jean Paul Gaultier

Raymond Depardon, *7x3, An Exhibition of Films*

Hiroshi Sugimoto, *Conceptual forms*

20 Years of the Fondation Cartier pour l'art contemporain

NOMADIC NIGHTS

Including Patricia Allio, Animal Collective, Antony and the Johnsons and CocoRosie, Kevin Blechdom, Forced Entertainment, Maurizio Galante, Susan Howe and David Grubbs with Dominique Fourcade, Faustin Linyekula, NLF3, Zeena Parkins and Kaffe Matthews, Genesis P-Orridge

INTERNATIONAL PROGRAM

Jean-Michel Othoniel, *Crystal Palace*, Museum of Contemporary Art, Miami, Florida, United States

Yanomami, Spirit of the Forest, Centro Cultural Banco do Brasil, Rio de Janeiro, Brazil

Marc Newson, *Kelvin 40*, Groninger Museum, Groningen, Netherlands/Design Museum, London, United Kingdom

Chéri Samba
at the Fondation Cartier pour l'art contemporain,
exhibition *J'aime Chéri Samba*

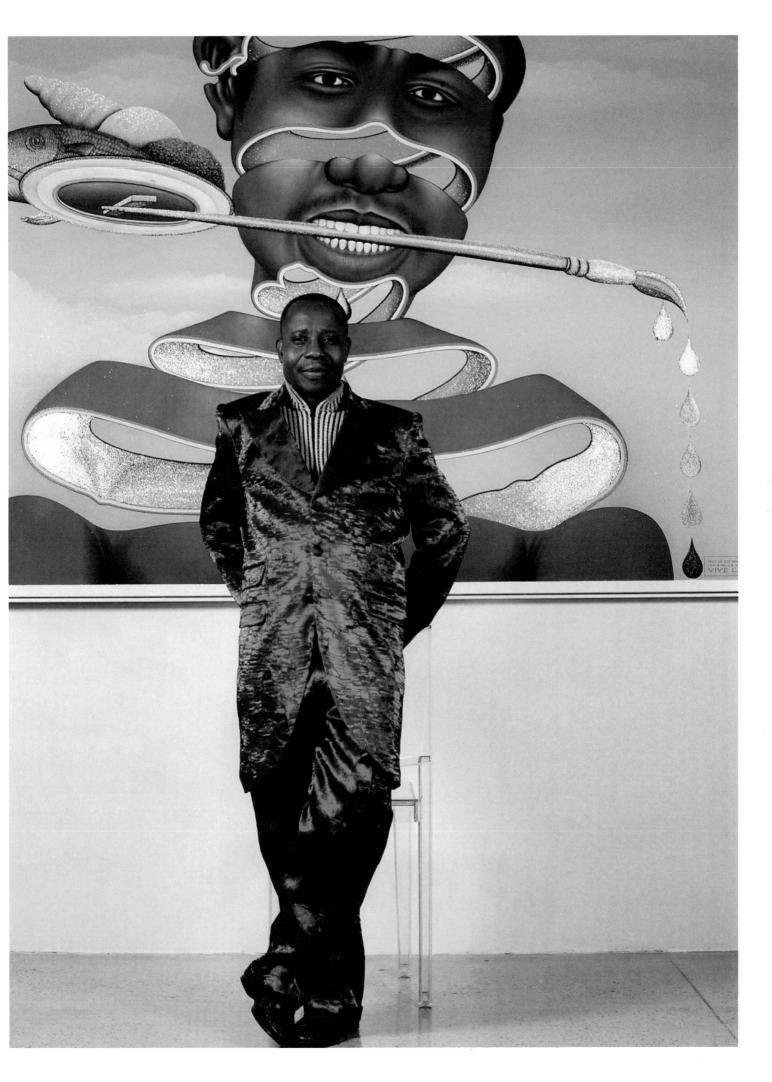

2005

EXHIBITIONS

MARCH 18-JUNE 5

Adriana Varejaõ, *Chambre d'échos*
Rinko Kawauchi

JUNE 24-OCT. 30

J'en rêve
Including Camille Henrot, Erina Matsui, Charwei Tsai

NOV. 19, 2005-FEB. 19, 2006

John Maeda, *Nature + Eye'm Hungry*
Ron Mueck

PUBLICATIONS

Adriana Varejaõ, *Chambre d'échos*

Rinko Kawauchi, *Cui Cui*

J'en rêve

John Maeda, *Nature*

Ron Mueck

NOMADIC NIGHTS

Including Cory Arcangel, François Chaignaud, Christophe Fiat, Four Tet and Steve Reid, Rémy Héritier, Romain Kremer, Eva Meyer-Keller, Moriarty, Rabih Mroué, Pascals, Ariel Pink, Red Krayola, Sébastien Roux, David Wampach

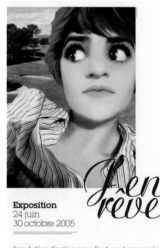

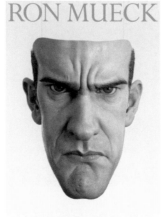

2006

EXHIBITIONS

MARCH 4-MAY 28

Juergen Teller,
Do You Know What I Mean

Tadanori Yokoo

JUNE 18-OCT. 8

Agnès Varda, *L'Île et Elle*

OCT. 27, 2006-FEB. 4, 2007

Gary Hill

Tabaimo

PUBLICATIONS

Juergen Teller, *Do You Know What I Mean*

Tadanori Yokoo

Agnès Varda, *L'Île et Elle*

Agnès Varda, *L'Île et Elle, Regards sur l'exposition*

Tabaimo

Fondation Cartier pour l'art contemporain at MOT, Tokyo

NOMADIC NIGHTS

Including Archie Shepp Quintet, Battles, The Books, The Chaddom Blechbourne Experience, Chuck D, Marcelline Delbecq and Benoît Delbecq, ESG, Grizzly Bear, Olivier Mellano, the Petit Théâtre Baraque, Louis Sclavis, Agnès Varda

INTERNATIONAL PROGRAM

Collection of the Fondation Cartier pour l'art contemporain, Museum of Contemporary Art, Tokyo, Japan

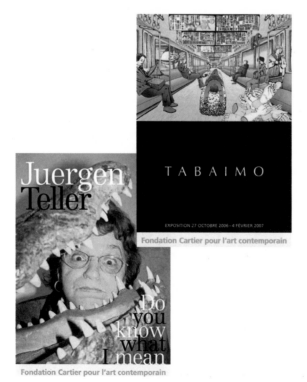

Agnès Varda
at the Fondation Cartier pour l'art contemporain,
exhibition Agnès Varda, *L'Île et Elle*

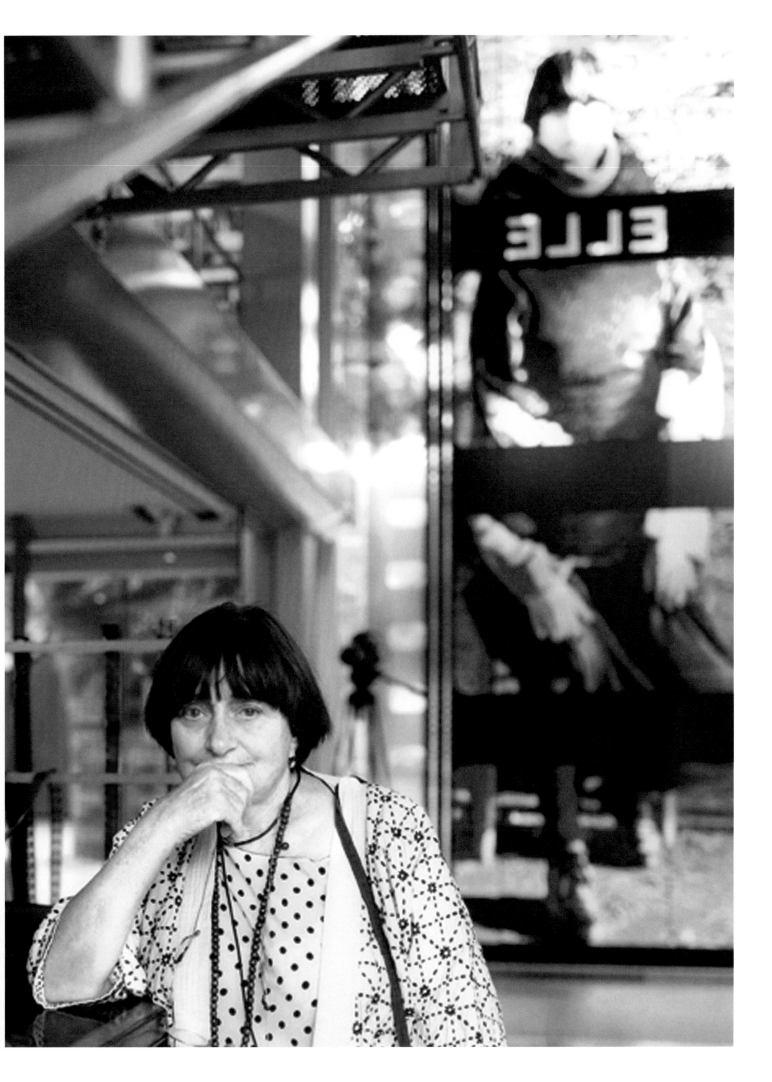

2007

EXHIBITIONS

MARCH 4-MAY 28
David Lynch, *The Air is on Fire*

JUNE 18-OCT. 8
Rock 'n' Roll 39-59

NOV. 16, 2007-JAN. 27, 2007
Robert Adams, *On the Edge*
Lee Bul, *On Every New Shadow*

PUBLICATIONS

David Lynch, *The Air is on Fire*

David Lynch, *Snowmen*

Rock 'n' Roll 39-59

Robert Adams, *En longeant quelques rivières*

Robert Adams, *Time Passes*

Lee Bul, *On Every New Shadow*

Raymond Depardon, *Villes/Cities/Städte*

NOMADIC NIGHTS

Including Au Revoir Simone, Anne-James Chaton
and Andy Moor, Heavy Trash, Lambchop,
Greil Marcus, Matmos

INTERNATIONAL PROGRAM

Raymond Depardon, *Villes/Cities/Städte*,
Museum für Fotografie, Berlin, Germany

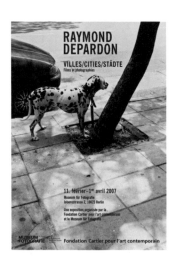

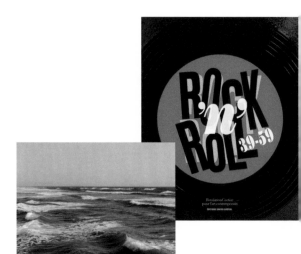

Robert Adams
"On the Edge"
16 nov. 2007 › 27 janv. 2008
Fondation*Cartier*
pour l'art contemporain

2008

EXHIBITIONS

MARCH 28-JUNE 22

Andrea Branzi, *Open Enclosures*

Patti Smith, *Land 250*

JULY 8-OCT. 26

César, *An Anthology by Jean Nouvel*

NOV. 21, 2008-MARCH 15, 2009

Raymond Depardon and Paul Virilio, *Native Land, Stop Eject*

Exhibition design by Diller Scofidio + Renfro
for Paul Virilio's *Stop Eject* part

PUBLICATIONS

Andrea Branzi, *Open Enclosures*

Patti Smith, *Land 250*

Patti Smith, *Trois (Charleville, Statues, Cahier)*

César, *Anthologie par Jean Nouvel*

Native Land, Stop Eject

Raymond Depardon, *Hear Them Speak*

NOMADIC NIGHTS

Including Pascal Contet, Jeffrey Lewis, Macha Makeïeff,
Ted Milton, Jean-Marc Montera and Pauline Oliveros,
Robyn Orlin and Seydou Boro, Patti Smith,
Tom Verlaine, Gisèle Vienne and Dennis Cooper,
White/Lichens

INTERNATIONAL PROGRAM

David Lynch, *The Air is on Fire*, Triennale di Milano,
Milan, Italia

Andrea Branzi, *Open Enclosures and Other Works*,
Grand-Hornu Images, Hornu, Belgium

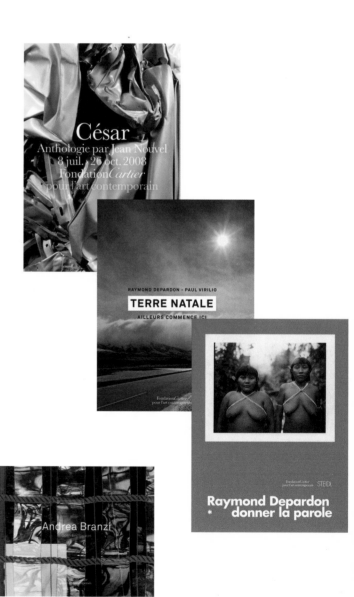

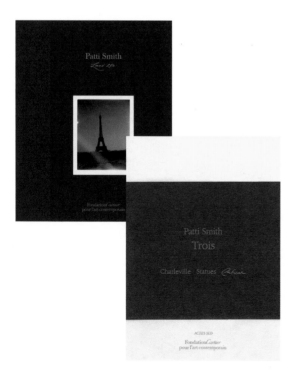

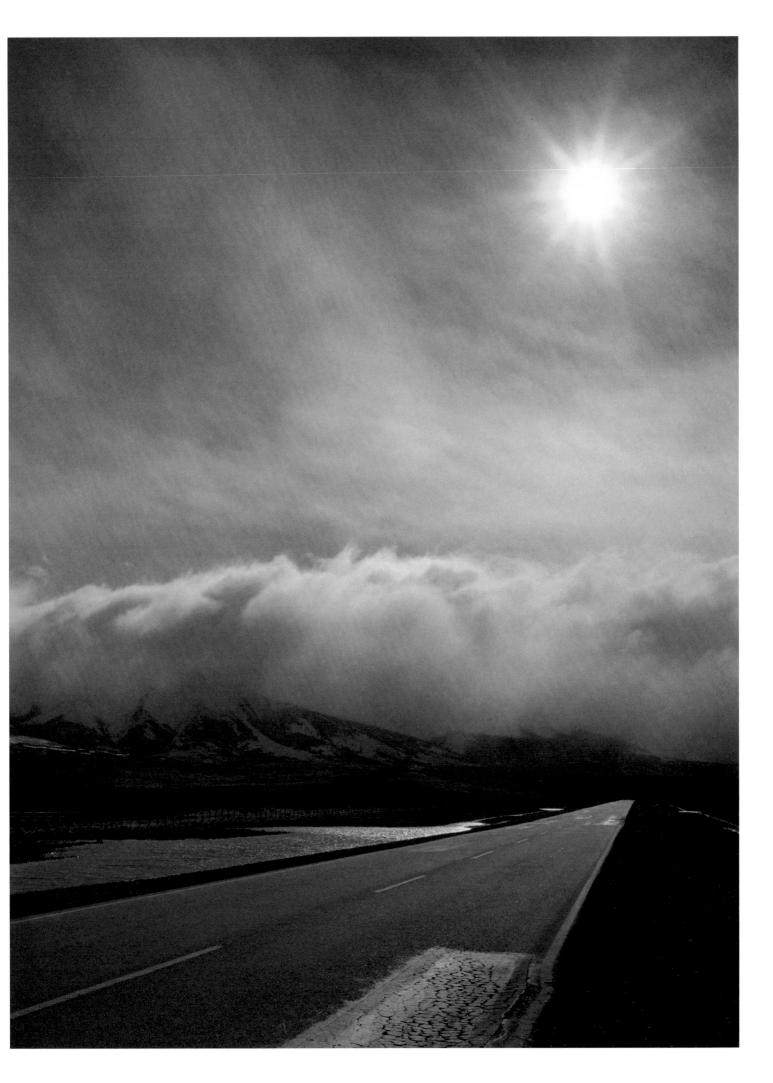

2009

EXHIBITIONS

Apr. 4-June 21

Beatriz Milhazes

William Eggleston, *Paris*

July 7, 2009-Jan. 10, 2010

Born in the Streets–Graffiti

Including Cripta, JonOne, Part One, Seen

PUBLICATIONS

Beatriz Milhazes

William Eggleston, *Paris*

Born in the Streets–Graffiti

Native Land, Stop Eject (paperback edition)

NOMADIC NIGHTS

Including Berlin, Rodolphe Burger and
Dupuy & Berberian, James Chance & The Contortions,
Anne-James Chaton and Andy Moor and Alva Noto,
Vincent Epplay and Sébastien Roux, Jim Jarmusch
with Michel Cassé, Nicolas Saada and Thee Oh Sees,
Joris Lacoste, Daniel Linehan

INTERNATIONAL PROGRAM

David Lynch, *The Air is on Fire*, Ekaterina Foundation,
Moscow, Russia

Native Land, Stop Eject, Kunsthal Charlottenborg,
Copenhagen, Denmark

Alva Noto, Anne-James Chaton and Andy Moor,
Décade (poetry and music), Nomadic Night, May 14, 2009

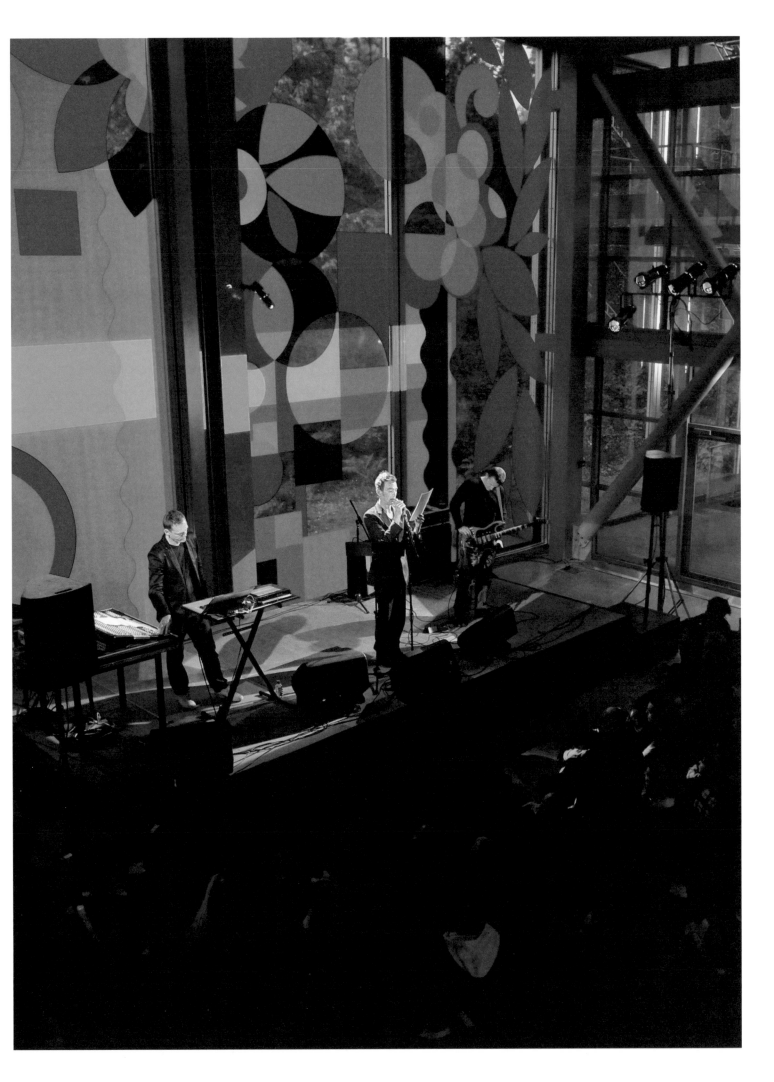

2010

EXHIBITIONS

MARCH 11-SEPT. 12
Beat Takeshi Kitano, *Gosse de peintre*

OCT. 12, 2010-MARCH 13, 2011
Mœbius-Transe-Forme

PUBLICATIONS

Beat Takeshi Kitano, *Gosse de Peintre*

*Gosse de peintre, Coloriages
avec Beat Takeshi Kitano* (coloring book)

Mœbius-Transe-Forme

Coloriages avec Mœbius (coloring book)

NOMADIC NIGHTS

Including Fabián Barba, Catherine Baÿ,
The Berg Sans Nipple, François Chaignaud
and Marie-Caroline Hominal, the Encyclopédie
de la parole, Gérald Kurdian, Lee Ranaldo
with Grégory Combet, Lê Quan Ninh, Franck Leibovici
and Éric Pasquiet, Violaine Schwartz

INTERNATIONAL PROGRAM

Native Land, Stop Eject, AlhondigaBilbao, Bilbao, Spain

William Eggleston: Paris-Kyoto, Hara Museum of
Contemporary Art, Tokyo, Japan/Hasselblad
Foundation, Gothenburg, Sweden

David Lynch, *The Air is on Fire*, GL Strand,
Copenhagen, Denmark

2011

EXHIBITIONS

APR. 5-SEPT. 25

Vodun: African Voodoo

Collection of Anne and Jacques Kerchache
Exhibition design by Enzo Mari

OCT. 21, 2011-MARCH 18, 2012

Mathematics, A Beautiful Elsewhere

With Jean-Michel Alberola, Sir Michael Atiyah,
Jean-Pierre Bourguignon, Alain Connes,
Raymond Depardon and Claudine Nougaret,
Nicole El Karoui, Misha Gromov, Takeshi Kitano,
Giancarlo Lucchini, David Lynch, Beatriz Milhazes,
Patti Smith, Hiroshi Sugimoto, Cédric Villani,
Don Zagier, Tadanori Yokoo

PUBLICATIONS

Vodun: African Voodoo

Panthéon vaudou,
Coloriages avec Patrick Vilaire (coloring book)

Mathematics, A Beautiful Elsewhere

David Lynch, *Works on Paper*

NOMADIC NIGHTS

Including Archie Shepp and Joachim Kühn,
Patrick Corillon, Laurent Grasso, Asta Gröting,
Trajal Harell and Perle Palombe, Hervé Le Guyader,
Charlie Le Mindu, Alberto Manguel, Jeff Mills,
Mœbius with Pierre Baux and François Couturier,
Christine Rebet

NIGHTS OF UNCERTAINTY

Mathématiques des petits with Pierre Pansu

Hyperbolique, animated by Stéphane Paoli,
with Étienne Ghys and Don Zagier

Harmonies, animated by Stéphane Paoli,
with Karol Beffa and Jean-Pierre Bourguignon

Aléatoire, animated by Stéphane Paoli,
with Jean-Michel Alberola, Nicole El Karoui
and Andrei Ujica

Le Grand Soir, animated by Stéphane Paoli,
with Alain Aspect, Jean Audouze,
Michel Cassé, Alain Connes, Thibault Damour,
Antoine Guggenheim, Étienne Klein,
Jean-Pierre Luminet and Cédric Villani

EVENT

OCTOBER 28

Live concert and reading by Patti Smith
and David Lynch

David Lynch and Misha Gromov,
Misha Gromov's Library of Mysteries, 2011,
exbition *Mathematics, A Beautiful Elsewhere*

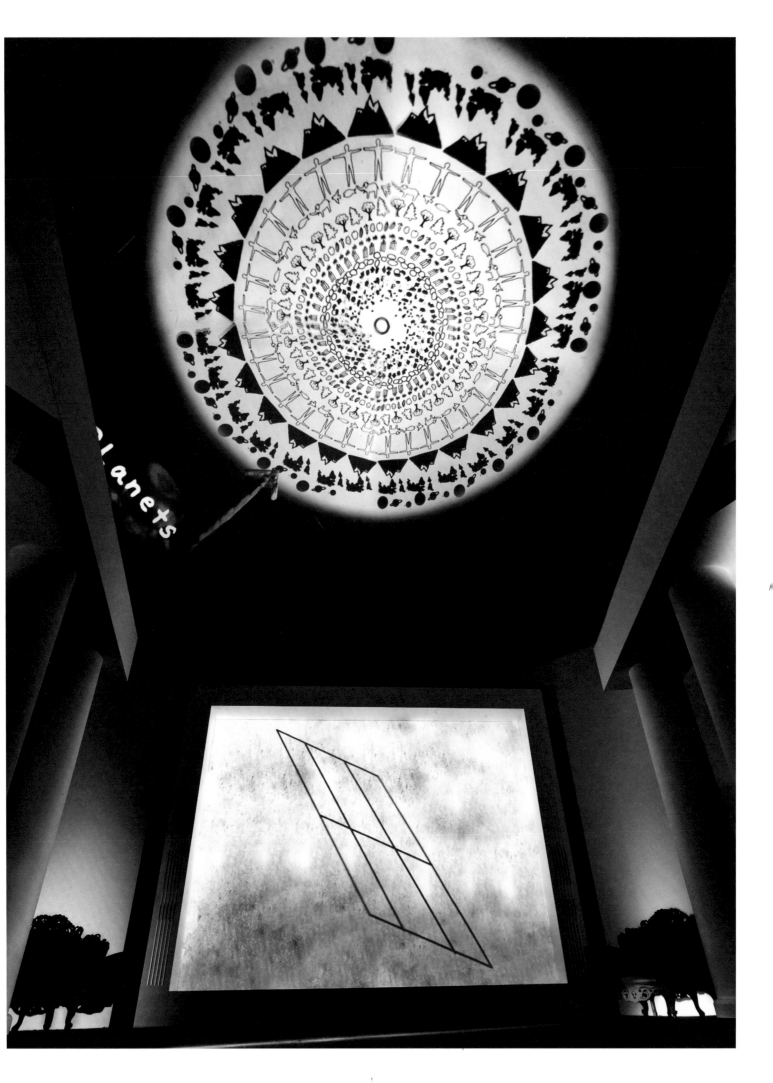

2012

EXHIBITIONS

MAY 15–OCT. 21

Histoires de voir, Show and Tell

Exhibition design by Alessandro Mendini
Including Mamadou Cissé, Jean Joseph Jean-Baptiste,
Huni Kuĩ drawers, Isabel Mendes da Cunha,
Jangarh Singh Shyam, Véio

NOV. 14, 2012–MARCH 24, 2013

Yue Minjun, L'Ombre du fou rire

PUBLICATIONS

Histoires de voir

Histoires de voir, Coloriages avec Alessandro Mendini
(coloring book)

Yue Minjun, *L'Ombre du fou rire*

Coloriages et fou rire avec Yue Minjun (coloring book)

Paul Virilio, *La Pensée exposée*

Misha Gromov, *Introduction aux mystères*

NOMADIC NIGHTS

Including Bettina Atala, Jonathan Burrows
and Matteo Fargion, Anne-James Chaton and
Carsten Nicolai, Marcelline Delbecq and Ellie Ga,
Mette Edvardsen, Frédéric Ferrer, Ariane Michel

Anne-James Chaton (in residence at Nomadic Nights)

NIGHTS OF UNCERTAINTY

L'Esprit de la forêt – 1, animated by Stéphane Paoli,
including Gregorio Barrio, Ibã, Jean Joseph
Jean-Baptiste, Ariel Kuaray Poty Ortega,
Virgil Ortiz, Amilton Pelegrino de Mattos

L'Esprit de la forêt – 2, animated by Stéphane Paoli,
including Mamadou Cissé, Ibã, Jean Joseph
Jean-Baptiste, Ariel Kuaray Poty Ortega,
Amilton Pelegrino de Mattos

L'Ombre du fou rire, animated by Stéphane Paoli,
with Michel Cassé, Fei Dawei, Ouyang Jianghe,
Yue Minjun

Introduction aux mystères, animated by Stéphane Paoli,
with Misha Gromov, Jean-Pierre Bourguignon

INTERNATIONAL PROGRAM

Beat Takeshi Kitano, *Gosse de peintre*,
Tokyo Opera City, Tokyo, Japan

Raymond Depardon and Claudine Nougaret,
screening of the film *Au Bonheur des Maths*,
Tate Modern, London, United Kingdom

Isaka (Huni Kuĩ drawer), *Untitled*, 2011,
exhibition *Histoires de voir, Show and Tell*

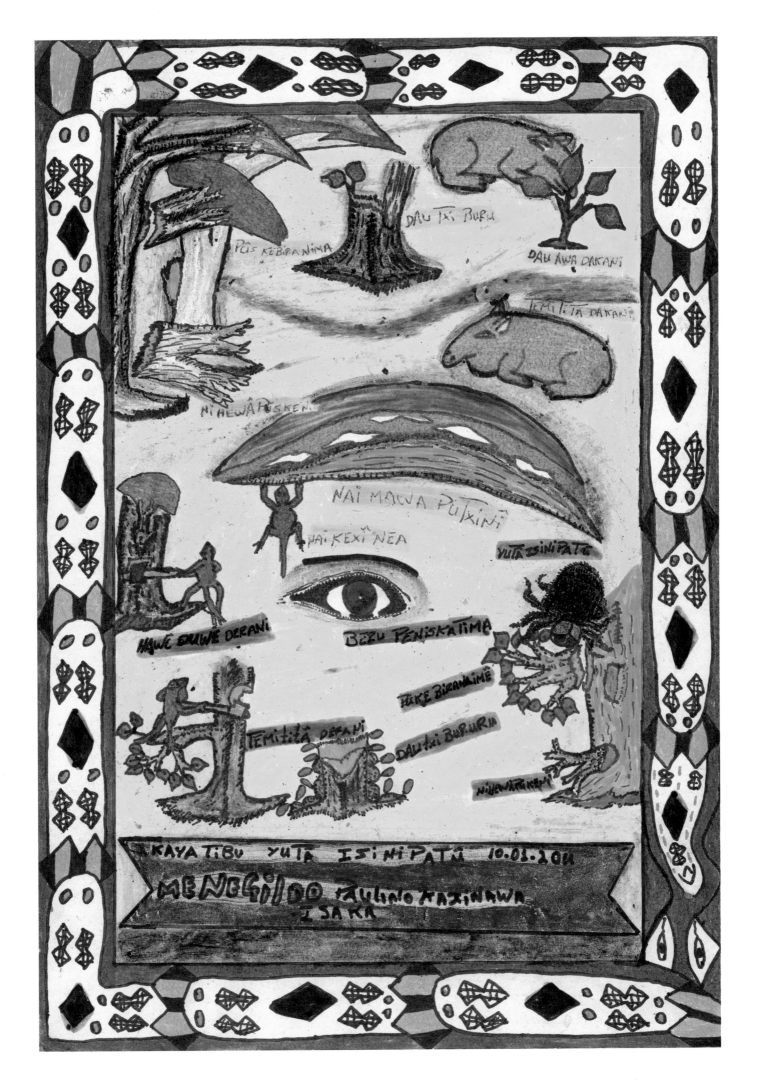

2013–2014

EXHIBITIONS

APR. 16-OCT. 27

Ron Mueck

Nov. 19, 2013-APR. 6, 2014

América Latina 1960-2013

Including Óscar Bony, Marcelo Brodsky,
Eugenio Dittborn, Graciela Iturbide, Adriana Lestido,
Marcos López, Milagros de la Torre

PUBLICATIONS

Ron Mueck

Ron Mueck (exhibition album)

Coloriages avec Ron Mueck (coloring book)

América Latina 1960-2013

Le Cercle et ses amis, Coloriages avec Beatriz Milhazes
(coloring book)

Raymond Depardon, *Manicomio*

NOMADIC NIGHTS

Including Chrysta Bell, Juan Domínguez,
Jean-Pierre Drouet, Alejandro Jodorowsky,
Jean-Yves Jouannais, Marie Losier and
Pauline Curnier Jardin, Ursula Martinez,
Miguel Rio Branco, Agnès Varda

NIGHTS OF UNCERTAINTY

Alice 2013, animated by Stéphane Paoli,
with Isabelle Autissier, Enki Bilal, Michel Cassé,
Hervé Chandès, Odile Decq, Raymond Depardon,
Philippe Descola, Miroslav Radman, Catherine Ringer,
Philippe Val, Cédric Villani

América Latina, animated by Stéphane Paoli,
with Claudia Andujar, Luis Camnitzer, Fredi Casco,
Paolo Gasparini

INTERNATIONAL PROGRAM

Ron Mueck, Fundación Proa, Buenos Aires, Argentina /
Museu de Arte Moderna do Rio de Janeiro, Brazil

América Latina 1960-2013, Museo Amparo, Puebla,
Mexico

Ron Mueck, *Woman with Sticks*, 2009–10,
exhibition *Ron Mueck*

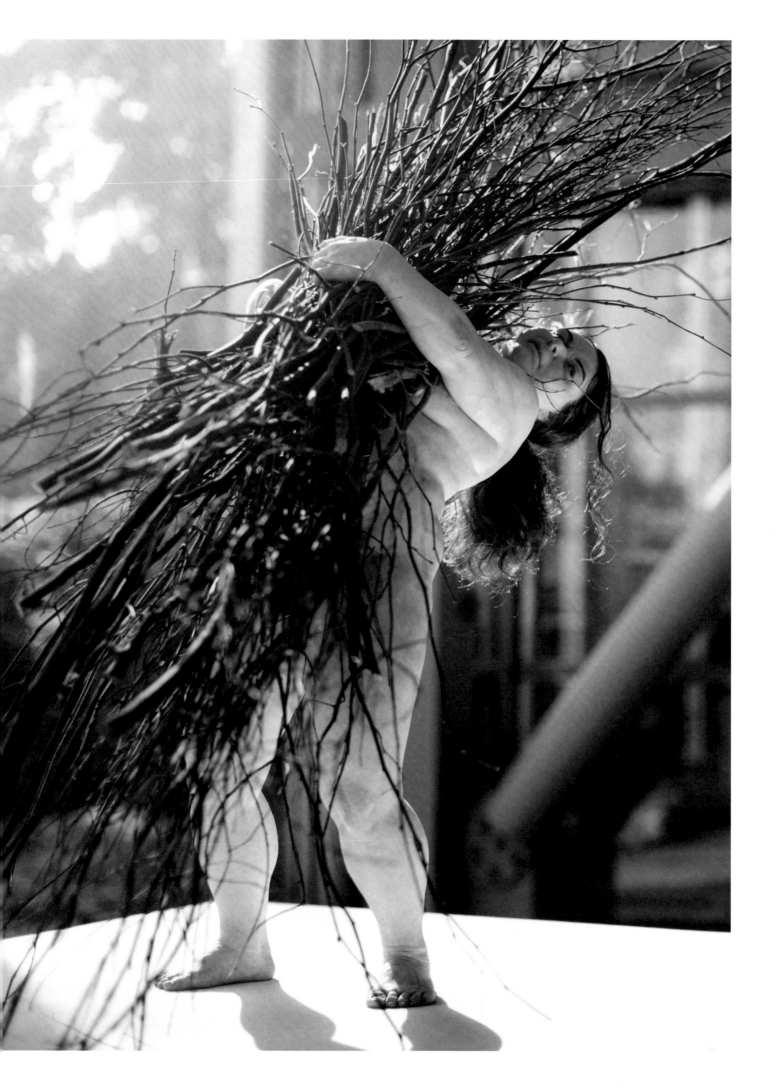

This book is published on the occasion of the 30th anniversary of the Fondation Cartier pour l'art contemporain.

GRAPHIC DESIGN
Akatre, Paris

EDITORIAL COORDINATION
Nolwen Lauzanne and David Lestringant assisted by Charlotte Jacquet and Cécile Provost

FRENCH/ENGLISH TRANSLATION
Gail de Courcy-Ireland and Jennifer Kaku

ENGLISH PROOFREADING
Amelia Walsh

PRODUCTION
Géraldine Lay, Actes Sud, Arles

PHOTOENGRAVING
Daniel Regard, Les artisans du Regard, Paris

Papers used inside the book
Condat matt Périgord 150g
Munken Pure 130g

Fonts
Titles: La Colossale ©Akatre
Texts: Arno Pro (regular and italic)

Fondation Cartier pour l'art contemporain
261 boulevard Raspail, 75014 Paris
France
fondation.cartier.com

Distributed in the United States of America by Thames & Hudson Inc., 500 Fifth Avenue, New York, New York 10110

thamesandhudsonusa.com

Library of Congress Catalog Card Number
2014937113

Distributed in all other countries, excluding France, by Thames & Hudson Ltd, 181A High Holborn, London WC1V 7QX

www.thamesandhudson.com

ISBN 978-2-86925-106-9

Printed and bound in Italy in April 2014 by EBS, Verona, Italy.